Street Photography

With both training and preparation, a street photographer needs to make rapid decisions; there may be only a fraction of a second to immortalize a moment in time that has never happened before and will never happen again. This is where *Street Photography: Creative Vision Behind the Lens* comes in.

Follow Valérie Jardin on an inspiring photo walk around the world. After an overview of the practical and technical aspects of street photography, Valérie takes you along on a personal photographic journey as she hits the streets of her favorite urban haunts. She shows you the art of storytelling through her photographs, from envisioning the image to actually capturing it in the camera. Learn about the technical and compositional choices she makes and the thought processes that spur the click of the shutter.

Perfect for both new photographers excited to capture the world around them and experienced street photographers wishing to improve their techniques and images, *Street Photography* requires no special equipment, just a passion for seeing and capturing the extraordinary in the ordinary.

After working as a commercial photographer, **Valérie Jardin** now dedicates her time and passion to educating others. Since 2012, Valérie has taken her camera all over the world, teaching students the art of storytelling in places where the people and streets abound: Paris, New York, Rome, Amsterdam, Melbourne, and San Francisco, just to name a few.

Apart from teaching, Valérie is the author of two e-books, has written nearly one hundred articles for various publications, writes her own blog, and records her own photography podcast called *Hit the Streets with Valérie Jardin*. She regularly speaks at conferences worldwide, contributes to numerous podcasts, sells fine art prints, and exhibits her work in various galleries. Valérie's talent as a photographer and skill as a business owner caught the eye of Fujifilm USA, and in 2015 she became an official Fujifilm X-Photographer.

Street Photography

Creative Vision Behind the Lens

Valérie Jardin

Routledge
Taylor & Francis Group

NEW YORK AND LONDON

First published 2018
by Routledge
711 Third Avenue, New York, NY 10017

and by Routledge
2 Park Square, Milton Park, Abingdon, Oxon OX14 4RN

Routledge is an imprint of the Taylor & Francis Group, an informa business

© 2018 Taylor & Francis

Library of Congress Cataloging-in-Publication Data
A catalog record for this book has been requested

ISBN: 978-1-138-23892-3 (hbk)
ISBN: 978-1-138-23893-0 (pbk)
ISBN: 978-1-315-29641-8 (ebk)

Typeset in Minion Pro and Avenir
by Apex CoVantage, LLC

Printed and bound in Great Britain
by Bell and Bain Ltd, Glasgow

Pour mes parents que j'aime et la patience dont ils ont fait preuve pour élever une enfant passionnée et intrépide.

For my parents whom I love and their enduring patience in raising a passionate and fearless child.

Contents

PART II: PHOTO WALKS **79**

PART I

THE FUNDAMENTALS OF STREET PHOTOGRAPHY

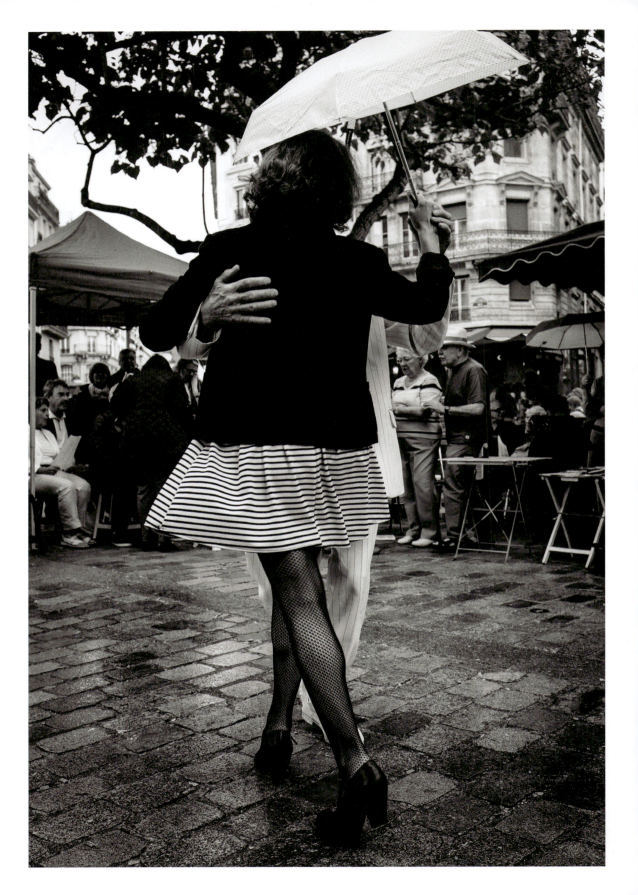

CHAPTER 1

What Is Street Photography?

The photographer will walk the streets mile after mile, day after day, chasing the light, looking for stories. Most frames will be uninteresting. The light is perfect at times, but the subject lacks interest. Other times, the story is there, but the gesture was missed by a fraction of a second. And then there are those rare moments when preparation and serendipity meet. There is nothing special about the light, but the moment moves you because it speaks to your heart. You just captured humanity in its pure form, and you are reminded that this is the reason why you picked up a camera in the first place.

What is the definition of 'street photography'? Sometimes referred to as 'candid' or 'social documentary photography', this genre usually includes people, or the idea of people, generally in a public place. It is important to add that the photograph doesn't have to be captured on the street. For example, the human element can be on the beach or inside a building. The notion of 'people' is more important than the notion of 'street'. Street photography doesn't require a street or even a city, but it requires people, or at least the idea of people. If the human element is not present in the frame, then there should still be an idea of humanity that shows through. The subject can be a still life photograph of a discarded shoe on the sidewalk, for example. It is often debated whether the street portrait, when the subject is aware that he or she is being photographed, is part of street photography. The purpose of this book is not to add to the controversy. Personally, I don't pay attention to those discussions. Street photography is simply recording life. It doesn't need a definition.

The first part of this book is aimed at giving you an introduction to the many different ways of approaching street photography. If you've been dabbling in it for a while and are ready to step up your game, then you will benefit from the sections on the many different elements that will make a stronger photograph.

The second, and more personal part, is a large series of street photographs from my own collection captured around the world. Each one is accompanied by a few words about the creative process and my personal experience, from seeing to capturing the story in a frame.

(facing page)
Dancers. Fujifilm
X100T 23mm ISO 1250
F/4.5 1/250 Sec.

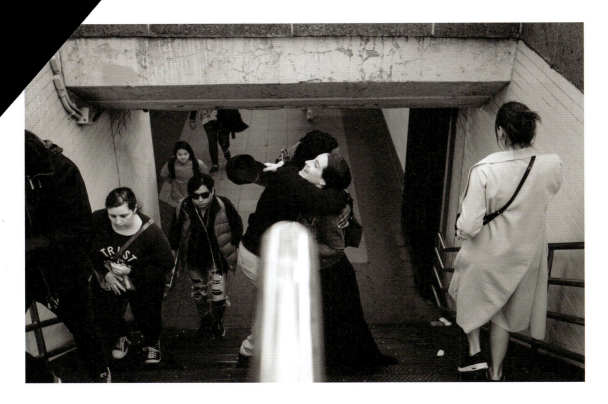

The Embrace. Union Square, New York City. Fuijfilm X100F 23mm 1/125 F/3.2 ISO 640.

Regarding street photography, there is no shortage of interesting subjects in New York City, and it usually pays off to stop and observe, as shown in the photo above. I spent a few minutes watching people coming and going at the busy Union Square subway station. I was just about to leave my spot behind the metal railing at the top of the stairs when the moment happened. A young woman rushing to the subway and a young man going in the opposite direction saw each other and hugged. She was wearing a cap, which she removed quickly before the embrace. There was so much joy in the moment that it touched my heart and soul.

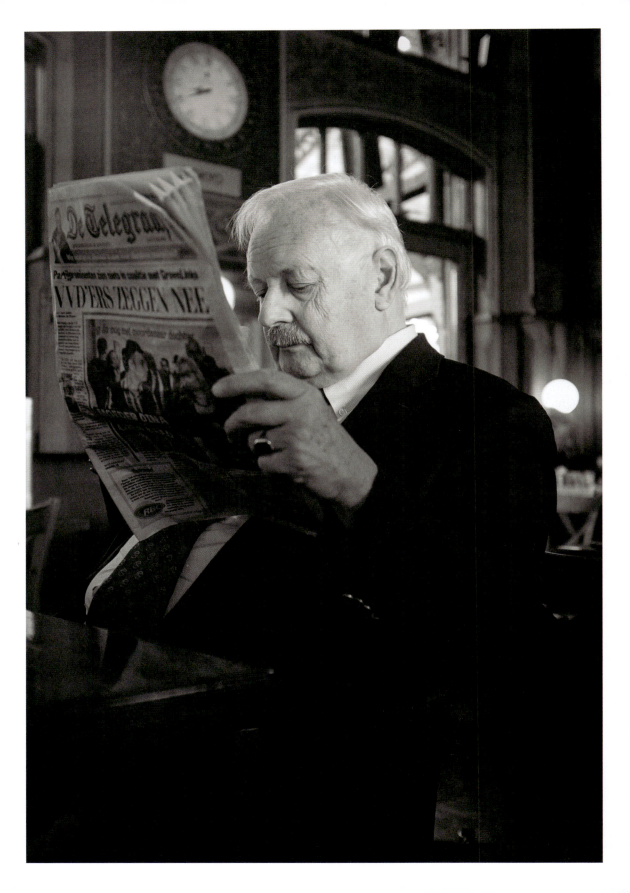

Getting Started

WHAT DRIVES STREET PHOTOGRAPHERS?

Some are extroverts, while many are introverts. What drives us? Is it our passion for mankind or our curiosity to catch a glimpse into strangers' lives? No matter what it is, we all have one thing in common: We see the extraordinary in the ordinary. We are light seekers and storytellers, and we have the need to freeze the moment in a frame.

IF THIS IS NEW FOR YOU, THEN RESET YOUR EXPECTATIONS

Street photography is not like any other genre of photography; you have to approach it differently. The decisive moment calls for a different standard, one that is subtler than any other photographic expression. You have only one opportunity at capturing something special, a moment that never happened before and will never happen again. You cannot expect everything to come together perfectly in every frame. With street photography, it's often about compromise. You have control only of your vision and your camera, nothing else. On some rare occasions, compositional elements will fall into place with the right light, a great background and the perfect subject, but it is often the 'imperfections' and surprises that make a great street image. Some of my favorite street photographs are technically imperfect but emotionally charged.

IS IT LEGAL, AND DO I NEED PERMISSION?

In most countries, as long as you are in a public place, it is legal to photograph people for editorial or fine art purposes without their permission or knowledge. Some countries have stricter privacy laws than others. This doesn't mean you won't be able to photograph strangers on the streets, but you may run into more resistance in those places than in others. However, if you intend to use any images with identifiable people for commercial purposes (which is very unlikely if you are a street photographer), then you would need a signed model release form. Each country has its own regulations, so make sure you do your homework before you get started.

(facing page)
In Amsterdam, NL.
Fujifilm X100F 23mm
ISO 3200 F/2.2 1/250
Sec.

Respecting your subject is the number one rule in street photography. Personally, my goal on the streets is to immortalize a special moment that will never happen again. I make a point of never photographing people in vulnerable or embarrassing situations.

Be aware that security guards will regularly stop you. They are only doing their jobs but can often be a bit overzealous. Know your rights. If a security guard stops you, then explain what you are doing. Make him or her aware that you know your rights. If you are still asked to leave the premises for no justified reason, then decide if it's worth pursuing further. For example, if you are within your rights and you drove a long way to the location in order to get a specific shot, then do not hesitate to ask to speak to a supervisor or a police officer to make things right. If the location is not worth it, then just drop it. It's important to choose your battles. Is a long argument that means getting more people involved just to prove your point really worth your time and energy? Most of the time, I get my shot before a security guard asks me what I'm doing. Then I simply wish them a good day and leave.

Always remember this important caveat: If someone confronts you, even though you are within your rights, then *never* become confrontational. Some people don't like to be photographed, period. They may even get angry if they catch you photographing them. Always try to appease people, and explain what you are doing. If things get heated, then just thank them and leave quietly.

IS IT ETHICAL?

We all have a different definition of ethics. We are influenced by our education, culture and upbringing. But there are, in my opinion, certain 'rules' of ethics that derive from simple common sense, no matter who you are and where you live.

If I inadvertently photograph a subject in an embarrassing situation, for example, then I will most likely never post the image publicly. I always ask myself, "If I were the subject of this photograph, would I feel bad having it displayed for the world to see?" If the answer is yes, then the decision is quite simple. Humor can also be interpreted differently from one culture to another; more on that later in the book.

If, for example, I photograph lovers who are not 'supposed' to be together but are in a public place, then I see nothing wrong with it. It's their choice to display affection publicly, knowing that security cameras at every street corner are filming them. I will certainly take the liberty to make a beautiful photograph of the moment if serendipity allows me to cross their path.

WHAT GEAR SHOULD I USE?

If there is one genre of photography where less is more, then it's street photography. Could it be the most affordable type of photography you can get hooked on? Quite possibly! Unless, of course, you're a 'gear head' and cannot resist the latest and greatest camera or lens. For my part, I can honestly say that I spend more money on good shoes than I spend on photo gear in any given year.

I shot street with a DSLR for years, and it was fine. I used a small prime lens to make my camera look less conspicuous. Now that much better and smaller cameras are available, it is unnecessary to buy a DSLR system to get started in the genre. Smaller is better, and quiet is gold!

I don't care about pixels and dynamic range. I care about easily accessible dials that get the job done quickly. I currently shoot with a mirrorless range-finder type of camera, the Fuji X100F. It has a 23mm fixed lens that is equivalent to 35mm on a full-frame camera. It's simple and gets the job done.

There are no bad cameras out there. You just have to find one that feels right for you. It should become an extension of your vision: You should forget that it is even there, and never let it get in the way. I often go on iPhone photo walks; it's an exercise in limitations. Others go out and shoot film for a day. Whatever you decide, remember that the camera is only a tool: The only way a new camera is going to make you a better photographer is if it takes you on more photo walks. So yes, buy a new camera if you can. If you feel good about it, then you'll take it out more, shoot more and grow in your craft as a result. Just remember that your camera has no vision, and the success of the photograph is 100 percent up to you and you only.

WHAT SHOULD I BRING ON A PHOTO WALK?

Comfortable shoes are the most important non-photo-related accessory a street photographer must invest in. I also carry some special blister Band-Aids in my camera bag just in case. Nothing will ruin your photo walk like a blister. It is also important to stay dry. Walking for hours and hours with wet feet is not conducive to creativity, and yet rainy days are filled with new photo opportunities. All it takes is a little preparation and a positive outlook. I also make a point to dress in layers. I dislike being too hot as much as I dislike being cold. Protecting your precious gear is also important. Many cameras are now water resistant, but my favorite one isn't, and I find that a small travel umbrella is much more convenient than a protective rain sleeve to keep shooting in the rain. Small cameras require only one hand to use.

I highly recommend adopting the one camera, one lens philosophy on the streets, preferably a fixed focal lens, also called a prime lens. You will shoot with more intent and be more comfortable without carrying extra weight.

Extra batteries and memory cards are a must. All batteries are not equal. Some will drain faster than others. It's always a good idea to carry one more than the number you think you will need. The same goes for memory cards. Buy from the top brands online to get a good deal. You never know what will cross your path, and you may shoot more frames than you think. I've seen many students in workshops resort to deleting their work to make space. This not only wastes time, but you will likely miss something while you're going through your pictures. You may accidentally delete a keeper, and deleting in camera may increase your risk of card failure.

Bring some cash. You may strike up a conversation with a street musician, for example, and do a series of portraits. The least you can do is give a few dollars to support them.

I always have a small snack in my bag. I often lose track of time when I'm 'in the zone', and I can suddenly feel extremely hungry. Rather than finding a place to eat, I prefer to have a healthy snack to keep going while I look for the perfect café or bistro that will offer some photo opportunities. The street photographer never puts the camera away!

The only reason I need a camera bag is to carry my personal items. My camera never gets a break.

THE FEAR OF PHOTOGRAPHING STRANGERS

Many photographers freeze at the thought of photographing strangers in the streets. It's a natural feeling. It is a very intimidating thing to do until you reach a point where your fear of not getting the shot becomes greater than your fear of getting the shot. At that moment, street photography becomes a way of life.

Many street photographers will tell you that photographing street performers doesn't count, that they are "too easy." If you are new to street photography and a bit shy, then I highly recommend that you start with photographing buskers. They are performing to be seen and heard. They are great subjects to get your feet wet and to help you get over the fear of photographing strangers. Don't forget to have some change in your pocket: Remember, they're performing to make a living.

Street performers also allow you to practice a series of storytelling images with a single subject. Start with an establishing (wide) shot where you show some of the surroundings to give your viewer a sense of place. Get closer for a medium shot of the artist, and don't forget creative angles for more dynamic images. Then get the close-up shots, such as the fingers on the saxophone or guitar, the money in the instrument case and so forth.

Street performers are also ideal subjects to practice removing distracting elements from your frame. When you are in a real-life situation, witnessing a moment that will last only a few seconds at most, you must react very

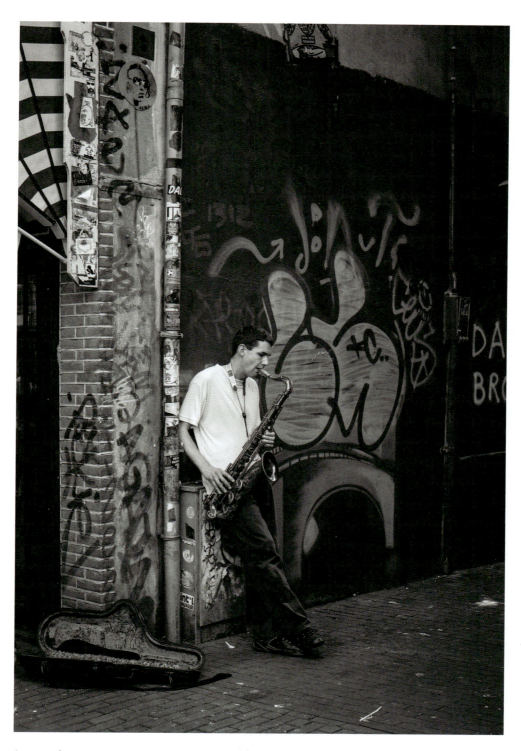

Street performers are easy subjects to practice on, and they are definitely part of the street scene. Amsterdam, Netherlands. Canon 5D MrkII 50mm 1/200 F/5.6 ISO 200.

quickly. Like most street photographers, I do not remove anything from the frame in postprocessing. It is part of the challenge, and also takes some skill, to remove distractions before pressing the shutter. Moving left or right to prevent a distracting element in the background from ruining your shot, such as an antenna sticking out of your subject's ear, requires quick thinking. Practicing those skills on subjects who are sitting still is a lot easier. Take your time, and as long as you dropped some money in the hat first, musicians will be more than happy to be photographed.

Busy markets or fairs are excellent venues in which to get started in street photography. You will blend in with the crowd, and no one will notice you or your camera. It is generally better to shoot street photography on your own because you are more invisible that way. But if the thought of going out alone is too intimidating, then take a friend. You will not only be emboldened but also surprised at how differently two people see the world.

Taking portraits of strangers can also be intimidating, often even more so than doing candid street photography. We will delve into this in more details

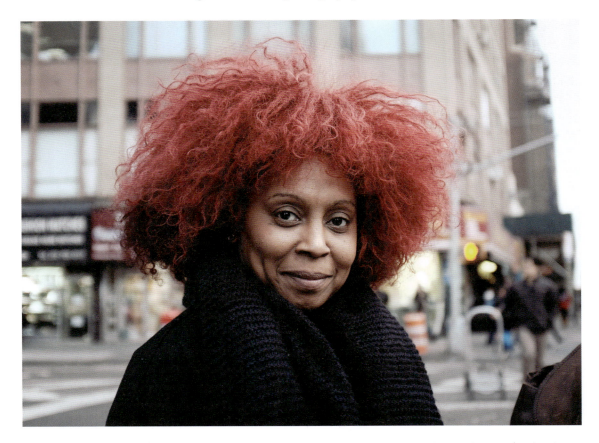

Taking portraits of strangers can be very intimidating—often even more so than doing candid street photography—but they are very rewarding for the photographer. Manhattan, New York City. Fuijfilm X100T 23mm 1/125 F/2 ISO 640.

further in this book, but here is a word of advice: If you are an introvert, then start interacting with strangers daily without a camera. Make small talk at the supermarket or the bus stop. You will be that much closer to the next step of making a portrait.

We all need to face our fears to overcome them. I started rock climbing to face my fear of heights. It is often by doing so that you develop a lifelong passion. Remember that creative people grow by going outside their comfort zones. This is certainly true in photography.

SHOULD YOU PICK A THEME OR GO OUT EMPTY?

Depending on the situation and the place, I occasionally leave the house with a theme in mind. This is especially fun if you are at a fair or other large event. I spent the day photographing people eating food on a stick at the state fair one year. This year, I photographed faces in the night using the available lights coming from the attractions and fair rides. Another time, while visiting a large outdoor car show, I focused my attention on people who 'look' like their cars (yes, people tend to match their collector cars!). The possibilities are endless and can turn an ordinary photo walk into a treasure hunt. You can also pick a color or search only for people wearing hats. This works well to focus your attention, and you will come home with a good series of shots.

Focusing on a theme can also be helpful when you are visiting a new place. When you visit a large city for the first time, the photo possibilities can often become overwhelming, and you may try to see too much, finishing the day with lots of mediocre frames without any consistency. If you focus on a theme, such as lovers or people walking their dogs, then you will still see other photo opportunities, but you will end the day with a good series of photographs and feel good about yourself.

Most of the time, I go out empty and completely open to possibilities. Something always catches my attention along the way—a story will unfold, or the light will be magical. Those moments are so rewarding!

THE POWER OF LIMITATIONS

Just like limiting yourself to a theme, limiting yourself to a single focal length or a number of frames can help you grow as a photographer. Although the digital age has made the learning curve much faster, it has also made photographers lazier. Many street photographers resort to the 'spray-and-pray' approach. Except in situations when you need a large number of frames to get a good shot, during street demonstrations or in low-light situations, for example, the spray-and-pray method will not teach you anything to improve upon. Moreover, the lucky shot is often not very satisfying for the

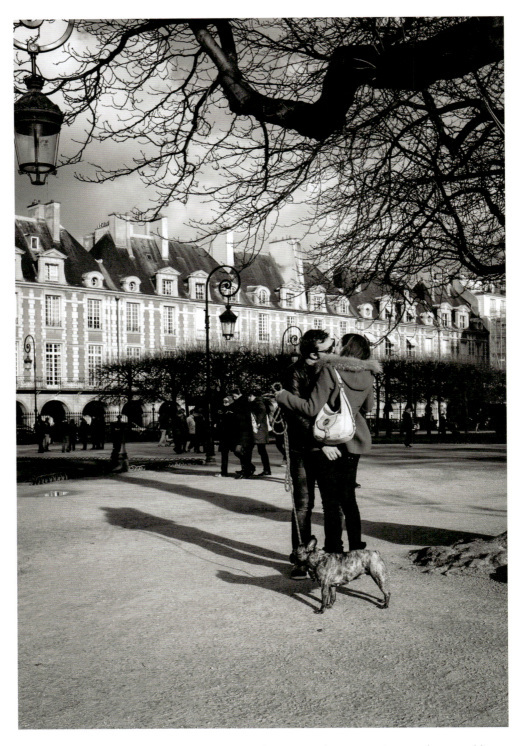

I was working on a 'Lovers' project for a few months and never missed an opportunity to catch some public display of affection while roaming the streets. Paris, France. Fuijfilm X100S 23mm 1/950 F/4 ISO 200.

photographer. The best photographers are discerning and consistent in the quality of their work. Having a vision, being in control of your gear and pressing the shutter with a purpose will yield more keepers at the end of any photo walk.

SHARE YOUR WORK

Those photographs are useless if they stay on your hard drive. Share them on a blog or social media platform. The more you share, the better you will feel about yourself, and the more you'll want to go out and shoot. Be aware that you do not go into street photography for the 'likes'. Many people do not know much about street photography or how to appreciate it. Grand landscapes or kittens will always get more attention than street photography on social media. It is important to share within groups that are a bit more discerning and specialize in the type of photography you are shooting. Whether it is on Facebook, Flickr or Google+, some groups may even give you constructive feedback and run contests. Always remember that no one makes the rules, yet, the street photography community seems to have its own 'police'. Do not let the negative people deter you from enjoying what you are doing: You are the only person you need to please with your new hobby. Although everyone enjoys recognition, do not let it become a crutch you can't live without. Look at others' work for inspiration, and keep raising the bar. Do not try to fit a style just because you think you will get more likes. Be true to yourself, and you will find your own voice.

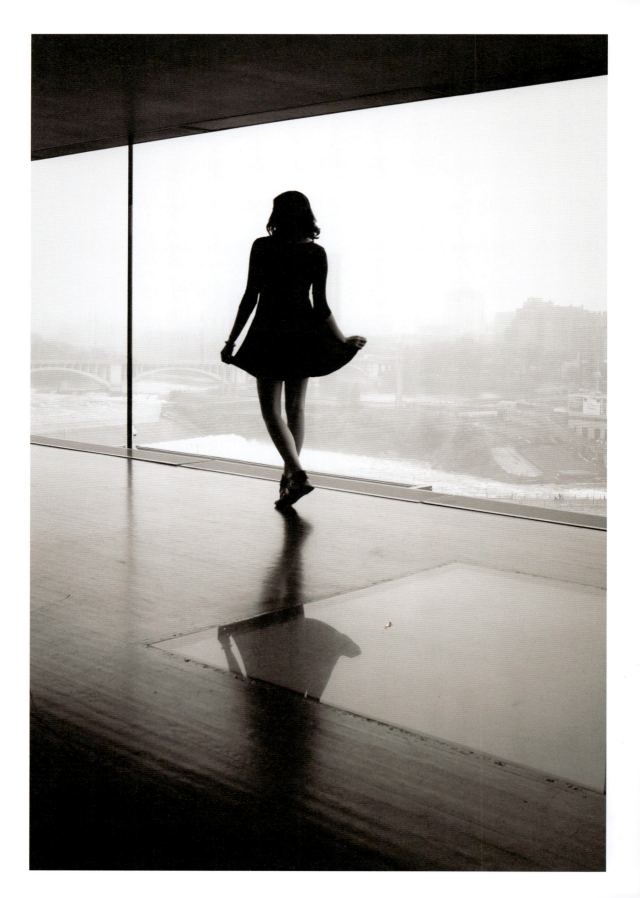

Different Ways to Approach Street Photography

Street photography is not necessarily synonymous with being in your subject's face. There are many ways to approach this exciting genre of photography. You may enjoy shooting all the different ways or just one of them. The important part is to have fun in the process; do not try to fit in a certain style just because you think it will get you more likes on social media. If getting too close is really uncomfortable and unpleasant for you, then why do it? Maybe your personality will fit with a different, more minimalist style.

Let's look at the different ways to 'shoot street'.

REACT TO A SITUATION

The most common way to do street photography is by simply walking the streets of any city, small or large, and reacting to a specific scene, light or subject. You may be struck by the way the light is illuminating lovers sitting on the riverbank, an interesting expression or gesture, a color and so on. The more you photograph people on the street, the more in tune you will be with your surroundings. Nothing escapes the seasoned street photographer. I always joke that our peripheral vision is so enhanced that it would be hard to pickpocket a street photographer. You will become so aware of life on the streets that you will kick yourself whenever you leave the house without your camera.

Once you see your subject, be ready. You may have only one shot at capturing that moment or gesture. You will have to do some quick thinking to position yourself in a way that will allow the best possible shot. Scan the frame to avoid any distracting background elements—you may need to adjust your framing by quickly repositioning yourself. Don't expect your background to be perfect, but it's best not to have a tree branch sticking out of someone's ear.

(*facing page*)
Impromptu Twirl,
Minneapolis, MN.
Fujifilm X100F 23mm
ISO 320 F/5.0 160 Sec.

You may have to run to get ahead of your subject. Very often, I will pass someone really interesting or see a really cool subject across the street. In times like these, I quickly make the decision to run ahead of the subject to find a spot that will give me the best possible angle, light or background. This doesn't always work, and at times, my subject will enter a store or make an unexpected turn. Yet, more often than not, this quick thinking pays off, and I get the shot I envisioned.

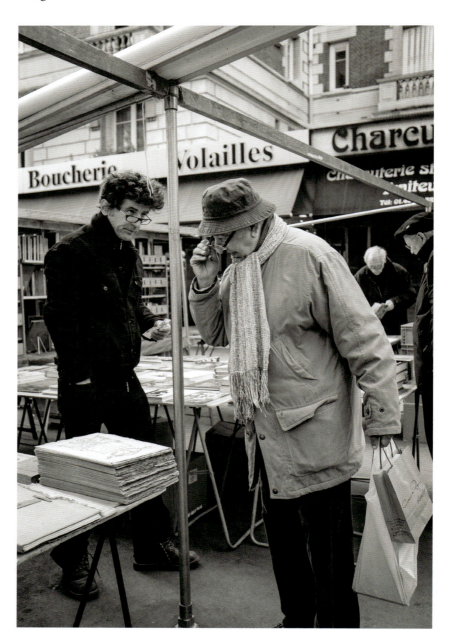

At a book fair, I could not resist photographing the men with their reading glasses. Paris, France. Fuijfilm X100S 23mm 1/340 F/2.8 ISO 400.

Anticipate the next move. A big part of successful street photography is the photographer's ability to anticipate the subject's next move. This is achieved by observing people all the time, with or without a camera. Of course, there will always be an element of surprise, but the better you become at observing and anticipating, the more keepers you will have at the end of the day. Also notice how people's actions are very predictable. It's human nature; we are creatures of habit.

Assignment: Put your camera on full auto, or take your smartphone to focus all your attention on seeing. It may be an interesting subject, the way the dappled light makes patterns on the sidewalk and so forth. Do not worry about settings; let your camera do all the work. Just learn to see.

BE PART OF THE SCENE

Today, we have the advantage of completely silent cameras, which are great tools in street photography. You can get close to your subject, right over his or her shoulder even, and the viewer will feel as if he or she is looking through the subject's eyes. This technique works particularly well in busy places, such as public transportation or fairs, where you can get close without being noticed.

There are many ways to get close to your subject without attracting attention. It's not about being sneaky; it's about not disrupting the scene. You reacted to something special, and any changes can ruin the moment. Not

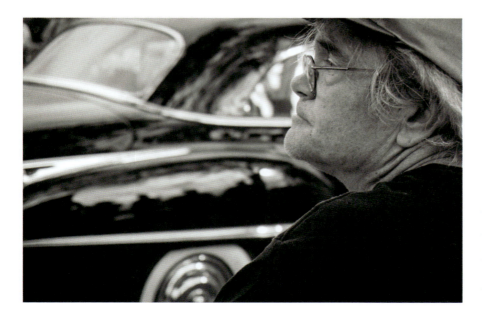

At a car show, I was so close to the subject that it feels as if the viewer is seeing through his eyes. Saint Paul, Minnesota. Sony A6000 50mm 1/160 F5.6 ISO 160.

bringing the camera to your eye makes you less conspicuous. Flip screens are also very helpful. You can also make it look like you are photographing past your subject—after all, most people see no reason why they would even be the subjects of a photograph.

Whatever your method for getting close without bringing attention to yourself, just be relaxed! If you are nervous, then you will transmit the wrong vibes, and people will feel that.

Assignment: Take the smallest camera you own or your smartphone. Silence it. Now buy a ticket to get on any public transportation that your city offers: city bus, subway, light-rail system. Find a spot with lots of people, stand or sit and take pictures up close. Practice shooting from chest or hip level.

FIND A STAGE

One of the countless joys of street photography is to find a stage and wait for the perfect subject to enter the frame. The background may be a variety of things: a nicely textured wall, a storefront, a symmetrical structure or a reflective surface. Writing or signage on a wall or billboard can also make the story; it can also have a comical effect when the right protagonist appears. This is where anticipation comes into play. You can see an opportunity and guess people's reactions as they walk by, but catching the right moment is up to you.

Street photographers constantly scan for those opportunities, and envision a potential shot. Of course, seeing the right subject also means capturing the right moment. The stepping is very important in a moving subject. Catching someone between steps doesn't make for a strong image. It is more satisfying if you can get the right moment in one shot rather than in burst mode, but the important part is to recognize that moment. Put all the chances on your side, and shoot several frames consecutively. You will soon learn to recognize which is the strongest image and why. An easy way to catch the right stride is to count each step as you watch the subject enter your frame. One . . . two . . . click! Anticipate the third step, and press the shutter when the subject's foot hits the ground. Better yet, catch the step at the moment when there is just a little separation between the foot and the ground.

How do you know if it is a strong subject? Part of it has to do with your subject's physical appearance. I avoid photographing people wearing baggy clothes or backpacks. I find people wearing elegant clothes much more interesting, as the clothes are more fitted, which allows for a better definition of the human form. Large writing on clothes, such as brand logos, are a distraction and draw the viewer's eyes away from the facial expression or gesture. Definition and separation are important considerations, which we will study further in this book.

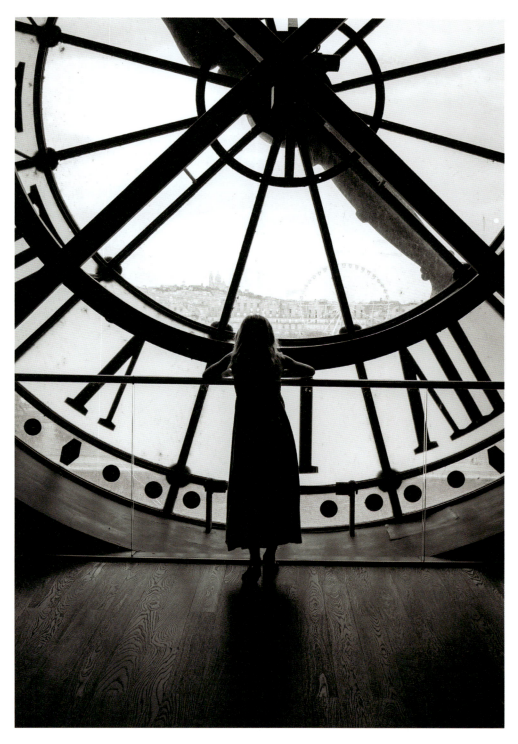

The clock at the Musée d'Orsay is a wonderful backdrop. It is well worth waiting for the right subject to enter the frame. Paris, France. Fuijfilm X100T 23mm 1/100 F/5.6 ISO 200.

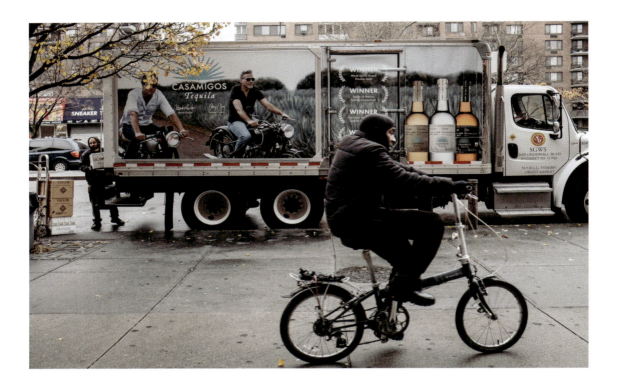

Signage and ads can offer great opportunities for juxtaposition. Harlem, New York City. Fuijfilm X100T 23mm 1/250 F/5.6 ISO 2000.

Also, you may want to photograph a subject who belongs to the place you are in. This is especially true if you are traveling and want to add authenticity to your travel images. Why photograph an American tourist clad with backpack, baseball cap and GAP sweatshirt in front of an amazing backdrop in Rome? Be discerning, and do not settle for the first person who walks into your frame.

Assignment: Take your camera, and find an interesting storefront with signage or a window display that could lead to a story. Envision the type of subject that would make an interesting shot and wait. Remember to look as inconspicuous as possible by not putting the camera in front of your face, or people will go around you or duck. Plan on waiting anywhere from five to thirty minutes, and be discerning!

INCORPORATE THE HUMAN ELEMENT INTO THE URBAN LANDSCAPE

This is a more minimalist approach to street photography. Your subject is usually quite small in the frame but becomes the focal point in an interesting urban landscape. Look for appealing architecture, repeated patterns, geometric shapes and so on. They all make for interesting backgrounds. Wait

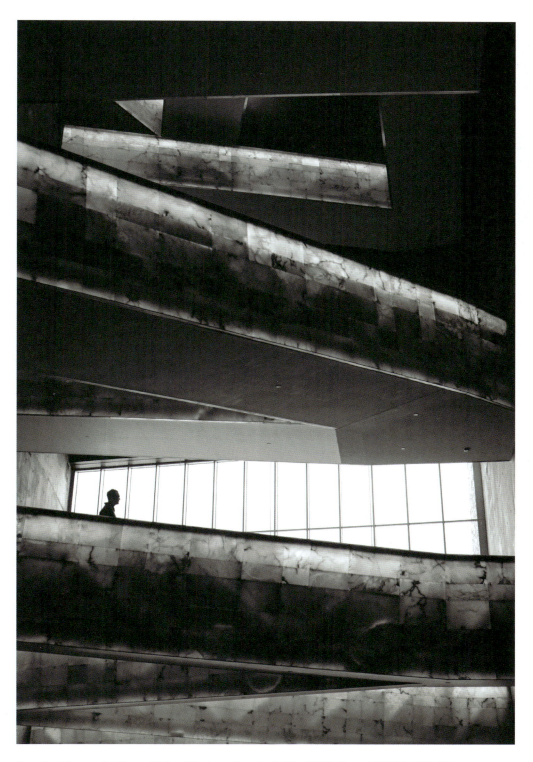

Canadian Museum for Human Rights. Winnipeg, Canada. Fuijfilm X100S 23mm 1/350 F/2.8 ISO 800.

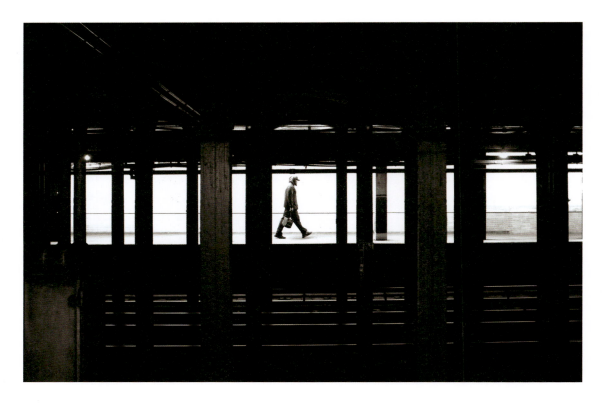

Subway. New York City.
Fuijfilm X100T 23mm
1/125 F/2 ISO 5000.

for the right subject to enter your frame, et voilà! Here again, not everyone will make a good subject, and being discerning is key to achieving a successful result. It's also important to find a subject who will stand out. If you are shooting black and white (B&W) and you are in a setting with a lot of contrast, then catching someone wearing a dark suit in the light will stand out more than someone wearing white, who might blend in and disappear. There are many factors to take into consideration; capturing a strong photograph is much harder than it looks. The environment doesn't necessarily have to be urban. The human element will enhance any landscape or seascape photograph. Remember to catch the right moment, the correct stepping. Separation in the body also makes for stronger images. Do not settle for the first shot you take. Wait around, and a better subject will likely enter your frame in a few minutes . . . or an hour. It's a game of patience!

Assignment: Think of a building in your city with striking architecture. Maybe it's very modern and futuristic or more classic with columns, archways or a grand staircase. Compose your shot in a way that highlights the architecture in a spot where people are likely to enter your frame. Wait for the best possible subject, and pay attention to the stepping and separation in the body.

THE EYE CONTACT

A common approach to street photography is provoking eye contact. I do not enjoy this method, finding it a bit too bold and not a good experience for the subject. Some street photographers will go as far as using a flash and photographing their subjects up close with the use of a bright light. When done well, the images can be very powerful. However, this method does not fit everyone's personality, and there are many other ways to practice street photography without provoking your subject. No one makes the rules, and you should march to the beat of your own drum. I highly recommend that you use this method only if you are comfortable with it and are ready to handle strong reactions from your subjects very calmly. Do not—and I can't stress this enough—become confrontational. Be friendly, and step away from the situation.

Although I never provoke eye contact, there are times when the subject will spot me, and I capture 'the stare' or the moment when the person becomes aware of my camera. I always cherish such moments. Eye contact, when it happens organically, can make for interesting photographs.

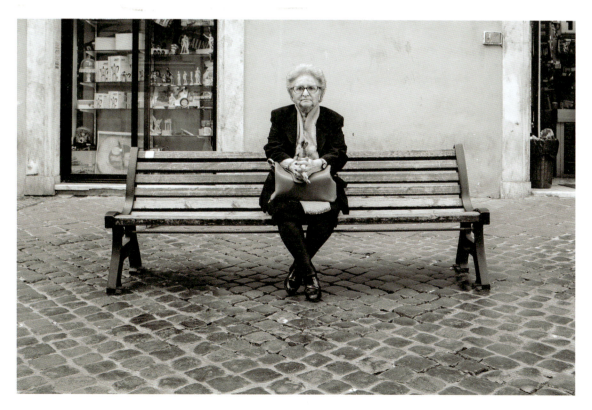

I really enjoy capturing eye contact when it happens naturally. Rome, Italy. Fuijfilm X100T 23mm 1/250 F/5.6 ISO 1250.

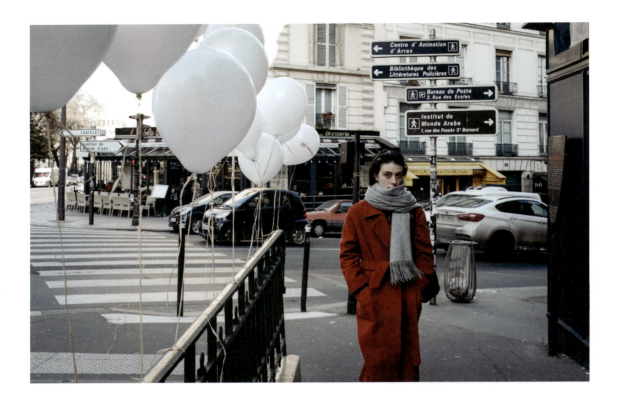

The Eye Contact with Red Coat and White Balloons. Paris, France. Fuijfilm X100F 23mm 1/125 F/25.6 ISO 200.

STREET PORTRAITS

Making a portrait of a stranger is a very different approach to street photography. It requires an interaction with your subject. Remember that the interaction doesn't necessarily have to be verbal; simple eye contact can be a silent agreement between you. In any case, it is usually considered a portrait as long as the subject is aware of you taking the picture.

If you are a very social person who talks to strangers anywhere you go, like I do, then taking the next step should not be too much of an issue. If, on the other hand, the thought of approaching a stranger terrifies you, then keep reading.

Practice Without a Camera

Make it a goal to talk with strangers every day for a few days. They can be waiting in line at the coffee shop with you or on the subway. Make small talk, or comment on the new coffee flavor—just about anything that comes to mind, as long as it's not weird. You may find it terrifying at first, but I can assure you that it will become easier every day, and you will soon look forward to your next encounter. Make it a goal to talk to five strangers every day for a week, and go from there. Granted, there is a big leap between

approaching a stranger to comment on his or her cool hat and asking to make a portrait. Yet, if you are shy, then this first step will help you get to the second. You have to be comfortable interacting with strangers before you can pull out a camera without freezing or giving off the wrong vibes.

Photograph a Street Performer

Street performers are there to be seen, and they are easy subjects. Purists will tell you they don't count because they are too easy. As far as I know, there are no authorities or rules for street portraiture or street photography in general, so go ahead! Photograph buskers, and remember to leave a tip. Be extra generous if you are going to take your time. They perform to make a living, after all.

People With Dogs

Dog owners may be the street portraitist's best friends! Start by commenting on the cute puppy and photographing it, then ask to make portraits of the owner and his or her dog. Nine out of ten times, you will succeed and make their day in the process.

Saint Paul, Minnesota. Fuijfilm X-Pro2 27mm 1/160 F/2.8 ISO 1000.

Interesting People

People with lots of tattoos or colorful and/or unusual hairdos or outfits are both easy and interesting subjects. They obviously like to be noticed, so they will love posing for you. Take your time getting some detailed shots of the tattoos, for example, and remember to compliment your subject. Who doesn't love a compliment when it is least expected?

Go With a Friend

Having another person at your side will embolden you, and you will find it easier to approach a stranger. It makes it fun, and if you're relaxed, then people will respond accordingly. It becomes a social event. The friend doesn't even have to be a photographer. He or she can simply be there for moral support.

Don't Hide Behind a Long Lens

Just like with candid street photography, the closer the better. Also, a smaller camera will be less intimidating for your subject. A smaller camera and a shorter focal length will make it feel like you are a part of the scene you are capturing.

Be Confident

Introduce yourself, and explain why you want to make a portrait of your subject. You're not doing anything wrong, so don't take the shot and run. If they ask why you want to take their pictures, then simply explain that you are photographing strangers for a personal project, and you found them quite interesting. Most people will be flattered.

Take Your Time

You asked for their permission to take the picture, so now it's your responsibility to do a good job. The background may be distracting, or they may be squinting from the sun in their eyes. Ask them to move or to even cross the street if the light is better. Take two or three shots until you are satisfied with the result. Show them the resulting image on the back of the camera, and make sure you thank them for their time before you part ways.

Enjoy the Experience

Ask for your subjects' names—maybe you'll even engage them in conversation and find out some interesting things about their lives. Share e-mail addresses, and send them the best picture if they ask. I always carry business cards. I leave it up to the subjects to contact me by e-mail if they want. You

will find that most of the time people won't bother, which always comes as a surprise to me. Other times, long-lasting friendships develop via social media, so you just never know. Some of my students have received photo assignments as a result of their street portrait projects, either due to the quality of their work or through the people they met in the process.

St Paul, Minnesota. Fuijfilm X100S 23mm 1/240 F/4 ISO 400.

New York City. Fuijfilm X100S 23mm 1/240 F/4 ISO 800.

Assignment: Take your camera out with the goal of doing only street portraits today. Set an easy goal of two or three portraits. Just don't stop after just one and certainly not after a rejection. Take a deep breath, and relax. Be genuine, and approach your first stranger with a compliment: "What a great smile. I'm documenting people on the streets of [insert the name of your town here], and I would really like to do a portrait of you."

ABSTRACT

Let your creativity go wild, and have fun. There are many ways to create abstract images on the streets, including using reflections, shadows and natural filters such as rain or condensation on a window. The human element doesn't have to be in its pure form; the 'idea' of people can make a powerful photograph as well. Some days, you find yourself in a place where the setting or the people are not particularly interesting. Shift gears, and you will probably find a way to make the best of it. You may focus on the raindrops on the window for a change, or shoot through frosty glass. Or you may find a story

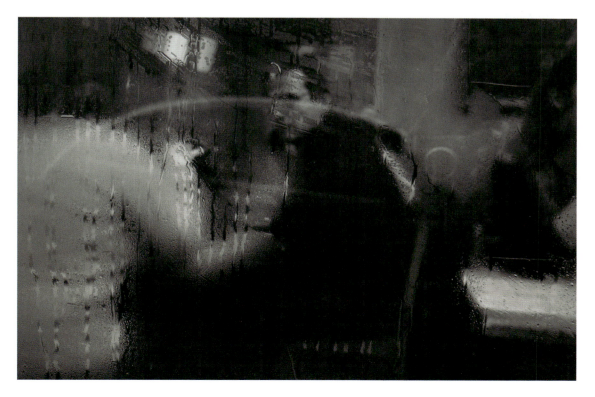

Through the Window. Paris, France. Fuijfilm X100F 23mm 1/250 F/4 ISO 2500.

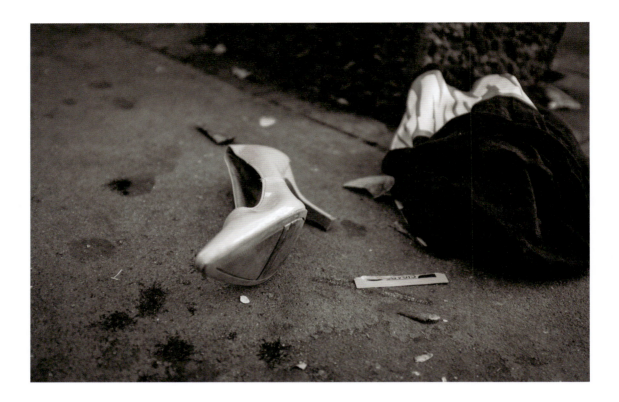

Discarded Shoe. San Francisco, California. Fuijfilm X100T 23mm 1/125 F/2 ISO 250.

without the human element. A discarded high-heel shoe in an urban setting can be very evocative. The human element is not present, but it is strongly implied, and viewers can use their imaginations to fill in the gaps.

Assignment: Hit the streets with a more abstract way of seeing. It's not as easy as it sounds. Think of creative focusing, using natural filters, reflections, layers. Forget the 'rules', and make your own.

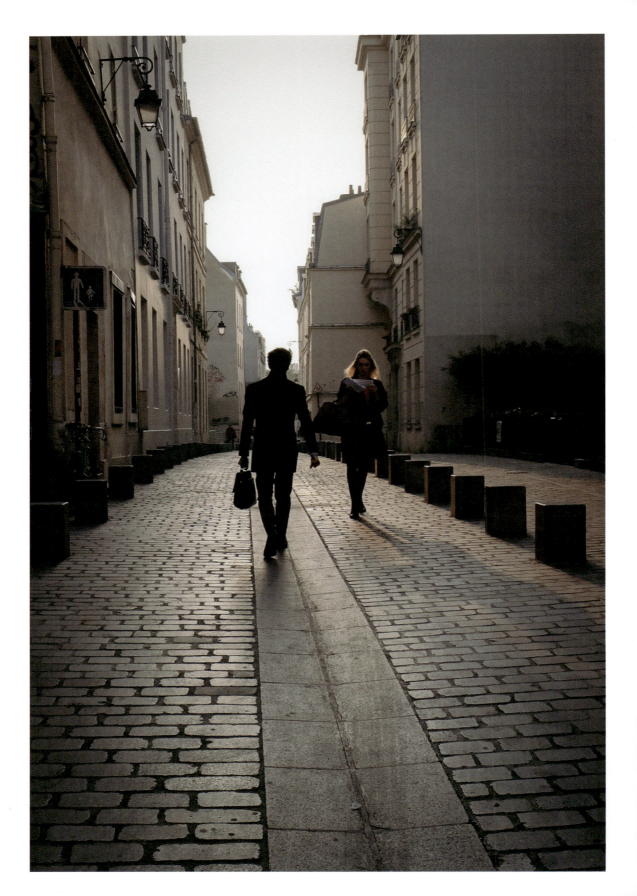

Elements That Make a Strong Street Photograph

Strong Subjects

EXPRESSION AND GESTURE

Facial expressions, body language and displays of emotions all trigger our street photographer's eye. You must be able to see the extraordinary in the ordinary. Anticipation, just like patience, is also the name of the game. Not unlike the wildlife photographer who studies the behavior of animals in order to be better prepared to get the shot, the street photographer must rely on his or her study of human behavior to be able to capture the 'decisive moment'.

French Magnum photographer Henri Cartier-Bresson coined the term 'decisive moment', which refers to the defining moment or critical point when the story happens. The master summarized the decisive moment in the preface of his book by the same name, originally titled *Images à la Sauvette*, published in 1952: "To me, photography is the simultaneous recognition, in a fraction of a second, of the significance of an event as well as of a precise organization of forms which give that event its proper expression."

It is very important to observe, without the camera in front of your face, and to be ready to capture the right moment in a fraction of a second. The 'machine gun', also known as the spray-and-pray approach, when the photographer takes multiple frames of the same subject, is not always desirable in street photography. You will only draw attention to yourself, and you will not learn to become a better photographer in the process. Putting intent into every shutter click is important in order to grow in your craft. The machine-gun approach is not much different from taking a frame from a video. There is very little merit in doing so, and it takes the challenge and fun out of street photography. There are times, however, when you will have to shoot more frames than others. There are situations when you will capture several approaching shots as you move closer to your subject to get the shot you are

(facing page)
Une Homme et une Femme, Paris. Fujifilm X100F 23mm ISO 200 F/5.6 1/250 Sec.

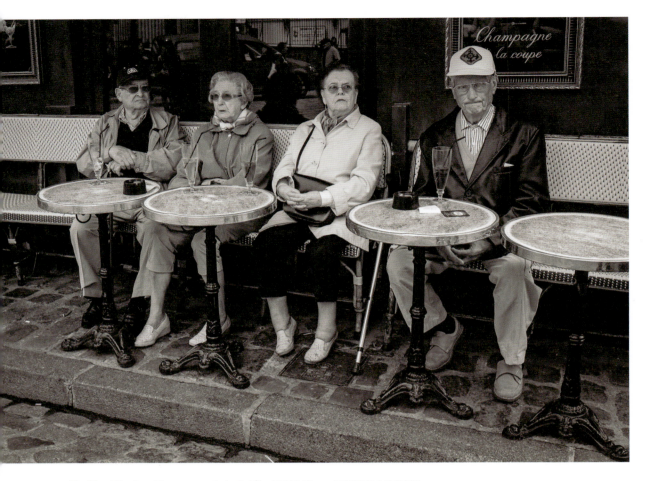

The Tired Tourists. Montmartre, Paris. Fuijfilm X100S 23mm 1/200 F/5.6 ISO 200.

envisioning. After all, the situation can change in a split second, and those approaching frames may be all you get. Other times, such as in low-light situations or when you are documenting a fast-moving event, you will need to shoot in burst mode to save the day. The spray-and-pray approach should only be used occasionally, or you will not grow in your craft. Also, street photography is not only about the resulting image but also very much about the process.

By refining skills such as patience, observation and anticipation, you will become a better photographer. Period.

Being discerning is key. Having an interesting subject in front of your lens is not enough. Will you be able to recognize the gesture or expression that will make a strong photograph?

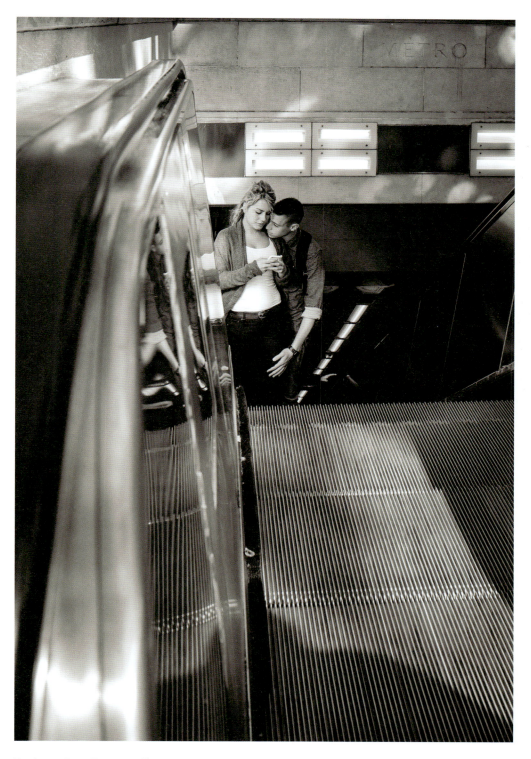

Escalating. Paris, France. Fuijfilm X100T 23mm 1/125 F/5.6 ISO 250.

APPEARANCE

We are often drawn to certain subjects by the way they are dressed. People who stand out in a crowd are likely to make strong subjects. Sometimes the interest lies in the simple contrast between the main subject and the other protagonists in the scene. Again, having a wildly dressed subject will not make a good photograph on its own. You are in control of the moment when you chose to press the shutter, so look for the right gesture.

Be aware of the power of signage. Unless the message is part of the story you want to tell, any writing on your subject's shirt will distract from his or her facial expression. We are conditioned to read, and words can be as distracting as a bright color.

The way people dress is also an important factor to consider when photographing silhouettes. More fitted clothing helps create some separation and makes for more interesting silhouettes. Accessories, such as large hats, dogs on a leash, a bicycle and the like, also work well when shooting against a bright background.

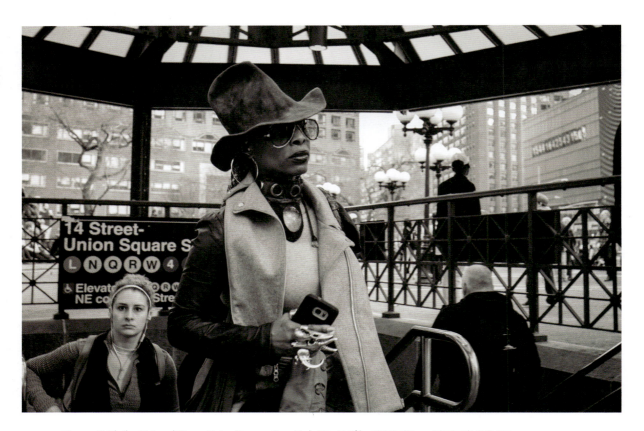

Woman With the Hat and Rings. Union Square, New York City. Fuijfilm X100F 23mm 1/125 F/4 ISO 500.

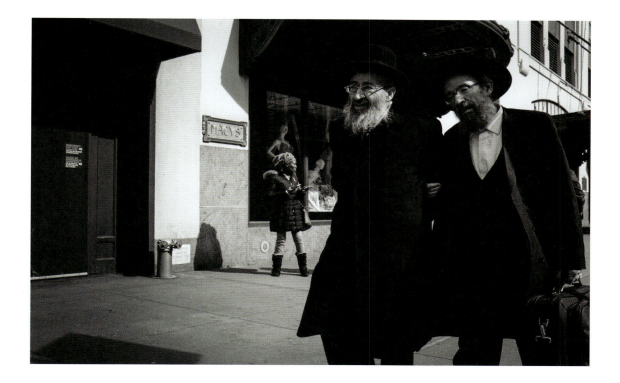

Friends on 34th Street. New York City. Fuijfilm X100F 23mm 1/400 F/5.6 ISO 200.

Assignment: Leave the camera at home, and find a busy street corner. Spend some time there observing people. Does anyone stand out? Maybe someone very colorful among a crowd of dark business suits, a tall man walking a tiny dog, two people talking with their hands or lovers in an embrace. Fine-tune your observation skills by 'feeling' the street with your eyes first, not behind the lens. Did you leave this experiment kicking yourself for not having a camera in your hand? Great, you're ready!

THE IMPORTANCE OF CAPTURING THE CORRECT STEPPING MOTION

As we saw earlier, the stepping is very important in a moving subject. Catching someone between steps doesn't make for a very strong image. By shooting several frames consecutively, you will soon learn to recognize which is the strongest image and why. In order to catch the perfect step in one frame (which is much more satisfying for the photographer), practice counting each step as you watch the subject enter your frame. One . . . two . . . click! Anticipate the third step, and press the shutter when the subject's foot hits the ground. See the difference between the photographs with the correct stepping motion versus the failed images on the next three pages.

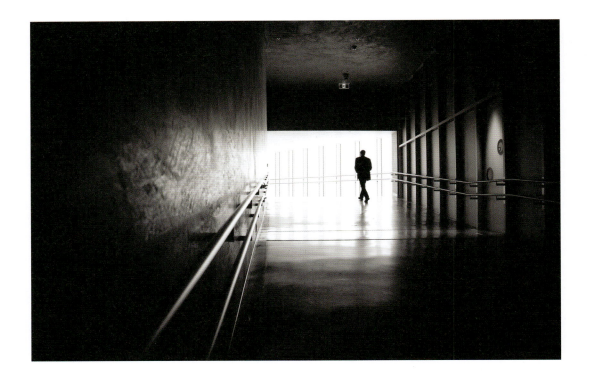

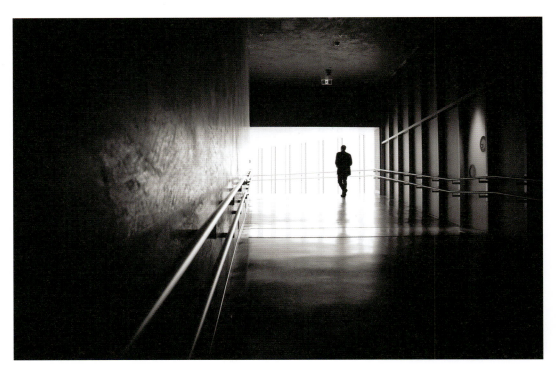

Canadian Museum for Human Rights. Winnipeg, Canada. Fujifilm X100T 23mm 1/125 F/4 ISO 2000.

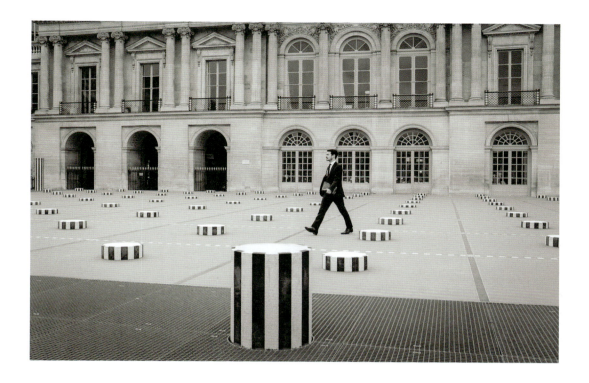

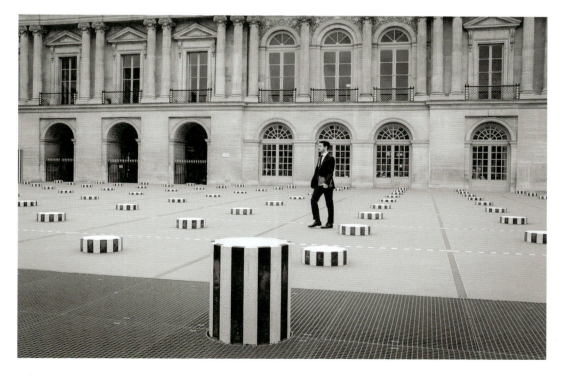

Colonnes De Buren. Paris, France. Fujifilm X100T 23mm 1/500 F/4 ISO 200.

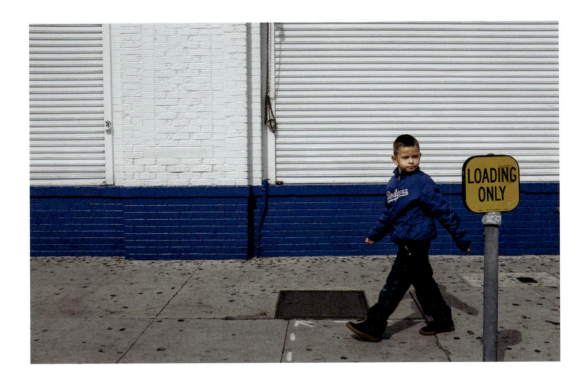

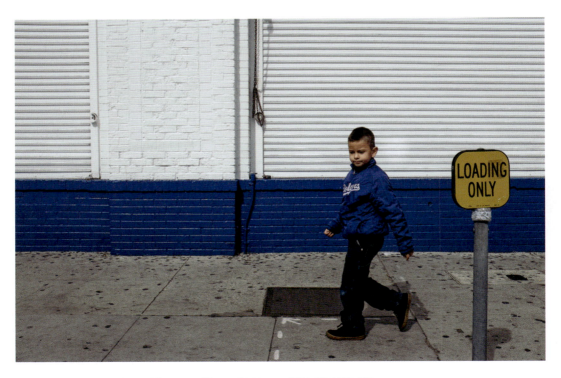

Loading Only. Los Angeles, California. Fujifilm X100S 23mm 1/2500 F/5.6 ISO 200.

Assignment: Stand in a location with a lot of foot traffic. Do *not* set your camera to burst mode. Instead, practice the counting technique just described, and press the shutter in the correct step.

Composition

POINT OF VIEW AND PERSPECTIVE

Shooting everything at eye level makes for static images. Street photography, like any other genre of photography, allows for a lot of creativity in composition. Vary your point of view to make stronger images.

Shooting from above can make for interesting shots. On a sunny day when the sun is low and creates long, dramatic shadows, find a bridge or terrace over an empty space and wait. A cyclist or a dog walker will eventually pass by and give you a shadow worth a shot. Other times, you may find some interesting designs or lines on the pavement, which will only give the full effect from a bird's-eye view.

Shooting low, from ground level, also creates interesting perspectives and distorts reality. Don't hesitate to place your camera on the ground. You'll be surprised at how interesting that low vantage point looks.

A low-angle point of view can make for an interesting perspective. Rome, Italy. Fuijfilm X70 18.5mm 1/250 F/16 ISO 640.

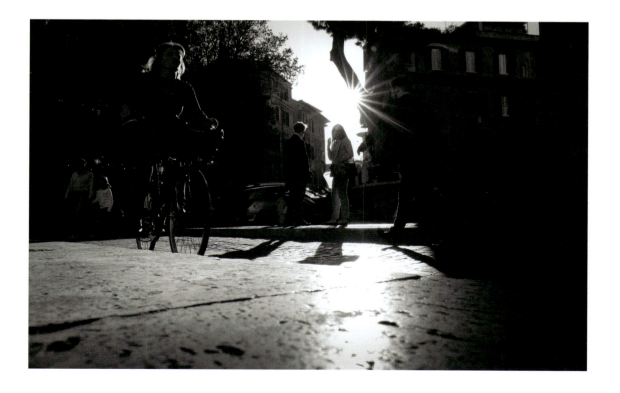

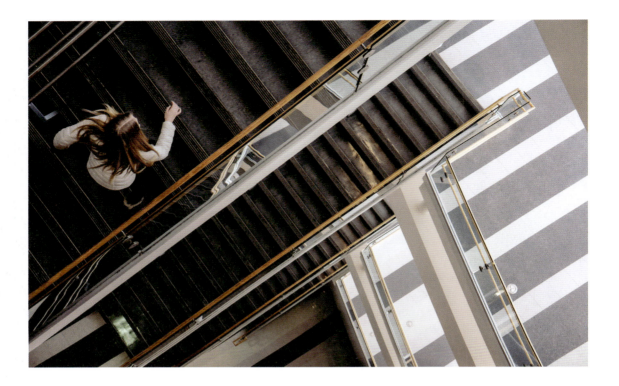

Photographing from above is also a fun way to approach your subject. St Paul, Minnesota. Fuijfilm X100T 23mm 1/250 F/5.6 ISO 3200.

Towering ever so slightly over your subjects makes a statement by making them look small or submissive. A low-angle shot with a wide focal length will have the opposite effect and make them look more impressive or important.

Tilting your camera also creates interesting effects. But if you tilt, then do it like you mean it. Only a slight tilt can look awkward, and verticals that are slightly off will draw unwanted attention. You are better off straightening verticals if it's a slight distortion. A nice dynamic tilt, with intent, can make a very powerful photograph.

Assignment: Use your camera from an angle you've never used it before. Shoot straight up, put it on the ground or shoot straight down from a high vantage point. Of course, make sure the subject is interesting too!

RULE OF THIRDS

Imagine a grid dividing your frame into three equal parts vertically and horizontally. The crossing sections represent the thirds. Positioning your subject in one of the intersections has been used for ages in art. The rule of

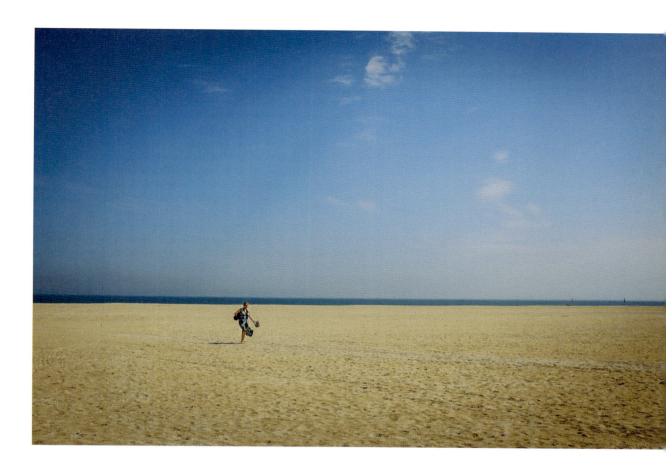

thirds works. It is esthetically pleasing, and you can't really overuse it. But you can and *should* break it as long as you do it with intent, and you want to make a bold statement.

You can't overuse the rule of thirds. Normandy, France. Fuijfilm X100S 23mm 1/2500 F/5.6 ISO 200.

CREATING TENSION

Going against the natural visual flow is an effective way to grab the viewer's attention. We normally want to leave room for our subject to move toward. Placing your subject at the edge of the frame creates impact and draws attention. Most of us read from left to right, so reversing the direction creates tension, especially if your subject is also on the edge of the frame. As I said before, it's difficult to overuse the rule of thirds, but placing your subject at the top, bottom or dead center can add impact and make a statement. Ignoring the rule of thirds can be highly effective so long as you know why you're doing it, and there is a good visual reason for doing so. Some subjects deserve center stage!

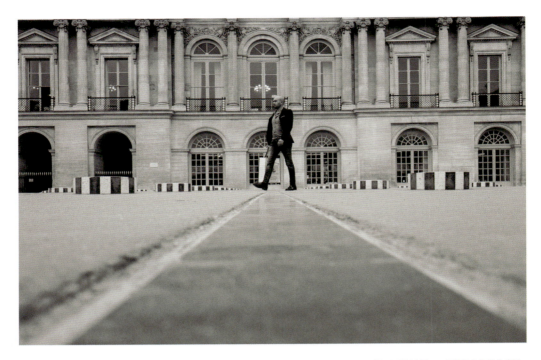

Breaking the rule by centering your subject will make a statement. Paris, France. Fuijfilm X70 18.5mm 1/250 F/8 ISO 800.

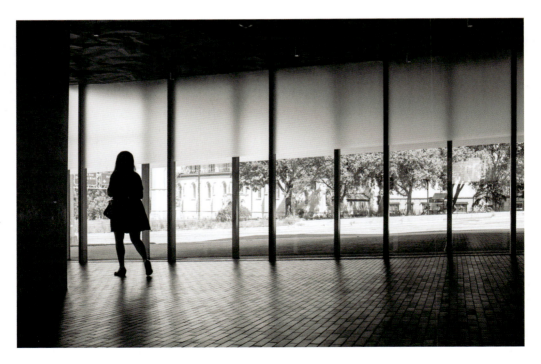

Placing your subject walking out of the frame will get a reaction from the viewer. Minneapolis, Minnesota. Fuijfilm X100S 23mm 1/600 F/4 ISO 800.

Assignment: Break the rule that you are the most attached to in your photography, and do it with intent. Are you getting a reaction from the viewers? If so, then it means you created tension.

TRIANGLES

The triangle, although simple, is one of the strongest compositional shapes. It allows elements to flow well together. The eye automatically wants to 'connect the dots'. Often, the photographer is not aware of the triangle in the composition when pressing the shutter, but upon viewing the images later, the stronger compositions will often reveal a triangle. A good exercise, when looking at images in a book or online, is to analyze the ones that truly resonate with you. You may be surprised how often a triangle is present in the composition.

Assignment: Pick up a book from one of the masters of street photography, and page through it slowly. Pay attention to the presence of a triangle in many of the images you connect with. You may be surprised at how often it is present.

Two Men and a Swan. Paris, France. Fuijfilm XT-1 35mm 1/320 F/5.6 ISO 1600.

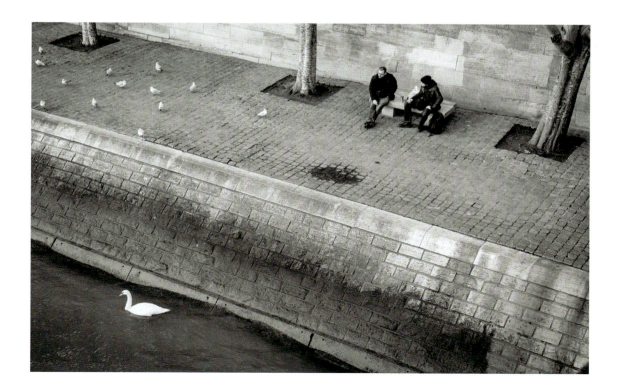

LEADING LINES

Just like in other photographic genres, leading lines make strong compositions in street photography. They simply lead the viewer's eyes to the subject. Lines can be as simple as a path or a wall leading to your subject. When close up and in the foreground, the subject's arms can serve as leading lines too, especially with a wide-angle effect. Lines can be part of the architecture or

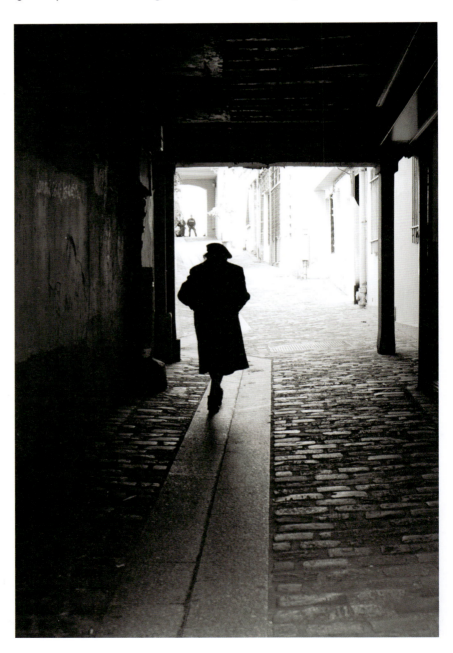

Leading lines can be very powerful in street photography. Paris, France. Fuijfilm XT-1 35mm 1/60 F/4 ISO 200.

even a sign. By shooting at a low angle, you can create leading lines going to your subject, hence making him or her more imposing.

Assignment: Make a point of looking for leading lines in your composition. This will become second nature once you start to 'see photographically'.

ADDING A SENSE OF PLACE IN THE BACKGROUND

A good depth of field is usually preferred in street photography. The background is often part of the story and helps give a sense of time and place. Unless you are going for a timeless look, incorporating elements such as cars or cell phones will give historical value to your images a few years down the road. The background is also an important part in your travel images, as it helps tell the story of a place.

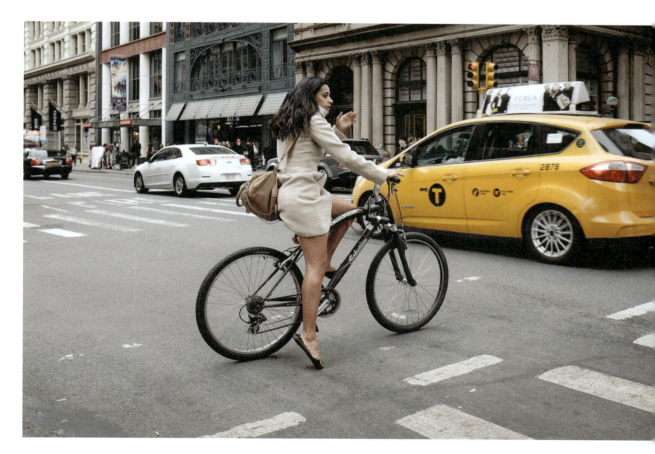

Very New York! An interesting subject and a yellow cab add a sense of place. New York City. Fuijfilm X100T 23mm 1/300 F/5.6 ISO 500.

Juxtaposition: Old vs. Young. Paris, France. Fuijfilm X100S 23mm 1/1000 F/5.6 ISO 400.

Assignment: Pretend you are a tourist in your own town, and include a sense of place in your composition. It can be a famous landmark or signage.

JUXTAPOSITIONS

Juxtapositions in art simply mean drawing a contrast between two elements. It is a way to add interest, and sometimes an element of humor, in a photograph. This type of shot can happen while you are walking down the street and you stumble upon such a contrast (young/old, etc.), or you can find the right stage, and wait for the right person to enter your frame (a billboard featuring a model on an exercise machine and an overweight passerby eating a giant ice-cream cone, for example).

INTERCONNECTIONS

Similarities among subjects can make for some very interesting images. Body language, facial expressions or fashion statements can all play a part in a strong composition. The connection can also be found between the subject and the surroundings.

Assignment: Go out with your camera with the sole purpose of seeing and photographing a clever juxtaposition or an interconnection. This will take vision, anticipation, preparation and patience. Maybe start with an interesting storefront or billboard, and wait for a contrasting subject to enter your frame.

DEPTH

Create depth in your composition. Different layers of subjects, different sizes and reflections in mirrors or windows all help to create depth. Think of including a foreground, a middle ground and a background. The focus on the middle subject will often result in creating impact in the composition.

LAYERS

Just as with depth, layers keep the viewer exploring the frame. The eye goes from the primary subject and travels to the background subjects. This also works particularly well with a clever play with reflections. A good depth of field is preferred if there are several subjects in the frame with interesting facial expressions. Motion blur of a person walking by in the foreground can also add interest and a desired sense of motion.

Assignment: Find an interesting window with people inside, and wait for people walking by to reflect in the glass. This will be hit or miss. Very few shots will actually work. This may go against your instinct for a clean composition, but it's a good exercise nonetheless.

Interconnection: Red on White, White on Red. New York City. Fuijfilm X100F 23mm 1/125 F/5.6 ISO 640.

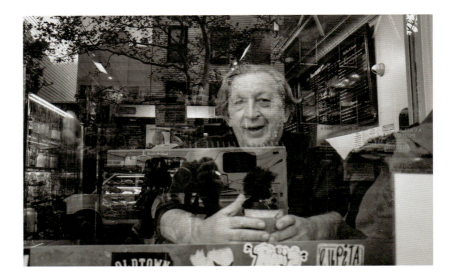

Reflections create depth and make for some really interesting compositions. Brooklyn, New York City. Fuijfilm X100T 23mm 1/250 F/5.6 ISO 2500.

NEGATIVE SPACE

The use of negative space is one of the strongest statements in art. It is equally effective in street photography, as it enhances the importance of your subject (the positive space). Leaving room for the eye to roam effectively brings attention to your subject.

Assignment: Find an interesting lone subject, and make good use of negative space in your composition.

Light

EXTRAORDINARY LIGHT

There is no 'bad light' in photography. There is easy light, and there is light that will make you work harder. It's all about making the light work for you and photographing a subject that will work well in it. Harsh light will give you a dramatic look, late afternoon light will give you long shadows, fog will give a mysterious feel to your image, rain will open new possibilities and nighttime is one of the best times to hit the streets. Remember: There is no bad light on the streets.

Assignment: Become aware of the quality and quantity of light any time of day or night. You don't need to be out with a camera; you can be stuck in traffic and aware of the light on the passenger in the car next to you. Put your observation into words, and say it out loud, even if you are alone. Light should become almost as important to you as the air you breathe.

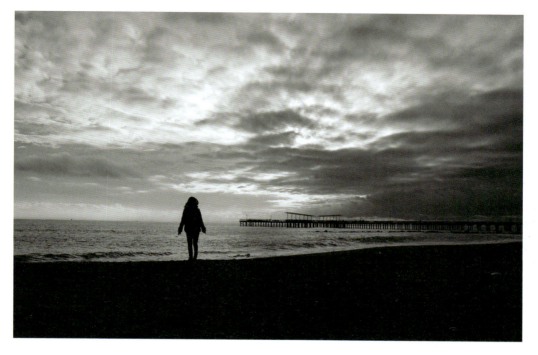

The negative space enhances the importance of your subject. Brighton Beach, New York City. Fuijfilm X100T 23mm 1/1250 F/8 ISO 200.

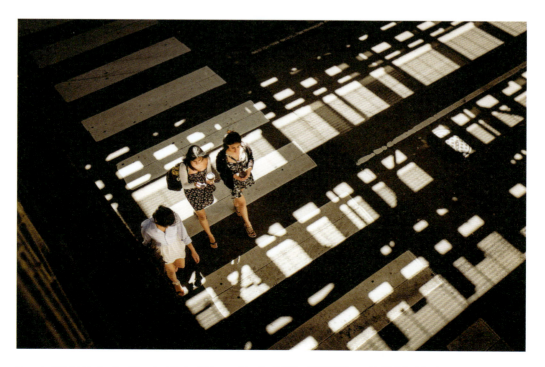

Dappled Light Under the Elevated Train. Chicago, Illinois. Fuijfilm X100S 23mm 1/640 F/4 ISO 800.

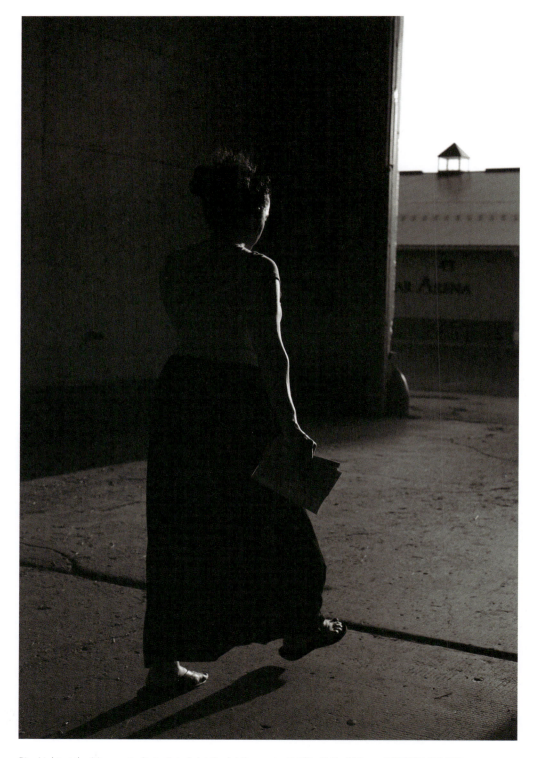

Rim Light at the Minnesota State Fair. Saint Paul, Minnesota. Fuijfilm X-Pro2 35mm 1/850 F/4 ISO 200.

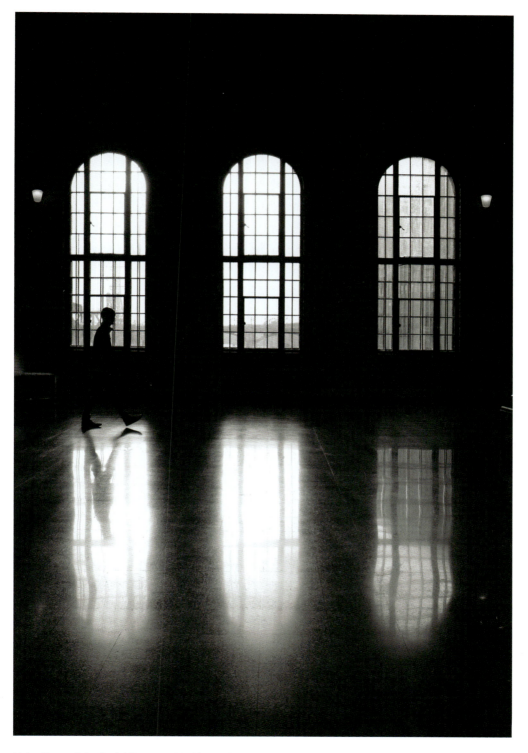

Union Depot. Saint Paul, Minnesota. Fuijfilm X100F 23mm 1/160 F/5.6 ISO 250.

SHADOWS

Shadows offer creative possibilities as well. For example, late afternoon sun will cast long shadows that are fun to shoot from above or against a wall. You can also skillfully capture a shadow while the actual subject remains completely or partially out of the frame. Sometimes shadows will look like something entirely different from the subject itself and create a story on their own.

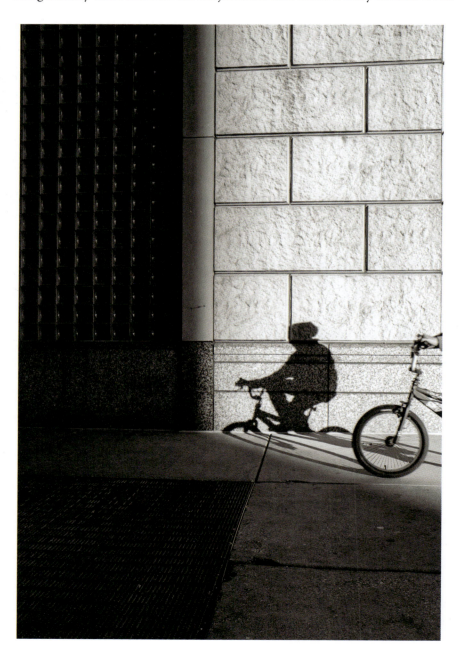

Indianapolis, Indiana.
Fuijfilm X100T 23mm
1/250 F/5.6 ISO 640.

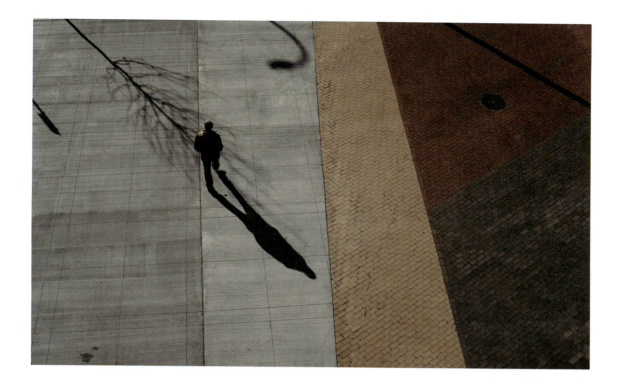

Assignment: Take your camera, and select your 'hunting ground' according to the type of shadows you want to capture (long shadows from above or against a wall, etc.).

Minneapolis, Minnesota. Fuijfilm X100F 23mm 1/1700 F/5.6 ISO 200.

SILHOUETTES

One of my favorite ways to photograph life on the streets is to make good use of a backlit subject. Here are a few things to consider before you set out to photograph silhouettes.

You must take control of your camera first. Ideally, your exposure is set for the highlights or the background. Failure to do so will expose your subject properly, and you will lose the silhouette while blowing out the highlights in the background. Exposing for the highlights is easily done if your camera is set to spot metering. You can also use average metering and trick your camera by stopping down your exposure compensation so that your subject remains dark.

Focusing can be difficult. You can spot meter for the highlights and manually focus on your subject. Or, if you shoot in Aperture Priority, set your camera to a small aperture to allow for a large depth of field and most of the scene to be in focus.

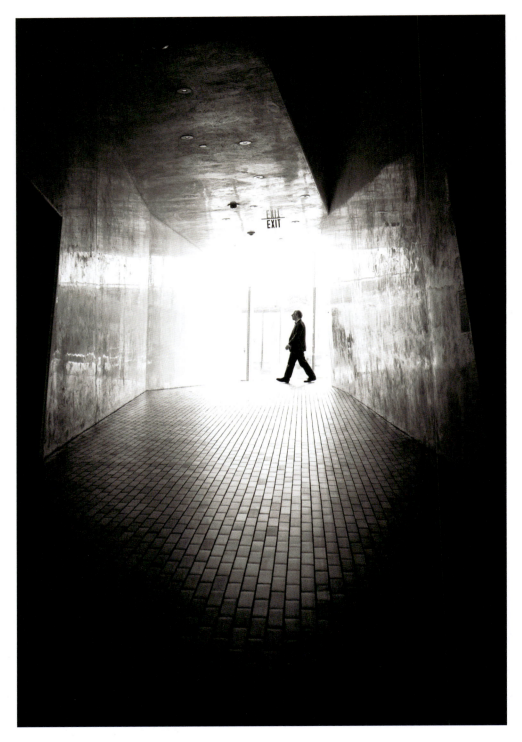

Blowing out highlights behind a silhouette is often preferred and makes for a more dramatic composition. Walker Art Center, Minneapolis, Minnesota. Fuijfilm X100S 23mm 1/800 F/2.8 ISO 800.

Blowing out the highlights can also be effective. Unless you are shooting against the sunset, sunrise or moonlight, in which cases the background adds to your story, you're better off blowing out the highlights. Doing so will give a more dramatic effect. Your silhouette will stand out more on a white and unobtrusive background.

Now you know the basic technique to shoot a silhouette—that was the easy part. What is most important is to be able to see a potentially strong subject. Many elements come into play. Separation in the body parts is important. You should be able to recognize the shape right away. If the subject is facing you or his or her back is turned to you, then there should be space between the arms and the body, and the legs should also be well defined. If you are photographing a person looking sideways, then their facial features should be quite clear.

Avoid obstructions in front of and behind your subject. Timing is important. Silhouettes of posts or other obstructions can ruin the shot. Position yourself accordingly for the best possible shot. In such situations, putting your camera in burst mode will put more chances on your side, especially if the foreground or background is busy with obstructions that will ruin the shot.

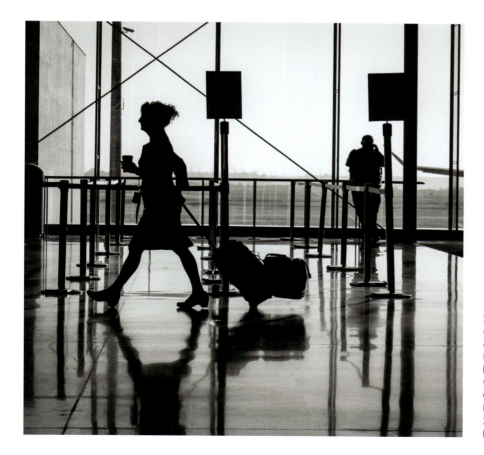

Silhouettes of posts or other obstructions can ruin the shot. Putting your camera in burst mode can save the day! Charles de Gaulle Airport. Roissy, France. Fuijfilm XT-1 35mm 1/2500 F/4.5 ISO 200.

A sunburst is an added bonus to a silhouette photograph—and an added challenge for you, the photographer. There is no need for a star effect filter, as you will achieve a starburst by setting your camera at a small aperture (f/16 is a good place to start) and positioning yourself so that the sun is partially obstructed by a post, building or tree. The extra challenge lies in

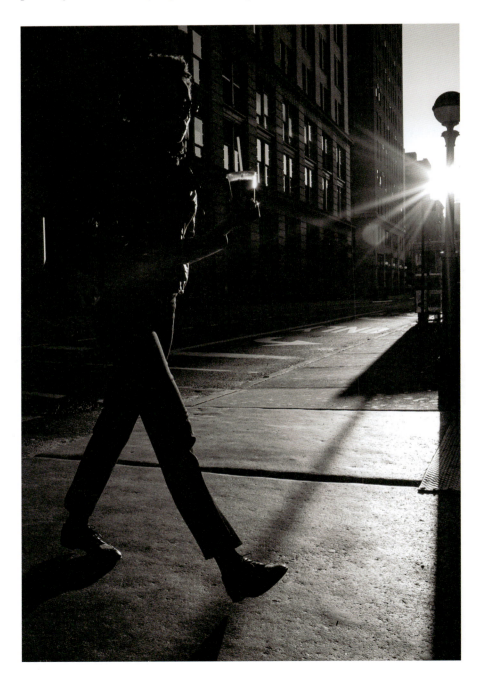

Sunburst. New York City. Fuijfilm X100S 23mm 1/1900 F/8 ISO 1600.

the fact that you now have several things to consider: the subject, the right moment and the technical aspect of the sunburst. It's a juggling act, but it's so rewarding when it results in a successful photograph.

Assignments

1. Find a clean foreground and background, and practice photographing silhouettes by paying attention to the important separation in the body, the stepping and the outline of the silhouette.
2. Find a busy and challenging spot, and practice capturing the silhouette in the least distracting part of the frame. Position yourself according to the distractions present in the foreground and/or background, and determine the ideal position of the subject. Once you know when to click the shutter, wait for the right subject, and be discerning by looking for the same factors as in the previous assignment.

REFLECTIONS

Reflections add another dimension to your photographs by creating mystery and depth. Always be on the lookout for mirrors, windows, puddles and the like. Here again, the possibilities are endless, and the rewards can be amazing. Scan around your subject to make sure there are no distracting elements that can easily be avoided by slightly changing your position.

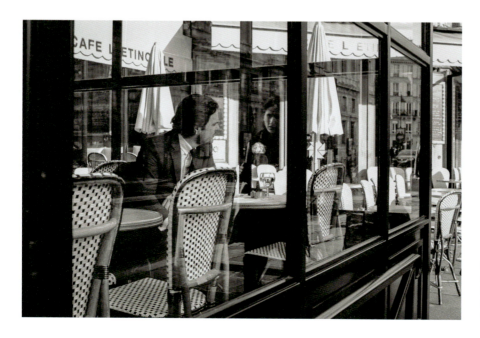

Reflections can create complex compositions. Paris, France. Fuijfilm X100T 23mm 1/280 F/4 ISO 200.

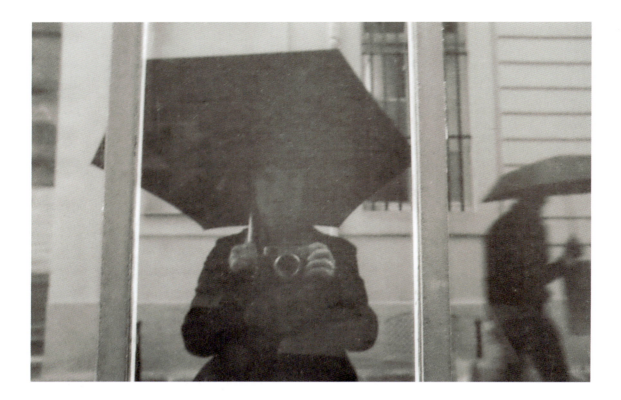

Mirrored-Me. Paris, France. Fuijfilm X100T 23mm 1/30 F/5.6 ISO 6400.

The play of reflections can also create intriguing recursive images. They can be a creative way to add yourself into the frame as well.

MYSTERY OF THE NIGHT

One of the best times to photograph life on the streets is after dark. Make use of all kinds of light sources, such as shop windows, streetlights, mobile screen lights, neon signs and so on. You will often have many more pleasing results in black and white than in color. The different light sources create a white balance nightmare and will often cast an unpleasant yellow tone to your images. Black and white creates a nice moody feel to your night shots. This is also one of the best times to do street portraits. Ask your subject to move close to the light source, and use it as a giant soft box. Pay attention to the catchlight in your subject's eyes—the way the shadow defines his or her features. All these fun experiments will make you a better photographer in general.

A common mistake I often see photographers make when processing their night shots is to bring out too many details from the shadows. The result often looks like a daylight scene, which defeats the purpose of shooting at night. Just because we have the ability to bring out the details in the shadows

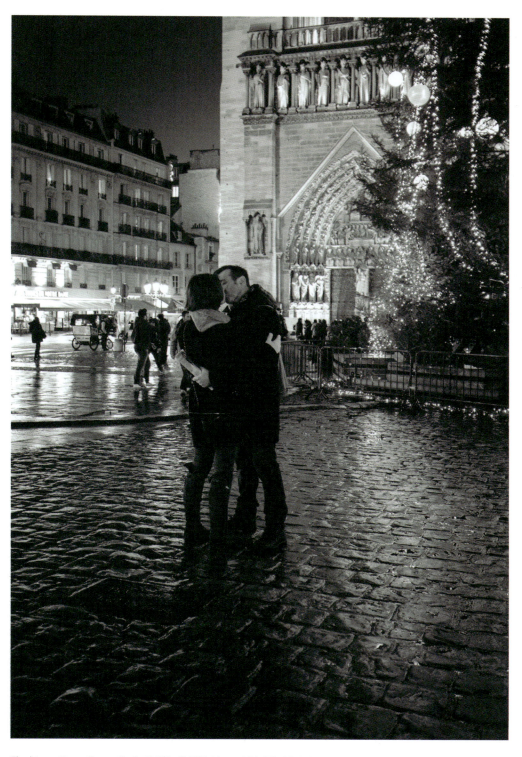

The kiss at Notre-Dame, Paris. Fuijfilm X100S 23mm 1/40 F/2 ISO 3200.

Two Apples and the Big Apple. New York City. Fuijfilm X100T 23mm 1/50 F/2 ISO 6400.

doesn't mean we should. Let the deep shadows fall where they should. Crank up that ISO, embrace motion blur and capture those moody night scenes.

Assignment: Find a great storefront, and look for a good subject among the people who pass by. Make sure to ask someone who does not seem to be in a hurry, absorbed in music or in the middle of a conversation with someone. Ask him or her to pose for a portrait next to the light source. Pay close attention to the way light falls on your subject's face; move yourself slightly to see the difference it can make.

Techniques

MOTION

There are many ways to capture motion in a still photograph. Isolating a subject standing still in a crowd of passengers in motion in a train station is an easy example that comes to mind. If you try the technique outdoors in bright sunlight, then you will have a bit more of a challenge. There are a few ways to make it work. You can wait for the light to be reduced. Early evening or dark clouds in the sky will help. Also, rainy days are easier to work with. Switch your camera to shutter priority; the aperture should automatically set itself to a small aperture (large number) to reduce the amount of light hitting the sensor. It is also helpful to set your camera to the lowest possible ISO. If all else fails, then you may have to use a neutral density filter to reduce the amount of light hitting the sensor from the long exposure. Using a tripod may help, although I find that hand-holding 1/30th second exposure is usually not a problem. For anything longer, I look for a wall or post to set the camera on, and I use the two-second timer to avoid any camera shake.

You can choose to freeze motion by catching your subject at the right moment. Other techniques require a little more patience and skill, such as panning. I recommend practicing on any moving subject to get used to the technique. It will often take dozens and dozens of attempts to get a successful shot, so do not get discouraged. It's part of the learning process, and very few photographers ever master panning perfectly. But be aware that the right choice of subject is just as important in a panning shot as it is in the rest of your street photography.

Assignment: Try your hand at panning on the streets. Set your camera on shutter priority. Start at 1/30th of a second. Put your camera on high-burst mode and focus tracking, if available. Find an interesting background, and make sure there are no obstructions on either side of you. Wait for a moving

Melbourne, Australia. Fuijfilm X100TS 23mm 1/200 F/2.8 ISO 400.

Panning. Paris, France. Fuijfilm X100S 23mm 1/30 F/14 ISO 200.

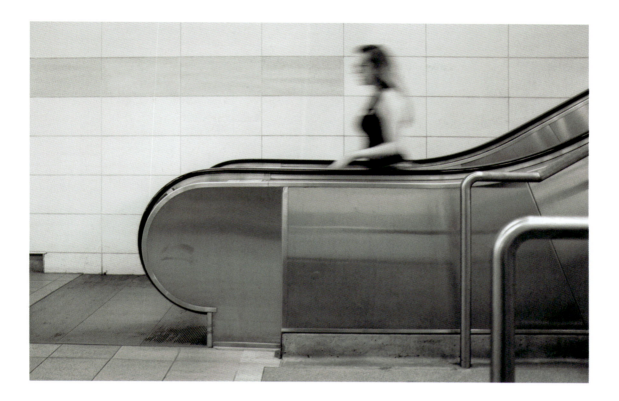

subject—a bicyclist or someone riding a scooter work well to start. Turn your body in ending position (you will unwind yourself for a smoother motion). Start the panning movement early, before you even want to get the shot. Lock your focus on the subject, and follow it even after you think you got the shot. This will allow for a smoother movement. Once you have the technique down, look for an interesting subject. For example, a cyclist wearing a helmet will not be as interesting as one with long hair blowing in the wind. You will shoot dozens of frames to get one that looks right, so you may want to set your camera in JPEGs instead of RAW.

Vancouver, Canada.
Fuijfilm X100T 23mm
1/15 F/2.2 ISO 320.

LOOKING IN/OUT

As street photographers, we are all a bit voyeuristic. As a child, one of my favorite pastimes when riding in the car down any city street was to peek into brightly lit homes and apartments, catching glimpses of the lives of everyday people. Today, I love looking through café and restaurant windows and capturing special moments, especially when it's dark on the streets. Reflections in the glass are usually not a problem and add a sense of place to the image. If you want to avoid a reflection of yourself, then I recommend wearing dark clothes and trying to shoot from a slight angle. A fun and less intimidating

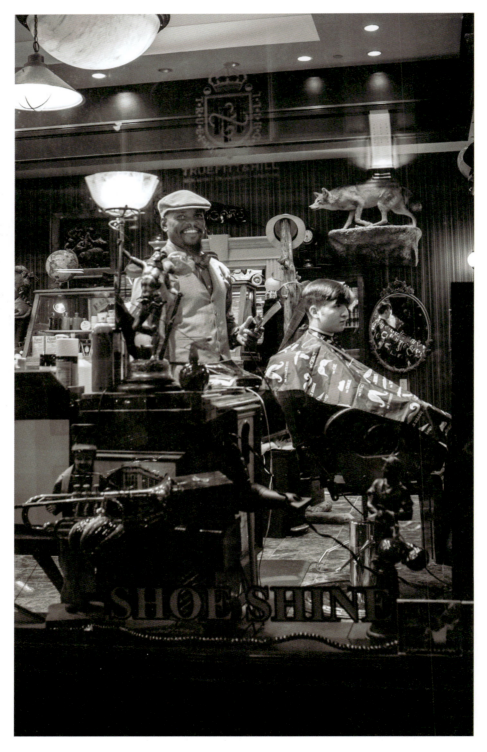

Inside the Barbershop. Saint Paul, Minnesota. Fuijfilm X100S 23mm 1/40 F/2.8 ISO 1250.

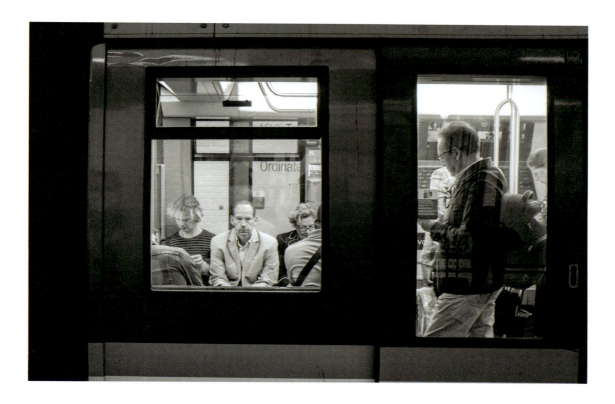

way to practice this technique is to photograph people on public transportation, especially if the bus or subway is about to leave.

Metro. Paris, France.
Fuijfilm X100S 23mm
1/60 F/4 ISO 3200.

Assignment: Find a bus or subway stop, and wait for people to settle in their seats just before departure to photograph someone doing something interesting. The challenge here is to find someone having a conversation with another passenger, daydreaming or reading a book. You will see that most passengers will be on their mobile devices, which doesn't make for the most exciting photographs.

HUMOR AND RESPECT

Humor may very well be the toughest assignment for the street photographer. It takes a keen eye to see humor on the streets and some skills to capture it in a fraction of a second. Here are a few things to consider before you head out to photograph humorous situations.

Just like a good joke, no explanation should be necessary. A catchy caption should suffice to enhance the humor conveyed in the image. Many newspapers still have a 'feature' picture at the end of every issue. They think

of it as a visual treat for the reader. Its purpose is to provide a break from all the dreary news that fills the newspaper pages.

Different cultures have a very different sense of humor. What may be funny in one country can be interpreted differently in another. What one photographer finds humorous in one part of the world can be considered offensive or insulting in another. Yet, thanks to the Internet, those cultural boundaries are becoming softer, as one is exposed to the world at large with the simple swipe of a smartphone.

Humor is subjective and personal. What I find humorous may leave you completely unresponsive. This is not only a cultural difference but also a personal one, based of life experiences. Age, gender, culture, education and the like, will all play a part in what qualifies something as funny.

Humor adds another level of difficulty to your street photography. The opportunities are there, but they are often very subtle and extremely fleeting. I recommend practicing 'seeing' first and becoming proficient at telling a story in a frame before you add the element of humor to your street photography.

Is everything that looks funny also fair game? I believe the number one rule in street photography is respect. Humor is great, but ridiculing your

Normandy, France.
Fujifilm X100T 23mm
1/1250 F/5.6 ISO 200.

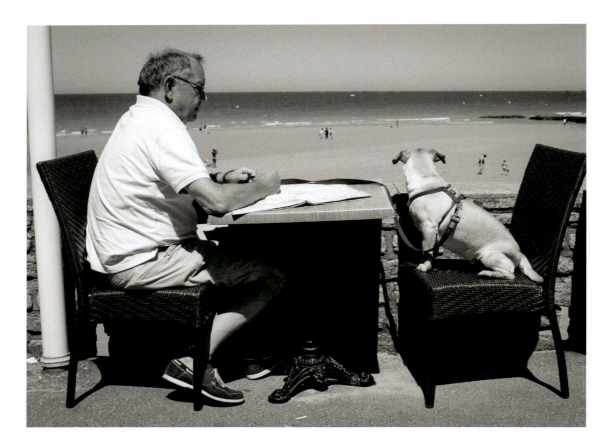

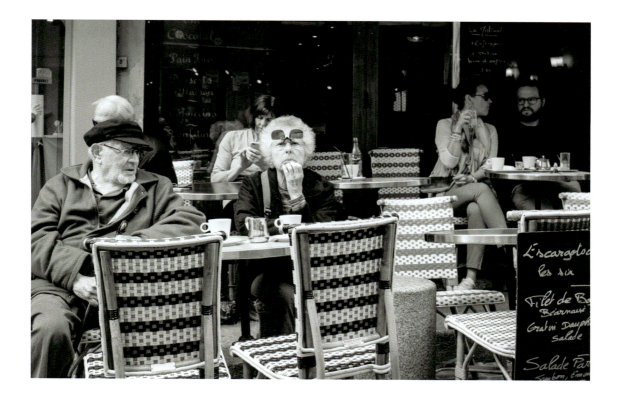

subject is going too far. Turn it around. If it were you in the picture, then how would you feel? Would you mind it being posted on social media for everyone to see? If the answer is yes (you would mind), then you should probably think twice about using the image.

Consider this example. I was at the back of a 1950s car show in Minnesota. It attracts around twelve thousand collector cars and their owners for a weekend of revving engines and showing off the latest street rod accessories. I was making portraits of people and their cars. It's quite interesting how much people match their cars. I happened upon a middle-aged woman dressed all in pink, sitting next to a classic Cadillac of the same color. She was eating a lemon cupcake. I asked her if I could make a portrait of her next to her beautiful car. As a proud car owner, she accepted, and as I was about to click the shutter, she gave me the biggest smile, showing a definite lack of teeth and a lot of yellow cupcake stuck between the few that were left. I almost didn't press the shutter, but she was so happy and proud that I had to take the picture. She was obviously not bothered by her lack of teeth, but I figured that she had a daughter or a mother who may feel a bit embarrassed if they saw the picture on social media. I never posted the image of the pink lady and the pink Cadillac.

In general, contrasts will make people smile and so will extreme situations or juxtapositions. The unexpected and the unusual also often convey

Paris, France. Fuijfilm X100S 23mm 1/150 F/5.6 ISO 400.

humor. Sometimes several components come together in a fleeting moment, and you have only a fraction of a second to record it. This requires some quick thinking and a very good knowledge of your gear so that it doesn't get in the way. Ideally, it should become an extension of your vision. Other times, a bit of planning, a certain degree of patience and some luck will all come together and give you the shot you envisioned. Setting the stage as a way to gain some control of the situation allows you to capture some funny situations. You can position yourself in front of a billboard that will make the situation funny when the right protagonist enters the frame.

It is clearly impossible to set out with the expectation of capturing humor in the streets every time you go on a photo walk. You can train yourself to see better and to work at increasing your response speed to a situation. Serendipity will play a big part in the outcome of your quest to find humor in the streets. The more you train yourself to observe the world around you, the more prepared you will be to get the winning shot.

Assignment: Go to a market or fair with the goal to capture only humor. You may come back empty, but do not get dis0couraged. Remember that it is one of the toughest assignments you'll ever give yourself as a street photographer.

COLOR OR BLACK AND WHITE

Should you shoot street photography in color or black and white? There is no right or wrong answer to this question. It's personal preference. Some photographers always shoot in B&W, others in color. For my part, I let the subject dictate my choice.

When Is B&W Preferred?
You may like to use B&W for its timeless quality or to emulate the work of the early masters. If no element in your frame dates the shot (mobile phones, cars, etc.) and your subject also has a timeless look, then a black-and-white processing will make your image stand the test of time and give it a more artistic look.

There are also strategic reasons to favor monochrome over color.

As street photographers, we usually do not remove elements from the frame in postprocessing. Our job is to record an authentic moment in time that never happened before and will never happen again. A skillful street photographer makes quick decisions and removes distracting elements from the frame as much as possible before pressing the shutter. Most of us would not resort to using postprocessing tools to remove distracting objects.

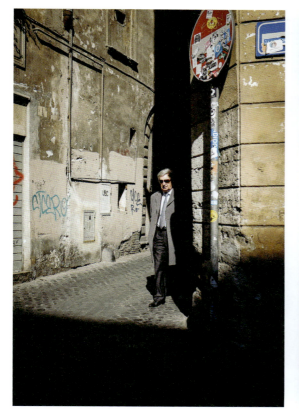 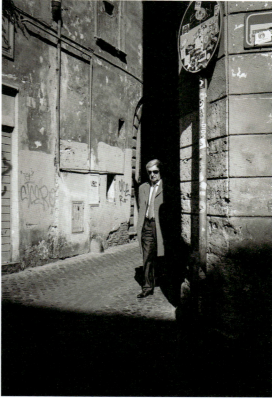

The color on the street signs competes with the human element. Fuijfilm X100S 23mm 1/900 F/5.6 ISO 400.

Without the color distraction, your eyes stay on the person longer. Fuijfilm X100S 23mm 1/900 F/5.6 ISO 400.

There are times, however, when bright, colorful elements such as red stop signs, trash cans or cars are inevitable and will draw the attention away from the subject. By removing the color distraction, you bring the eyes back to the subject.

Other times, the color may be amazing but also overpowering and risks becoming the subject instead of the human element, which becomes lost.

When Is Color Preferred?

The color may be an integral part of the story—it may evoke an emotion or a reaction.

Finding an expressive background, such as a textured wall or colorful storefront, is a great way to anticipate a shot by waiting for the right subject to enter your frame. It may be even more important to get the right subject in a color shot than in a black-and-white picture. Color harmony plays an important

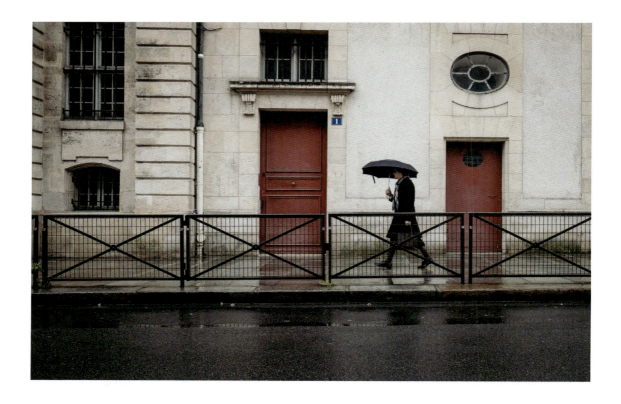

Paris, France. Fuijfilm X70 18.5mm 1/250 F/2.8 ISO 200.

role in making, or breaking, the image. Most importantly, color should not overpower your subject. It should be part of the story, not a distraction from it.

Color will also often give a sense of place or time in street photography. It will evoke the feeling of a season, for example, or the time of the day—from the warm glow of the golden hour to the cool tones of the blue hour.

Going out on a photo walk with a specific color in mind is a fun way to approach street photography. You will be surprised at the creative ways you will see the world around you by focusing your vision on one color.

Assignments

1. If you usually shoot color, then set your camera on JPEG B&W. Your LCD display will also be in monochrome, and you will force yourself to 'see' in gray tones.
2. If you usually shoot B&W, then go out with your camera with the intention of focusing your attention on color. Either way, you will be surprised at how you start paying attention to different attributes when you make the conscious choice of monochrome or color. Limiting yourself to one or the other will be a valuable exercise.

Rome, Italy. Fuijfilm X100T 23mm 1/500 F/5.6 ISO 6400.

New York City. Fuijfilm
X100T 23mm 1/250
F/2.2 ISO 200.

Portrait with approval of
a parent. Minneapolis,
Minnesota. Fuijfilm
X100S 23mm 1/240
F/2.8 ISO 400.

PHOTOGRAPHING A MINI SERIES OF IMAGES

Most of the time, we don't have the luxury of capturing more than one shot of any given street scene. It's a story in a frame. Occasionally, we can take our time and photograph the subject over a longer period to do a series of storytelling images, including wide, medium and close-up shots or a sequence of events. Such opportunities can be very rewarding and allow us to exercise different skills to create a cohesive series.

Assignment: Attend a local event such as a race or marathon. Photograph an establishing shot of the event, some medium shots of the participants and then some close-up images such as race number bibs, hands lacing a running shoe, medals and so forth. Think of it as a photojournalist assignment, and include a lot of details that really tell the story of the event. Then pick the best four to five photographs and sequence them.

A FEW WORDS ON PHOTOGRAPHING CHILDREN

Children make wonderful subjects. They are uninhibited and often lend themselves to creating sweet moments that the photographer will want to immortalize. It is crucial to approach such situations with caution. If you are a parent, then you can relate to the uncomfortable feeling you get when you see someone observing your child. In a candid situation, if a parent is present, then make eye contact and show your intention to photograph the child without disrupting the scene. It is as simple as pointing to the camera and smiling. If the parent has an objection, then he or she will let you know without any doubt, whatever his or her language may be. If that is the case, then simply nod and move on. Do not try to convince a parent that you're not doing anything wrong or that your intent is only to capture a beautiful moment in time. Parents have the right to be protective of their children, and you should not push them. If, as is most often the case, the parent nods back in approval, then go ahead and photograph the child. Make sure you do not capture the moment in any way that could be misused or misinterpreted, especially if you are posting on social media. You will find that it is often easier to do a street portrait of a child than to capture a candid moment. Once the parent gives you consent, then take your time, make a beautiful portrait and give a card to the parent so that he or she can contact you for a copy.

~

I hope you found some useful information in the previous pages to give street photography a try or to take it to the next level. Keep in mind that it should always be fun and relaxing. Don't feel pressured to fit into a certain style. You will find your voice by following your heart.

PART II

PHOTO WALKS

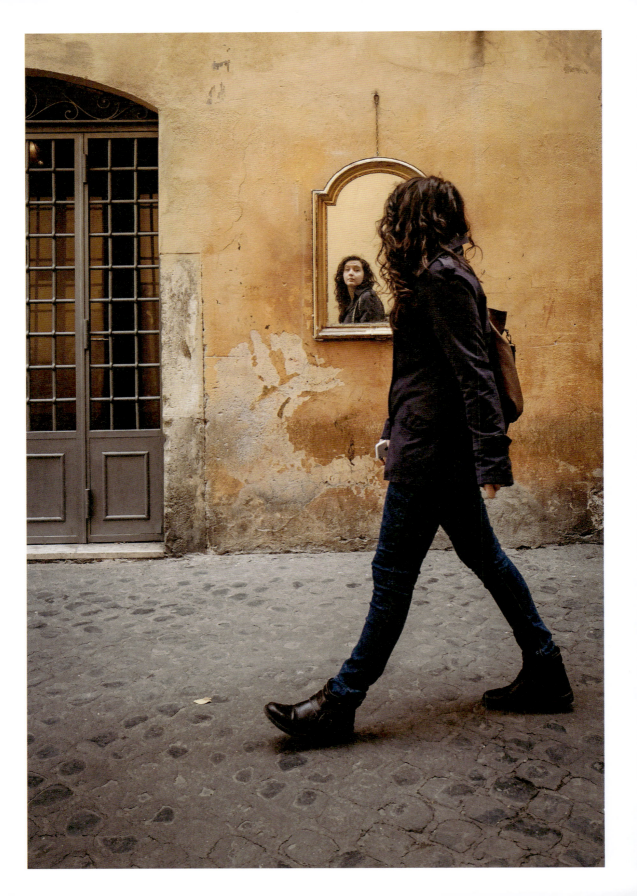

Stories in a Single Frame

In part II of this book, I take you on a photo walk. You will travel to Paris, Rome, New York and more and witness slices of everyday life through my lens. For each photograph featured, I invite you to learn about my personal approach, from seeing to capturing each story in a frame. I hope you enjoy these special moments on the streets.

(facing page)
Mirror, Mirror on the Wall. Rome, Italy.
Fujifilm X70 18.5mm
ISO 1600 F/5.6 1/500
Sec.

PARIS

Three Suits at Lunch

I never actively look for interconnections on the streets. I see them, and I react to them. Sometimes they are so 'big' that I wonder how people can walk by without noticing them. This was one of those days. I was walking through Palais Royal gardens during lunchtime when I saw these men wearing black suits siting on a bench, each with identical lunch bags by their feet. They were inside a smaller enclosure within the large garden. I had a 23mm lens and needed to move quite close to make the composition work. I entered the garden trying to look like a curious tourist. I pretended to take a few shots of the birds and plants as I moved closer and closer. I took a few approaching shots, not knowing how long the three men would stay or whether one of them would decide to stand up while the other two were finishing their lunch. Approaching shots can sometimes work, but the discerning photographer will always aim for the best possible composition without settling for a mediocre one.

There is a fountain in the middle of the garden, and it is visible on the edge of the frame. Thankfully, it was late October, and the fountain had been emptied in preparation for winter. I must have looked very silly crawling on the edge of the fountain, pretending to look for something in the gravel. It worked because the three men never even looked up, and I finally captured the shot I was envisioning—straight on, just a few feet away, the perfect balance of two men leaning while the one in the middle is sitting straight. This was the shot. I could have put the camera away for the rest of the day. I had my shot, and I felt that moment of exultation that other photographers can certainly relate to.

Three Suits at Lunch.
Fujifilm X100S 23mm
1/500 F/5.6 ISO 200.

The Professor and My Morning Coffee. Fujifilm X70 18.5mm ISO 1250 F/5.6 1/60 Sec.

The Professor and My Morning Coffee

It was my last day in Paris before flying back to the States. I had just finished teaching a workshop, and I was looking forward to some 'me time' with my camera for a few hours. I made a quick stop at the café around the corner from my apartment. In the winter, the terraces are often partially enclosed to keep the smokers away from the cold. I don't smoke, but I quite like the smell of cigarettes outdoors when I'm in Paris. It's part of the experience. As a photographer, I find smokers to be a lot more interesting to photograph than people on their phones.

As I was enjoying my grand crème and catching up with e-mails on my phone, I noticed a gentleman a few tables away who looked like he was correcting papers. Being in the heart of Sorbonne University, it was a rather common sight. It struck me that he was using an iconic four-color Bic pen. The same pen that I, like everyone else, used as a student in France. I remember also that the color green never was of much use . . .

As a typical Frenchman, he had a pen in one hand and a cigarette in the other. I had to smile because the sight was *so* stereotypically French that it almost looked fake. To top it off, the advertisement behind him added a touch of humor.

I was testing the new X70 by Fujifilm. It's a tiny camera that looks a lot like a point and shoot, with a flip screen and an 18.5mm fixed lens. I decided to do some creative framing to better tell my story. I set the camera on the table, included the cup of coffee in the foreground and framed the professor next to it. The photograph instantly brings me back to that special day. It tells the story of my morning routine—a scene that most would take for granted and not even notice but one that I miss dearly because I live so far away.

In Sync. Fujifilm X100T 23mm ISO 3200 F/5.6 1/125 Sec.

In Sync

It was early evening, and I was walking from my apartment to meet my students at their hotel for our final presentation. It was September 2015 in Paris. The end of a workshop is always bittersweet, especially when you spend a whole week with new friends who share your passion. I always feel happy because everyone learned so much and beautiful friendships developed, but I also feel sad that it's over, and we all have to part ways. The final presentation is always greatly anticipated by everyone. It is a time to reflect on the week and to see the growth in each photographer. It is followed by dinner at a nearby restaurant, where we share street memories and many good laughs over delicious French food and wine.

When teaching a workshop, I do most of my photography off-hours. During the photo walks, I spend my time giving as much personal attention to my students as possible. We work on whatever technique they want to master, depending on their level. I usually spend extra time walking to and from our daily photo walks to do my own photography. On that day, I was running late after putting the final touches on the group's presentation. I was running up Rue Mouffetard when I stopped suddenly in front of a restaurant where two waiters, dressed identically, were performing the same action in sync. This is called an 'interconnection' in street photography (similarities in people's behavior or body language). In a fraction of a second, I grabbed one shot. Note: Running is never a good idea when you're hunting for a shot; walking fast isn't either. You will miss opportunities, and any sudden stop will draw attention. As I was in a hurry, I wasn't consciously looking for potential photographs. But such an extraordinary scene could not escape a photographer's eye. I clearly remember people giving me strange looks, wondering what I was photographing. It always strikes me that people look but forget to see. This photograph made my day—my week even! It will always remain one of my favorites because it all happened in a fraction of a second, and the resulting image was exactly as I had envisioned it. This type of personal satisfaction is hard to beat for the photographer.

When I met my students, they all saw the smile on my face. They knew I had captured something special. It never gets old!

The Reader of Île Saint Louis

Île Saint Louis, the island on the Seine located directly behind the famous Île de la Cité, is one of my favorite places to explore the riverbanks. Parisians frequent the park benches regularly throughout the seasons.

For the street photographer, the age of smartphones is making our quest for interesting images more and more difficult. Few people spend their leisure time daydreaming, reading or talking with others anymore. Most of us are buried in our phones, expressionless. I have an ongoing photo project called 'Readers' that focuses on real book and newspaper readers, not e-readers. Parisians love their books, and it's reassuring to see bookstores opening, whereas they seem to be closing everywhere else in the world.

I was walking on the sidewalk along the wall above the river walk, looking down often so as not to miss a photo opportunity when, to my delight, I saw a reader. Nothing says Paris like a gentleman dressed in black, cigarette in one hand, book in the other. I decided to frame the subject at an angle, to try something different and more dynamic. Using a fixed focal length makes you work a little harder and often pushes you to make challenging framing decisions. Those limitations make you a more creative photographer. I chose to frame in a way that only gives the idea of the river and the tree around him. With a minimalist framing and the use of negative space, the subject becomes the focal point. Your eyes explore the frame, but your attention quickly comes back to him.

The Reader of Île Saint Louis. Fujifilm X100S 23mm ISO 200 F/5.6 1/150 Sec.

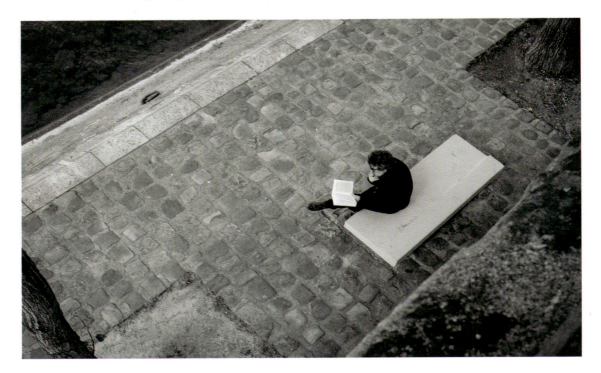

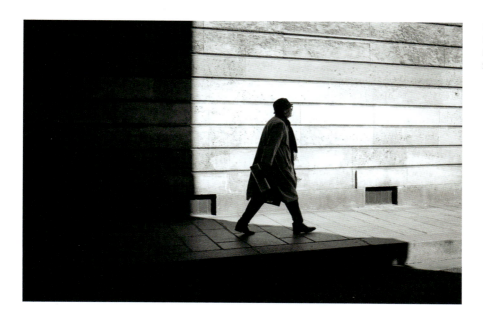

Inspector Clouseau.
Fujifilm X100T 23mm
ISO 200 F/5.6 1/400
Sec.

Inspector Clouseau

I was walking in Le Marais with a small group of workshop participants. We had just regrouped to walk toward our last 'hunting ground' for the day. Our photo walk was almost done; we had walked for hours on the streets of Paris, cameras in hand, and my students were getting tired after a very productive day. Street photography requires constant attention; we scan around us non-stop for hours during photo walks. Capturing life on the streets becomes a way of life. You never stop looking for potential photographs, even when you break for lunch.

Suddenly, I spotted this gentleman walking at a brisk pace across the street and pointed him out to the few students who were close to me. In a situation like this, it's all about quick thinking. You need to anticipate your subject's next move and to get ahead to shoot the best possible frame with as little distraction as possible. Fortunately, he was heading toward an area with a large wall. There were no cars in the way, and it was the perfect spot for a silhouette shot, with deep shadows and bright sun. A subject like that doesn't cross your path too often, and missing the right step would break the shot. I quickly switched my camera to drive mode to increase my chances and pressed the shutter just before he entered the light. The movement in his coat accentuates his speed—he is in a full stepping motion. It was a winner. A couple of my students got some equally good shots of him, though slightly different, because no two street photographers will respond to a scene in the same way. This man remains a mystery. He looks as if he came straight out of a different era. Inspector Clouseau, maybe?

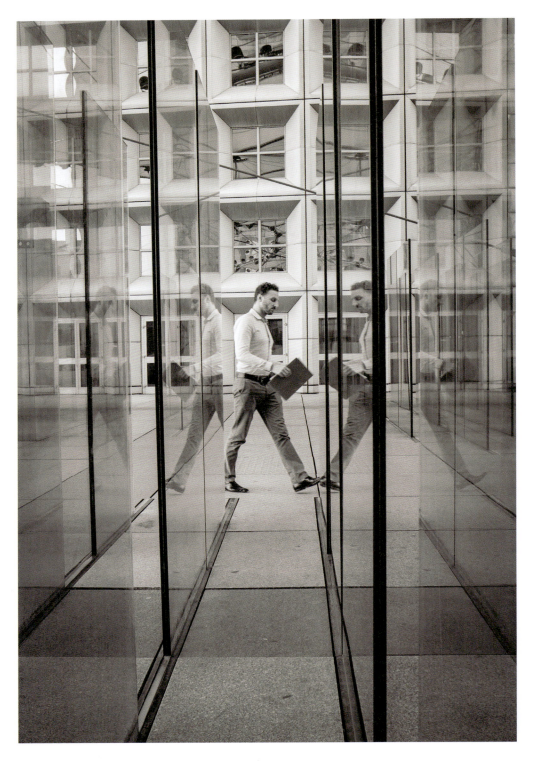

Multiplicity. Fujifilm X100T 23mm ISO 200 F/5.6 1/120 Sec.

Multiplicity

I was walking through the famous Grande Arche in La Défense business district of Paris when I spotted these staggered glass panels. By positioning myself just right, I noticed the multiple reflection opportunities. The timing was everything, but more importantly, the right subject had to walk through the panels. Being a business area, the ideal subject should give a sense of place by either wearing a suit or carrying a briefcase—or something similar. I was in a real time crunch, as this was during a family vacation, not a photo trip. Since I spend the rest of the year roaming the streets of my favorite cities with my camera, I do not make photography my priority when I am on a family vacation. My camera is always with me, but I content myself with grabbing images here and there without taking away from valuable family time.

While the rest of my family was taking in the view and resting a moment on the steps of the impressive square building, I planted myself in a spot that would potentially yield a strong composition. I immediately put my Fuji X100T into burst mode to put all the chances on my side if the right subject entered my frame. I don't get the same satisfaction from getting *the* shot in multiple frames as I do in only one frame, but there are times when it becomes necessary to get the shot.

Several tourists entered my frame, but none were interesting enough to warrant a shutter click. Luckily, within a few minutes, this young professional with a folder in his hand walked through the glass panels. I got the shot with the perfect subject, given the location. The stepping was perfect, and there was separation between the man's heel and the ground as an added bonus. I rejoined my family, satisfied with myself for having captured the photograph I envisioned within such a short time. I never settle. I prefer not to shoot over settling for an uninteresting subject or one that would not fit the story I want to tell.

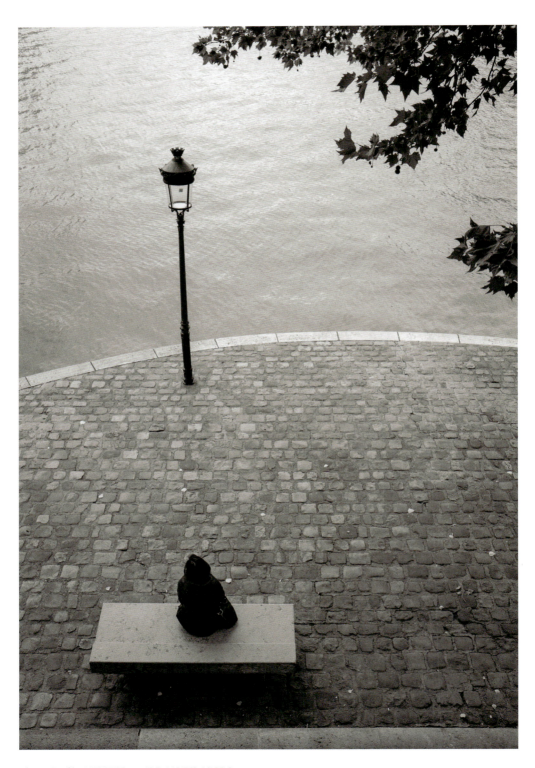

Alone. Fujifilm X100T 23mm ISO 640 F/8 1/125 Sec.

Alone

When I look at this photograph, it always brings me back to the exact emotion I was feeling when I framed it. It was May, and I had just landed in Paris. As is customary, I didn't sleep on the plane, and I spent the entire first day walking my favorite streets with my camera. I needed to reconnect with my beloved city.

I was particularly tired that day, and I had just learned that my best friend would not be able to meet me before my workshop as planned. I was feeling sad and lonely. Not sleeping in nearly forty-eight hours didn't help. I was walking around Île Saint Louis when I spotted this woman, sitting alone on a park bench, looking toward the river Seine. I immediately identified with her loneliness and was compelled to photograph her in the same state of mind that I was feeling. To emphasis the feeling of loneliness, I positioned her low in the frame and included simple elements such as the lamppost and the tree branches to complete the composition. The three elements form a triangle, a powerful shape in photographic composition that allows elements to flow together.

To this day, a feeling of loneliness fills my heart when I see this photograph. I am connected to it on a deeper level because of the way I was feeling that day.

Through the Front Door

It was a January night in Paris, and I was heading out to meet some friends for dinner. The main door of my apartment is made of frosted glass. Every night, the glow from the street lamps creates this wonderful mood and a great photo opportunity for a silhouette. Unfortunately, there are always cars parked right outside the door, and it's impossible to get a clean shot. That evening, I was surprised to see there were no cars parked outside. I could not miss the opportunity to finally get the shot I had envisioned all week. I didn't have much time, but I quickly framed the door and crossed my fingers that someone would enter the frame within the next few minutes. I'm never late for appointments or meetings with friends, but this was too good of an opportunity to miss, so I allowed myself just a few more minutes. I'd run to the restaurant after, if needed.

There is always an element of luck in street photography. We have no control over our subjects; we control only our vision and our gear. I was prepared, and serendipity played its part. A woman soon walked by the front door, and I clicked the shutter, forever immortalizing the moment. I was quite happy with myself; nothing beats the feeling you get when vision and preparation pay off.

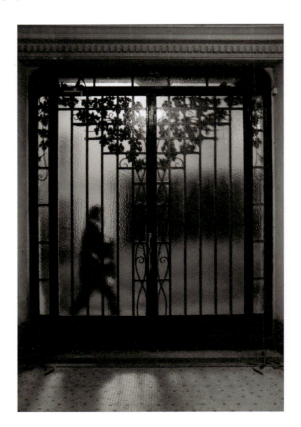

Through the Front
Door. Fujifilm X100T
23mm ISO 6400 F/2.0
1/80 Sec.

The Time Sweeper

It was July 2015. Summer is not my favorite season in Paris because of the heavy tourist traffic, but there is never a bad time to be in Paris. I embrace the challenge of looking for authenticity among the sea of tourists. My family and I were visiting the Musée d'Orsay, and I immediately climbed the stairs to reach the big clock of the former train station. Silhouettes only work when there is separation. Groups of people don't work well. Ideally, you want to capture a lone subject with enough separation so that the shape is easily recognizable. Because of the many tourists, I had to be especially patient that afternoon. I was shooting with a 23mm lens (35mm equivalent on a full frame) and figured out quickly that in order to put more chances on my side, I needed to move closer to the clock to minimize the number of people walking through my frame. By doing so, I also eliminated the distracting beam that crosses the top part of the clock. I managed to isolate and photograph a young girl in a dress who stood for a few seconds leaning on the railing to watch the view through the clock. I was ready to move on when a janitor carrying a broom and dustpan entered the room. I quickly grabbed the shot, and it has become one of my favorite Musée d'Orsay photographs due to its originality.

Although I try not to have too many distractions behind a silhouette, in this instance, I was also careful not to over expose it to keep the Ferris wheel and Le Sacré-Coeur visible in the background for an added sense of place. I named this photograph 'The Time Sweeper'.

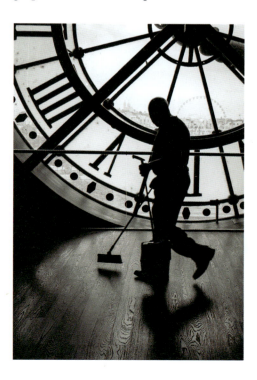

The Time Sweeper.
Fujifilm X100T 23mm
ISO 200 F/5.6 1/150
Sec.

Paris en Scene

When including signage in photography, it is important to make the words part of the story. No matter the language, we are conditioned to try to read anything written in big letters. Signage can even become a bigger distraction than color. Thus, it is important to make these creative decisions carefully whenever possible.

There is a lot of public display of affection in Paris, and the riverbanks especially offer great photo opportunities. I spotted this young couple from a distance. As I was approaching, a tourist riverboat passed in the background. I had just enough time to raise my camera and take the shot, framing the young couple and the name of the boat next to them. Paris en Scene (Paris on stage) is a play on words with the name of the river (Seine), which worked perfectly to give a sense of place to the photograph. As an unexpected bonus, the boat's clear windows allow a great view of the people on the other side of the river. The choice of black and white gives this shot more boldness by removing the color distractions of the various items around the couple.

Don't hesitate to include signage, especially if it offers a sense of place to your photographs. Just make sure that it adds to your story, not distracts from it.

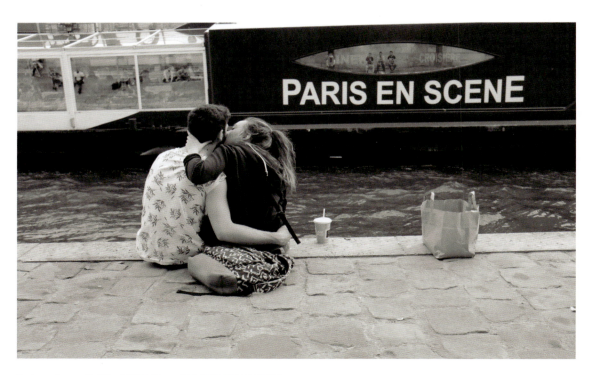

Paris en Scene. Fujifilm X100T 23mm ISO 3200 F/5.6 1/125 Sec.

Harley Chihuahua

My arrival in Paris is always magical. The city is full of surprises, and it never ceases to amaze me. One of the few luxuries I allow myself when I travel internationally is to take a taxi from the airport. I do not want to drag luggage through metro stations after such a long trip. As soon as I jump in the taxi, the camera comes out, and the window rolls down. There are many opportunities to shoot while the taxi slows down or is stuck in city traffic. This was a particularly productive day. Maybe it was because of my mood. I felt happy, as I was about to start teaching another weeklong workshop in my favorite city in the world. As we made our way through the 6th arrondissement on the left bank, we got stuck for several minutes behind a delivery truck. Suddenly, a motorcycle appeared on my right and had to wait for the street to clear. I glanced over and noticed a tiny head with two big round eyes peeking out of a bag between the two passengers. It was a Chihuahua. The riders noticed me too while I photographed them. The delivery truck finally moved, and they left on their Harley with smiles on their faces. I was home!

I originally shot in monochrome and cropped this photograph in postprocessing because I was sitting in the taxi, and I could not get close enough to make the right composition. There was too much space behind the motorcycle, and the main subject, the tiny dog's head, was lost. In cases like this one, when getting closer is physically impossible, the cropping tool in postprocessing software saves the day. The triangle of the three faces works well: the viewer's eyes jump from one to the other, making the tiny dog center stage.

Harley Chihuahua.
Fujifilm X70 18.5mm
ISO 640 F/5.6 1/200
Sec.

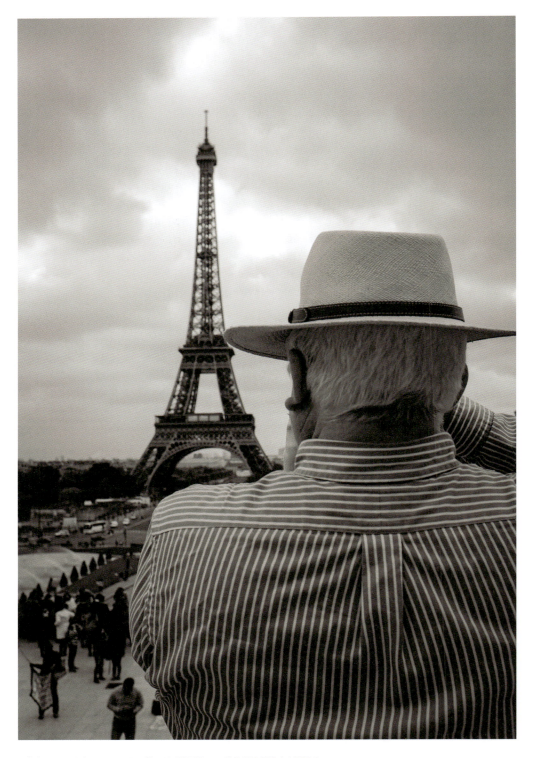

Eiffel Tower Cabana Hat. Fujifilm X100T 23mm ISO 200 F/5.6 1/750 Sec.

Eiffel Tower Cabana Hat

Photographing an iconic landmark in a new way is a challenge every photographer should undertake. Fortunately for the street photographer, the moment you include a human element in your frame, you have a photograph that no one has ever taken before and no one will ever take again. This uniqueness is one of the draws to the genre of street photography.

I spend a lot of time in Paris. I usually stay away from the tourist attractions, but whenever I happen to walk near the Eiffel Tower, I always make a point to capture something new, whether that includes people or not. Very few locals go there, so it's all about embracing the tourists and incorporating them into your photography. It was a mostly cloudy spring day. I walked up the Esplanade du Trocadéro across the river Seine and observed people taking pictures of the most recognizable monument in the world. It's always entertaining to observe people trying to immortalize their visit. For many, it's the trip of a lifetime. The point is to look for something out of the ordinary; photographing tourists with selfie sticks doesn't fit the bill for me. The novelty of it wore off several years ago.

I was watching people for a few minutes when I spotted a gentleman sporting a cabana hat walking down the steps. I quickly ran toward him and stood two steps above as he was framing the Eiffel Tower with his point-and-shoot camera. I had time to compose the shot to include him and the iconic landmark, the hat being the key element in the photograph. It makes me smile each time I look at it.

Giant Feet

Les Colonnes de Buren offer amazing compositional opportunities for the street photographer. Every time I go there with my camera, I feel like a kid in a candy store. For quite a while, the area was boarded up for renovation. That added a level of challenge that I embraced by being more creative. It was a quiet day: no children playing on the famous columns, no modeling shoots happening. I spotted a gentleman sitting on one of the columns observing the passersby from a distance. I found the situation a bit ironic because he would have made a good street photographer himself. He probably thought nothing of my camera set on the ground aimed in his direction. He seemed very busy watching the comings and goings of the elegant Parisian women. I saw this as a great opportunity. Low to the ground behind my camera, I was virtually invisible. I positioned my camera on one of the black lines and used this architectural detail as part of my composition to lead the viewer's eyes to the 'observer being observed'. No sooner had I set my aperture to F8 to maximize the depth of field than a woman walked very close to me and gave me a gift of distorted reality and perspective. I had one shot, and this photograph remains one of my favorites to this day for its originality.

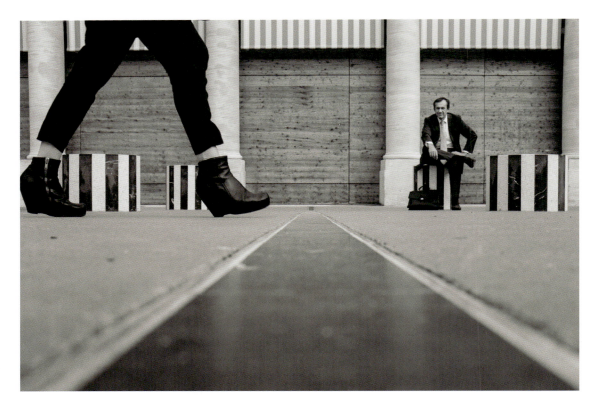

Giant Feet. Fujifilm X100S 23mm ISO 200 F/8 1/350 Sec.

The Model and the Boy

I always bring my workshop students to Les Colonnes de Buren at Palais Royal. It's like a pot of gold. For me, however, it's a bit like the Eiffel Tower. I've shot there so many times that I've likely captured some of the best photographs I'll ever be able to get at that location. I now use it as a challenge to capture something very different each time. The challenge has become a series of its own in a way, and it never gets old. In addition, it's always delightful to watch my students use their creative eye to show me something I haven't seen yet. The last week in September is fashion week in Paris, meaning there are even more elegant and well-dressed people on the streets than usual. It's really a treat to experience. It was a Thursday morning, and the place was not very busy, allowing us to isolate subjects in a world of black-and-white stripes. A tall and elegant young woman was being photographed by her friend as she was running and jumping on the iconic columns. I was following the scene carefully when I saw a boy running in the opposite direction a little farther away. I quickly composed the shot; fortunately, the two subjects are in similar stepping positions. There is a connection between the two for the viewer because of their similar actions, even though they are obviously unaware of each other.

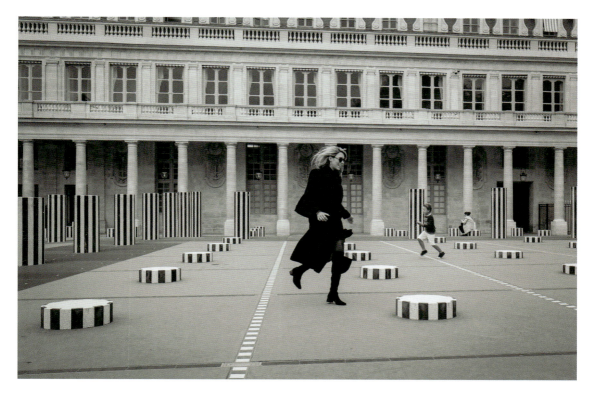

The Model and the Boy. Fujifilm X70 18.5mm ISO 800 F/8.0 1/250 Sec.

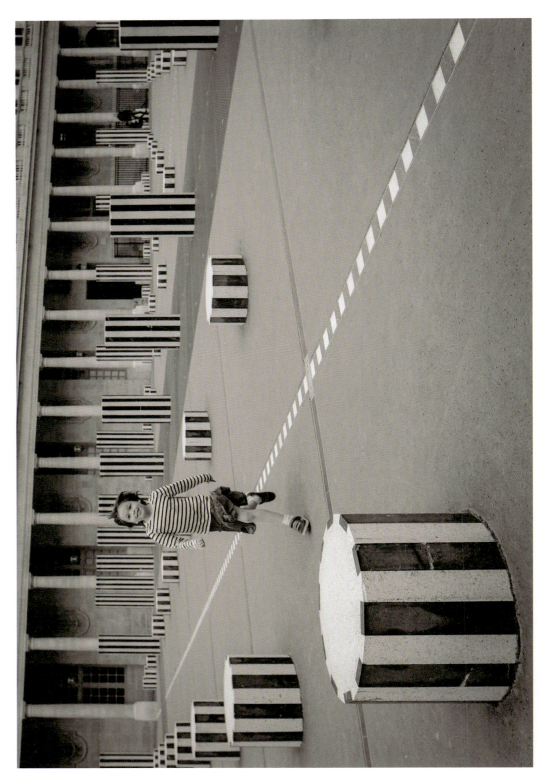

Stripe Story. Fujifilm X100T 23mm ISO 200 F/5.6 1/250 Sec.

Stripe Story

It is important not to repeat yourself in your photography. Once you capture a successful photograph in a specific location, you either have to set the bar higher next time or never go back to that location. Thus, it is important to see familiar spots in a new way at each visit. As a teacher, I have taken my students to some of my favorite spots in Paris. The challenge for me each time is to try not to repeat myself. Of course, because it is street photography, no two photographs will ever be the same, but the concept could be similar. Because of the striking black-and-white geometrical patterns, I had envisioned a shot with interconnection between the subject and the environment. The idea wasn't new, but I had not yet settled for a subject that I thought captured it quite right.

This was in May 2016. I was teaching a workshop and walking back and forth between the gardens and the columns to work individually with students and to point out some interesting subjects and situations. I was just returning to the Colonnes when I saw this little girl wearing a striped shirt run across the art installation. I pointed my camera and caught this photograph as she was running back in the direction of her grandmother, who was sitting on a column on the edge of the square. As soon as she reached her grandmother, she complained that she was too hot from running. She removed the popular French sailor-stripe shirt and went on running with the pink T-shirt she was wearing underneath. The moment was gone. I was so relieved to have captured the one shot of the stripes among stripes. Vision, preparation and fast action made the shot possible. The child is a bit soft, as my shutter speed wasn't set for such fast action, but that is never an issue in street photography. On the contrary, here it helps convey the sense of motion. This photograph continues to make me smile, just as I smiled when I knew I had captured such a special interconnection between the subject and the urban environment.

Lilly and Helliot

I was walking home to my rental apartment after a full day of teaching on the streets of Paris when I stumbled upon two happy pug faces sitting on the windowsill of a ground-level apartment. I had to stop. I love these dogs; their expressions are so much fun! No sooner had I stopped than their owners appeared in the window behind them. Such friendly people! The 'mom' explained to me that Lilly was the 'concierge' of the building. She is very vocal and will alert her people of anything out of the ordinary happening on the street. Her brother, Helliot, on the other hand, is the calm and quiet one, the silent observer. 'Dad' explained that he built a platform on the window for their comfort, as they love to sit and greet people. Of course, I couldn't miss this opportunity to make a family portrait. I'm a dog lover too! I gave them my card and promised to send them a copy of the picture, which I did a few weeks later. I left this encounter with a spring in my step. This moment was especially heartwarming. Such friendly people; I will visit them again on my next trip!

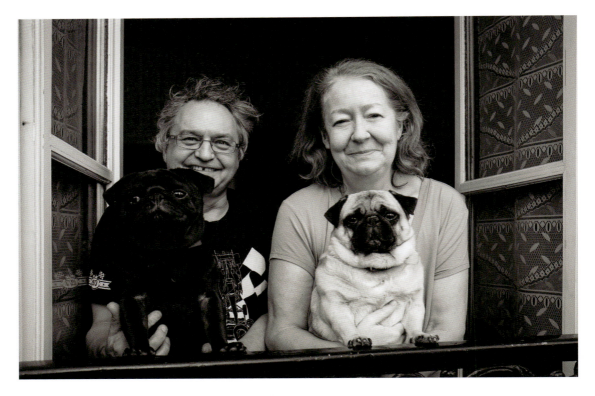

Lilly and Helliot. Fujifilm X100T 23mm ISO 200 F/4 1/140 Sec.

Same Hairdo

Photographing in the metro or subway is always fun but yet a bit intimidating. People are not exactly in their most relaxed mood as they enter a crowded train to get to work in the morning or to return home after a long day. Yet it is probably the only mode of transportation where you'll find people from the most diverse socioeconomic and cultural backgrounds. The grittiness of the metro is also an appealing backdrop for the urban photographer. So are the billboards that adorn the stations that offer an ever-changing stage throughout the year.

I saw the dog on the ad and the gentleman with the wild hair simultaneously. I may not have paid much attention to them separately, but they 'worked' together. They made a perfect pair with similar hairstyles. I saw them, grabbed the shot and smiled, knowing that I had captured something special and humorous. The man made eye contact with me, unsure whether I had photographed him or the wall behind him—and he was most certainly unaware of the connection between him and the billboard.

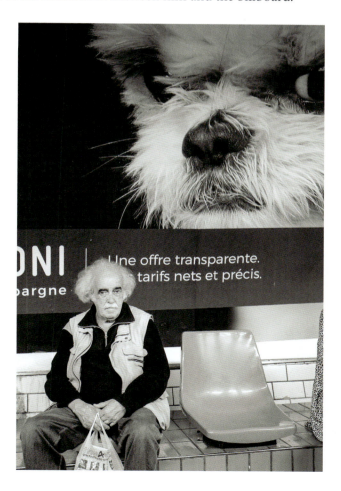

Same Hairdo. Fujifilm
X100T 23mm ISO 2500
F/2.0 1/125 Sec.

Political Boredom

I walked by this man napping at an outdoor café in Paris on my way to lunch between critique sessions during a workshop. I grabbed an approaching shot, as I didn't know how long he would remain still. I passed him and thought that the opportunity was too good not to try a closer shot. The newspaper was blowing slightly in the wind, turning the pages in the process. The gentleman was sound asleep, and I grabbed a couple of close-up shots. The black and white removes the distraction of the green construction barricade directly behind him. It wasn't until later, in postprocessing, that I realized the page was turned to one of the two US presidential candidates. Just a few weeks before the most controversial election in decades, the world was tuned in to the debates and growing concerned with the outcome. The page being turned to presidential candidate Donald Trump and the reader sleeping soundly are ironic and signs that the world was ready for the election to be over. I named this photograph 'Political Boredom'.

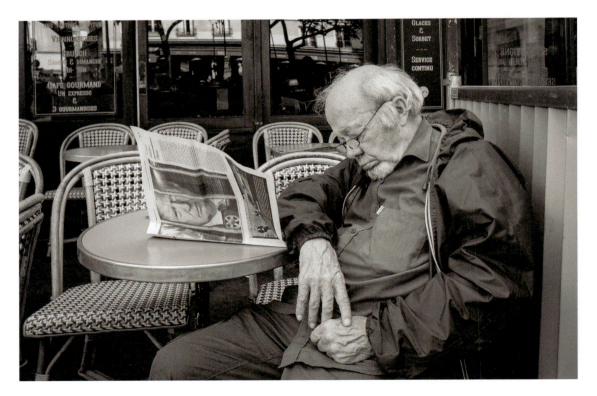

Political Boredom. Fujifilm X70 18.5mm ISO 640 F/5.6 1/200 Sec.

Waiting in the Light

Le Marais in Paris is one of my favorite 'street photography playgrounds'. There is always a great mix of people; it's both hip and timeless, with interesting backdrops and quaint cafés and restaurants. I was chasing the light that day around lunchtime—letting the light guide me and reacting whenever it illuminated an interesting gesture or expression among the people sitting 'en terrasse'. I saw this man at a table alone. The light illuminated his face, and he looked somewhat annoyed that the waiters were helping the tables on each side, while his order had not yet been taken. I observed for a few seconds and grabbed the shot at the moment when both waiters had their backs turned to me. Such framing helps isolate the main subject even more, emphasizing the fact that he is probably being ignored, alone in the light. The menu in the window and the waiters' iconic outfits give the viewer a clear sense of place. There is no doubt that we are in Paris!

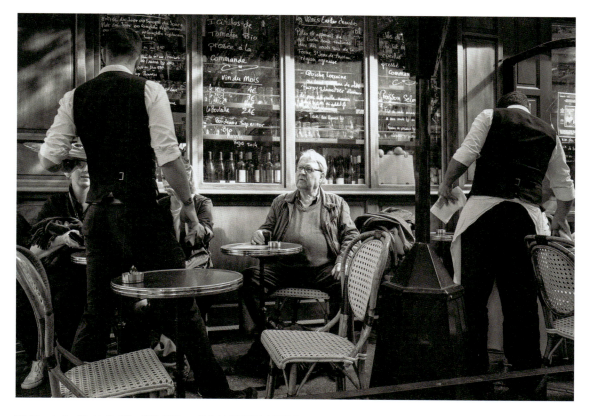

Waiting in the Light. Fujifilm X70 18.5mm ISO 1600 F/5.6 1/200 Sec.

Eyes on Her

Studying human behavior is as important to the street photographer as it is for the wildlife photographer to know and predict animal behavior.

I arrived early to meet a friend for lunch at Place de la Contrescarpe. I had my camera in hand and was walking slowly around the fountain to observe the people sitting at the outdoor terraces. It is important to walk slowly when you are 'hunting' on the streets. You see better if you slow down, and you do not attract as much attention if you pause for a second to grab a shot. Any sudden stop while walking at a fast pace will surely draw attention. It is something I learned over time because I am normally a very fast walker. I walk slowly only when I'm 'street hunting'.

I saw this beautiful young woman coming toward me and immediately noticed the men sitting at the café lock their eyes on her (and their wifes disapproving). It's very predictable, anywhere in the world. Men often don't realize how obvious they can be, which is particularly clear in this photograph.

This all took place in a fraction of a second. I was not waiting for this to happen, I simply reacted to it. The young woman is in soft focus, but the key subjects here are the couples sitting at the café. The viewer is drawn to them and jumps from one pair of eyes to the next while the woman walks by, facing the other direction. Even her friend is one step behind.

Eyes on Her. Fujifilm X100S 23mm ISO 320 F/4.0 1/60 Sec.

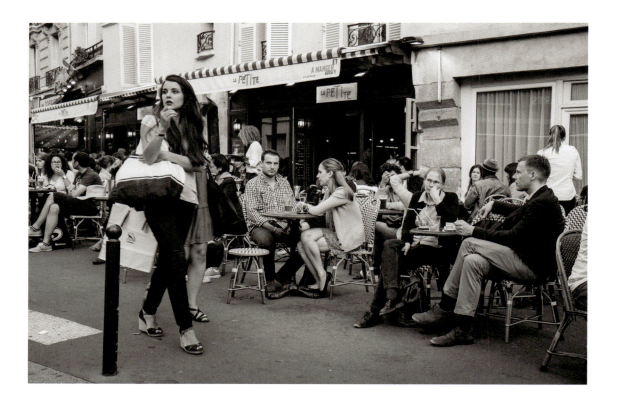

Boys Will Be Boys

The pond at the Luxembourg Gardens has seen generations of children pushing the iconic antique wooden sailboats with sticks for nearly a hundred years. The rental kiosk is open during the nice weather months. But on Sundays, from 10:00 a.m. to 1:00 p.m., the large pond is reserved for the 'older kids' of the Luco Club. You can see grown men of all ages walk to the garden from all directions, boats in hand. They are quite serious about their hobby and proud of their toys, from antique wooden sailboats to high-tech submarines. I was at the pond on a Sunday morning in January when I saw them for the first time. I was delighted by the discovery. Many are of retirement age, and it seems like a lovely pastime when so many retirees spend their time watching TV instead of getting some fresh air and exercise, and more importantly, socializing with others. There were few people at the Luxembourg Gardens that January morning, except for some tourists and the usual joggers. I watched the antique boat enthusiasts awhile, took some frames and exchanged a few words. This tall gentleman was playing with a relatively small antique sailboat. I photographed him a few times, and this is my favorite frame. The moment is just right, as he is reaching for his precious wooden boat.

Boys Will Be Boys. Fujifilm X100T 23mm ISO 500 F/5.6 1/125 Sec.

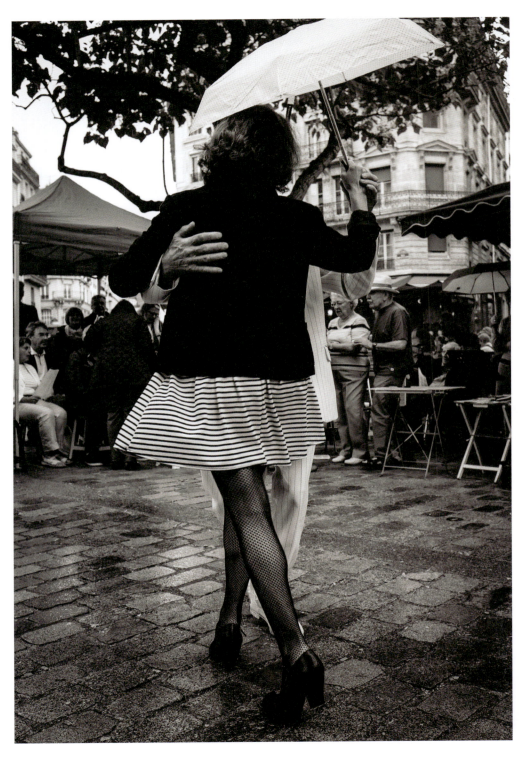

Dancers In The Rain. Fujifilm X100T 23mm ISO 1250 F/4.5 1/250 Sec.

Dancers In The Rain

Rue Mouffetard is Ernest Hemingway's old neighborhood. It's also my home away from home. The street market on Sunday is said to be the oldest one in Paris, and I visit every time I'm in town. At the bottom of the streets, just past Saint-Médard Church, there is always music playing and people dancing on Sunday mornings. There are the usual dancers who know every step and urge the passersby to join them. It's so iconic to Paris that I am always tempted to join in. Instead, I take pictures. It's always a challenge, as there are many distractions, such as market stalls, tourists and the like. I usually shoot from low angle to minimize the distractions. B&W also helps keep your eyes on the dancers by removing the colorful distractions.

It started raining that day, but instead of packing up, the dancers continued dancing with umbrellas. I was very excited, and I kept on shooting, placing my hand over my little camera to shield it from the rain. Since I am not a dancer, I cannot predict the next move, which is a disadvantage. Yet I can recognize an elegant move when I see it. The best option in a situation like this is to take a lot of pictures. It's very similar to sport photography: Things happen very fast, and very few frames will make interesting photographs. Ultimately, the photographer has to be able to recognize the strongest frame. In the series I captured that morning, only one or two frames were strong enough for my standards. This is the one I chose to keep. The dancers' faces are not visible, but the stepping is elegant, and the man's hand on the woman's back adds mystery and intimacy. The woman's striped skirt stands out in B&W. Rain always opens new opportunities for the street photographer.

Tango Dancers. Fujifilm X100S 23mm ISO 200 F/5.6 1 Sec.

Tango Dancers

I love summer nights in Paris. The city is alive late into the night. The river-banks become the stage for lovers' picnics, musicians, jugglers and dancers. Passionate tango dancers meet nearly every night. Beginners are welcome, and there is always a veteran tango dancer or two available to teach them a few steps.

I'm always very tempted to join in and learn, but the photographer in me cannot resist photographing the event instead.

After using a tripod for many years as a commercial photographer, I refuse to carry anything other than my small camera when I hit the streets. Whenever I need to steady my camera for a long exposure, I find a wall or other flat surface that will do the job. In a way, I look at it as part of the challenge of capturing a good shot.

The dancers perform in a small amphitheater on the riverbank. The large cement steps where people sit make a good steady surface for my camera. I don't carry a release trigger either, so I set my camera to the two-second self-timer. It takes a lot of shots to get one that will work. It's important to choose an exposure time that will capture the gestures and expressions and will not blur the scene to the point of making the dancers indistinguishable. Unless, of course, the photographer wants to make a more abstract composition. I'm at a disadvantage when it comes to photographing dancers because I don't know the moves, so I cannot anticipate them. But I know how to recognize an elegant or passionate gesture once I capture the frame, so it's more a game of patience and number of frames.

I was shooting RAW that year, but I knew that this would be a mono-chrome image immediately. Many of the dancers were dressed in bright, colorful clothes, while others were subtler. The colorful dancers were not always the most interesting subjects and risked stealing attention away from the others. From the many frames I shot that night, only two or three made the cut. This one was my favorite for two reasons. All the dancers are in motion blur, but the main subjects here are not moving as fast as the others. As a result, they are more in focus and more likely to get the viewer's attention. The passion in the woman's hand is the gesture that makes the photograph work. The eye travels from her hand to her face. Her eyes are closed, which conveys passion and emotion. The couple is in a brighter part of the dance floor and better lit than most of the others around them. I adjusted the exposure on her face and hand slightly in postprocessing to make her stand out even more.

It was a perfect ending to a full day on the streets of Paris.

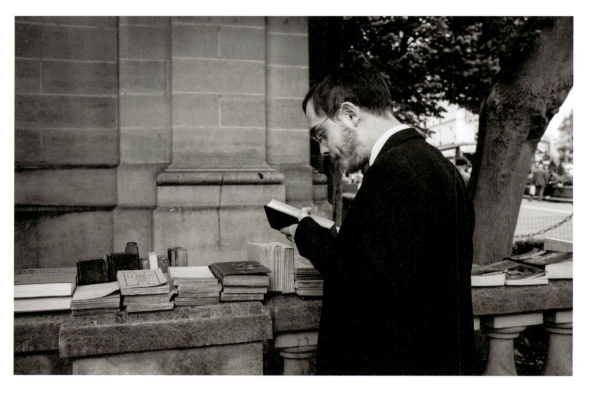

Book Lover. Fujifilm X100S 23mm ISO 250 F/4.0 1/125 Sec.

Book Lover

I am writing this on National Book Lovers Day, and this is the photograph that first came to mind to celebrate the occasion. I captured this scene near my apartment in the 5th district in Paris. It was a beautiful spring day. It couldn't be more fitting, as it is just steps from the building where Ernest Hemingway lived with Hadley when they first moved to Paris.

I noticed a few old books on the wall surrounding a church. I love books! And I love to photograph the texture of old books. As I got closer, I noticed this young man completely engrossed in a book. I particularly liked his timeless look. He was so absorbed in his reading that I was able to get quite close and frame him in a way that gave a sense of place while also highlighting his facial expression. There is passion in the way he holds the book and looks at it. I left the scene undisturbed. I did not disrupt his reading; I simply captured a beautiful moment between a reader and an old book.

"There is no friend as loyal as a book."

Ernest Hemingway

The Old Man and the Stairs

This photograph represents one of those moments when you catch something very special from the corner of your eye and quickly respond to it, hoping for the best in a difficult situation.

It was at Galerie Vivienne in Paris on a cold January Monday. I was enjoying one last day with my camera before flying back to the States the next morning. I had never really noticed the stairs at the far end of the covered passage that led to apartments above. I saw movement from the corner of my eye and noticed an open alcove above a door. Through the opening, I saw an old gentleman painfully walking up the stairs. I had to try the best possible frame for this beautiful moment. Working with a fixed lens and a rather wide focal length implies some limitations. It's perfect in most cases because it pushes you to get close, which makes for more powerful photographs. But in cases like this one, when it is physically impossible to get any closer, you just have to make the best of it. I quickly framed and clicked. The man wasn't moving very fast, but I still had a very narrow window of opportunity when he would have the right gesture. The hand low on the railing is key, as it does not hide the side of his face.

After taking the picture, I pondered the challenge of living in a building with no elevator, which is so common in Paris. This man probably has lived above the covered passage all his life, possibly on the third or fourth floor or even higher. I can imagine how long the climb now feels on his achy joints. How much longer will he be able to take those stairs? Where will he be forced to move to when he no longer can?

The Old Man and the Stairs. Fujifilm X100F 23mm ISO 2500 F/2.8 1/125 Sec.

Saint-Sulpice

Saint-Sulpice is one of my favorite churches in Paris. It's located in the busy 6th arrondissement. The large fountain on Place Saint-Sulpice in the front of the church is also a wonderful place to photograph. Occasionally, there will be a book or antique fair around the fountain as well. I visit this location every time I'm in Paris and often more than once. Although I am not a churchgoer, I am always respectful of people who need the peace and quiet of the sanctuary for their moment of prayer. I make a point of walking around the church very slowly, camera in hand, aware of all the light sources. The light coming from the windows above, the candles or an open door can make for interesting photo opportunities.

In the far back of the church, there is a door to a chapel. I noticed many people walking in that direction, most likely to attend a service. I stood there for a little while, hoping to isolate a silhouette in the light of the doorway leading to the chapel. A small nun came from the chapel and opened the door. My camera was in burst mode to increase my chances of a sharp shot in a very difficult low-light situation with slow shutter speeds. I pressed the shutter as she paused a few seconds to release the doorstop with her foot. This allowed enough time to frame her in the bright light. I increased the contrast slightly in postprocessing to keep the wood on the doorway very dark. There is something very serene and peaceful in this scene.

Saint-Sulpice. Fujifilm X100T 23mm ISO 6400 F/2.8 1/18 Sec.

Checking the Time

The spiral staircase inside the large pyramid in Le Louvre is an interesting piece of architecture in itself. I've photographed it many times and from many different angles. I have photographs of people walking up or down, standing at the top and looking down and so on. It is usually quite easy to isolate an interesting subject; few people use those stairs, as most favor the escalators. The central part of the spiral is an open elevator. Fortunately, the elevator was lowered during my visit. I had just arrived inside the pyramid and thought I might be able to get a different type of composition this time. I looked down and saw this gentleman sitting at the bottom of the steps. My first reaction was to wait for him to move so I could photograph him in action instead of stationary, when suddenly, he turned his arm and looked at his watch. I had my gesture and my story. The old man is done with museum galleries for the day. He left his family and told them he'd rest awhile. He found a quiet space to wait, occasionally looking at the time and gathering the strength to walk to the next metro station. He is even considering taking a taxi if his wife allows the extra expense. He is tired and hungry, and the thought of bœuf bourguignon and a glass of red wine or two will help him make the extra steps necessary to leave the museum. He may even walk up the spiral stairs instead of fighting the crowds up the escalators.

Checking the Time. Fujifilm X100S 23mm ISO 200 F/8.0 1/240 Sec.

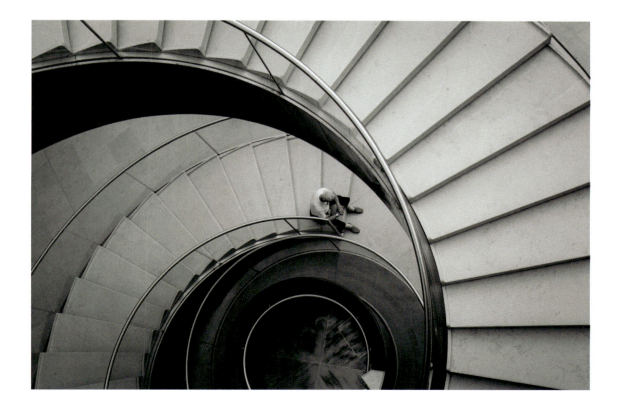

Under the Apple Store Stairs

I spend a lot of time under the stairs of Apple stores in Paris, New York, San Francisco and other cities. The translucent surface of the steps allows for interesting abstract photographs of human forms. So far, no one has ever asked me to leave the store. I make a point to look as if I am waiting for someone and to raise my camera only at the last moment when I see a potential photograph. I photographed these two men in Paris as one was going up the stairs, and the other one was going down. The gesture and body shapes are easily distinguishable, while the scene retains its abstract and mysterious nature. The choice of black and white was an easy one to make in order to eliminate white balance issues. The square crop cleaned up the edges of the frames, removing any distracting elements.

Under the Apple Store Stairs. Fujifilm X100S 23mm ISO 200 F/2.8 1/1250 Sec.

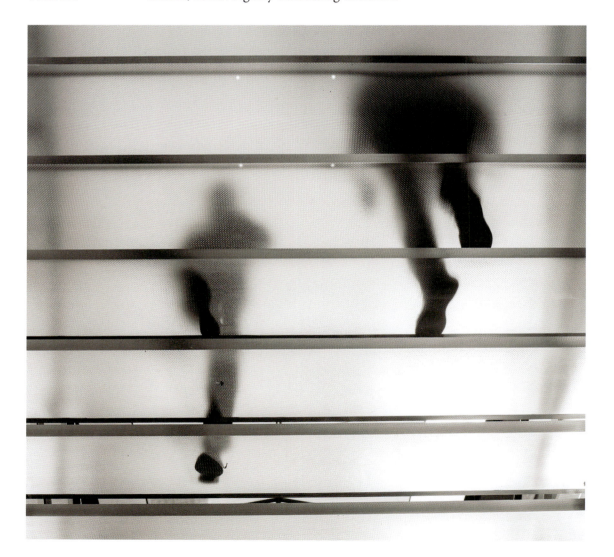

Passenger on the Train

After spending a few days at my family home in Normandy as I normally do each time I travel to France, I made my way back to Paris by train. It's only a two-hour train ride from Caen to Paris Saint-Lazare, and I quite enjoy it. Taking the train is something I never get to do in the United States.

A man was sleeping on my reserved seat. I decided to let him sleep and took the empty seat across the aisle next to a young woman who was listening to music. After a few minutes, the rhythm of the music and the train, combined with the sun shining on her face, lulled her to sleep. I quickly noticed the way the light was illuminating one side of her face and how her reflection appeared in the window. I pulled out my camera and took a few pictures. My camera being completely silent, she never knew I captured this peaceful moment.

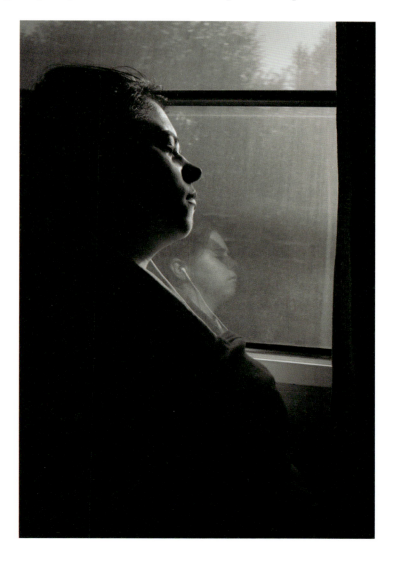

Passenger on the Train.
Fujifilm X70 18.5mm
ISO 200 F/4.5 1/400
Sec.

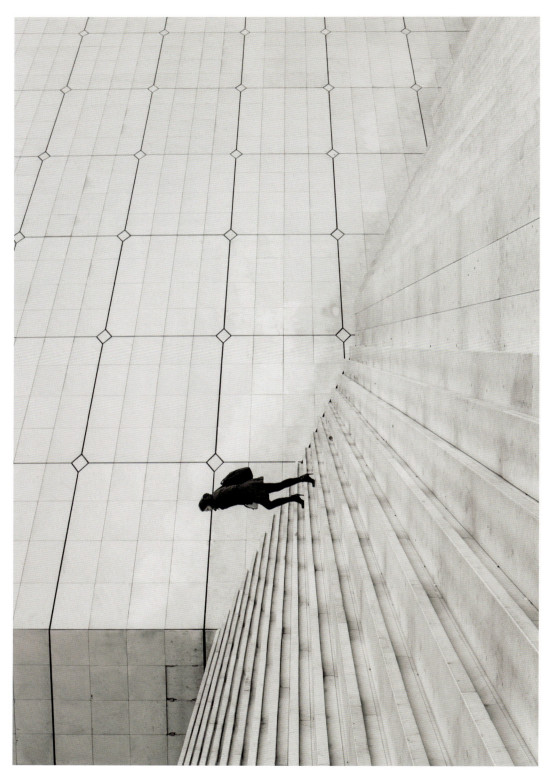

La Grande Arche. Fujifilm X100S 23mm ISO 200 F/5.6 1/160 Sec.

La Grande Arche

I live in the United States, so I rarely find the need to surround myself with modern architecture when I travel to Paris. Yet I love using lines and shapes in my photography. Modern, urban backdrops with a good subject make for some powerful photographs.

It was a blustery January day, and I was meeting a friend under La Grande Arche at La Défense, the Paris business district. I had a few minutes to spare, so I walked around in search of an interesting composition. A cold wind was channeling through the giant square building. I noticed that the few people who were walking up the long steps were bent to fight against the wind. The steps were unusually devoid of people due to the inclement weather. In preparation, and because I had little time, I set my camera in burst mode to put more chances on my side and scanned the surroundings for a fitting subject.

A woman dressed in black and with high-heel shoes came up the stairs at a good pace, possibly retuning to work after doing some shopping during her lunch break. I quickly composed my shot to avoid including any other person in the frame. I made use of the steps as leading lines. The woman is reaching the edge of my frame and going against the natural flow, thus creating tension. She is the only rounded soft element in an architecture composed of lines and angles. She is black against white. I captured a few shots but only one worked, as she is in stepping motion with good separation. The high heels are a strong compositional element. Her bent posture infers the cold, windy day.

I turned around and saw my friend coming toward me. I was satisfied with a few minutes well spent and a keeper as a result.

This is a good example of the importance of separation in the stepping motion. It also illustrates how an interesting urban landscape can be an ideal backdrop and how the human element, however small, becomes the focal point.

V

I love this pedestrian bridge over the Seine in Paris. Formerly known as Passerelle Solférino and renamed Passerelle Léopold-Sédar-Senghor, this interesting piece of architecture was designed by the Eiffel engineering company and built in the late 1990s. It is very unique, and I've photographed it many times and at different times of day. It is commonly shot straight on due to its beautiful symmetry. That day, I was either going to get a new shot or not photograph it at all. I walked around in search of a new and interesting angle and noticed the repeated V patterns. V also being the first letter of my name, I immediately responded to it. Now I needed the human element in my frame. The subject could only be captured in the opening. Being very discerning, I didn't want to settle for a tourist. I waited patiently, ready to fire, looking over my shoulder every once in a while. After a few minutes, the ideal subject dressed in black walked up the bridge. I captured this frame: The subject is at the right spot, with her hair in the wind. Of all the photographs I made of this pedestrian bridge, this is my favorite because it's different. It appeals to my architectural photographer's eye, and it is complete with a beautiful human element. Black and white was the only way to go.

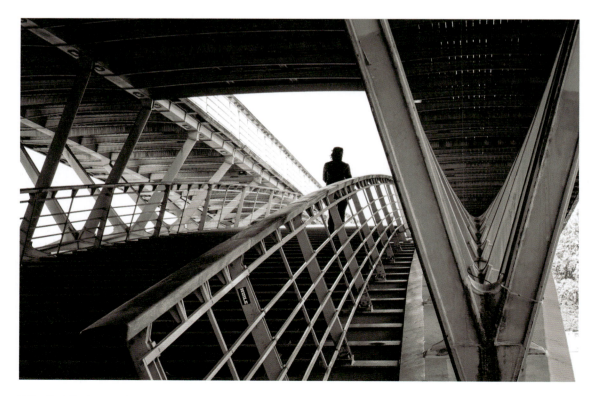

V. Fujifilm XT-1 35mm ISO 200 F/5.6 1/80 Sec.

Leaning With the Shadows

Every sunny spot is a welcomed haven on a cold January day in Paris. I was walking down Rue Clovis, which runs parallel to Eglise Saint-Étienne-du-Mont in my beloved 5th arrondissement. The streets were quiet. It was Sunday and colder than usual. The cafés and restaurants were full, and the streets were mostly deserted. There was not a cloud in the sky, and it was the perfect time to pay attention to interesting shadows. Next to the bus stop across the street, I noticed a tall young man leaning again the wall surrounding the church. His eyes were closed as he soaked up the January sun. As I got closer to and directly across from him, I was struck by the tall shadows on each side of him. They were angled in the same direction in which his body was leaning. The moment was too good to pass up. I quickly looked for traffic and ran halfway across the narrow street to get the best possible frame. I stopped down my exposure to keep the shadows nice and deep, grabbed the shot and ran back to the sidewalk. When I glanced back a few seconds later, I saw the bus approaching, and the young man had moved into the shade. The moment was gone but not lost. I knew I had captured something special: a photograph of a young man leaning with the shadows.

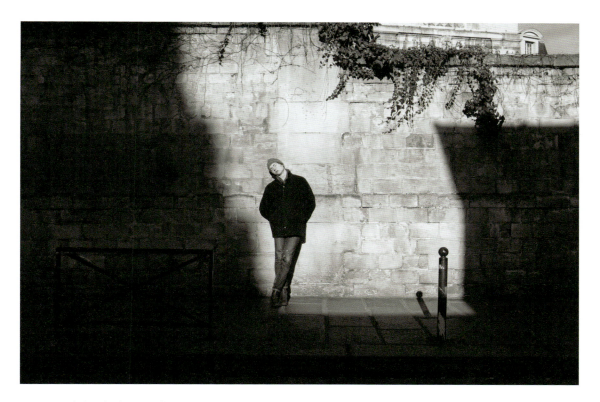

Leaning With the Shadows. Fujifilm X100F 23mm ISO 200 F/5.6 1/750 Sec.

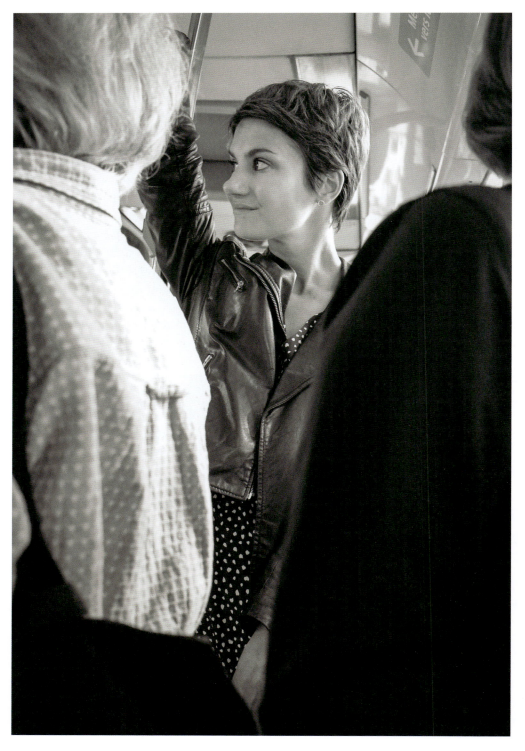

A Smile on the Bus. Fujifilm X70 18.5mm ISO 2500 F/2.8 1/200 Sec.

A Smile on the Bus

It was midafternoon on a warm September day. I rarely take public transportation. I prefer to walk everywhere as much as possible. That day, I took the bus from Le Marais to Saint-Germain-des-Près, where I had an appointment. The bus was incredibly crowded, and I almost decided to walk instead. In fear of being late for my appointment, I decided to brave the crowd and stood in the middle of the bus, camera in hand, watching the passengers come and go.

In public transportation, when people are crowded and uncomfortable, most have a stern look on their faces. There is nothing to smile about, I guess. It's always interesting because, no matter where in the world you are, you can expect to see busy transit passengers with the same facial expressions.

The light was bright on one side of the bus, and I noticed a beautiful young woman with short hair and a bright smile on her face. The moment was too good to pass up. I raised my camera and captured her expression. She is framed between two passengers, which helps convey the crowded and stuffy bus, enhancing the contrast between the discomfort of the situation and the smile on her face. Using the LCD instead of the viewfinder on the camera allows you to be close to your subject without attracting attention or disrupting the scene. Sometimes eye contact can be good, but in a situation like this one, it was necessary to remain invisible to capture the moment. Had she noticed my camera, she likely would have made eye contact, and the smile would have disappeared.

Red Wine. Red Dress. Fujifilm XT-1 35mm ISO 200 F/2.8 1/110 Sec.

Red Wine. Red Dress.

It was a beautiful September evening in Paris. I was teaching a weeklong photography workshop that was nearing its end. When you spend several days with a small group of like-minded people, friendships develop. Many of us often spend our free time together—with cameras, of course! This was one of those days. After walking tirelessly for miles on the streets of Paris, we decided to meet in the evening for a drink, fun conversations and more photography. Place de La Contrescarpe is one of my favorite spots for people watching. One of the joys of life in Paris is to sit at an outdoor café facing the street. Once you have your spot, there's no need to hurry. You can stay for hours, and no one will bother or rush you until you ask for 'l'addition'. When you're a photographer, the time is well spent capturing everyday life while sipping a glass of wine. The beauty of being with other photographers is that no one will be offended if you are enjoying a conversation while taking pictures. We all do the same thing, so it becomes a way of life.

The evening sun was already setting behind the buildings surrounding the Place, where we all sat facing the street in the front row of an outdoor café. We ordered red wine, and I started playing with creative framing using my glass of wine in the foreground and keeping the focus on it while people in the background became blurred abstract figures. This is a fun technique that I use a lot, indoors or outdoors. There are many misses because the background must be interesting enough, the subject still has to be in the right step and in the right portion of the frame. But with a little patience and some luck on your side, a woman in red may just enter your frame next to your glass of red wine! I was using a fixed 35mm (50mm equivalent), and the subject entered my frame relatively close to my table. There was no other choice than to frame her tight. It happened very quickly, and this image is all about the color red, which is also repeated in the background and in her reflection in the glass. The woman's face is irrelevant and unnecessary, and the mystery prevails. Who is this mysterious woman in red? She seems in a hurry to go somewhere. Maybe her lover is waiting at a nearby café to share a glass of wine with her . . .

High Heels on Scooter

Panning is a difficult technique to master. I'm not even sure you can ever master it. But it's a really fun technique to practice any day and in any city. This was on rue des Francs-Bourgeois in Le Marais. It's a busy, trendy shopping street, and there is also a lot of car traffic. It was a beautiful, warm day in late September. Many people were on the streets, and a lot were riding bicycles. I was panning on interesting cyclists, looking for particularly appealing subjects, when this woman rode her scooter down the street. I quickly locked my focus on her and followed her as she rode past, dressed for work and wearing high heels, as if this were common practice. In my opinion, walking in such heels is a feat in itself, but standing on a scooter in high heels while zooming down the street against traffic is nothing short of amazing. The background colors are subtle and not distracting. The person in motion blur crossing on the left adds to the sharpness of the subject. After all, we always look for something unusual when we hit the streets, and I had never seen a woman dressed in business clothes and high heels on a scooter. I doubt this will happen again anytime soon.

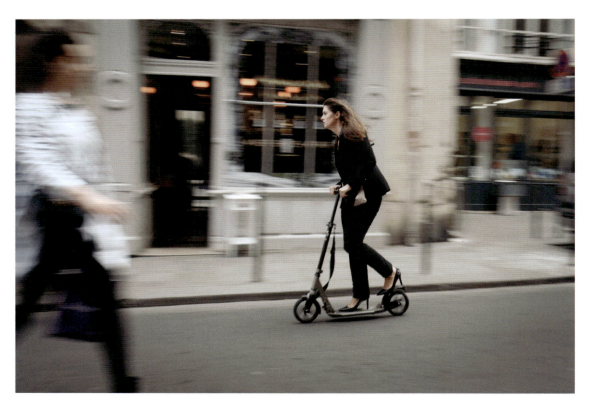

High Heels on Scooter. Fujifilm X70 18.5mm ISO 200 F/7.1 1/30 Sec.

Bicyclist at Saint-Sulpice

It was the first day of October, and after a long stretch of dry, sunny days in the French capital, it rained on my last night in Paris. I walked from the Pantheon to Saint-Sulpice to meet a friend for a drink before going to a gallery reception. I took my time, enjoying the light rain and the new photo opportunities that I had been waiting for all week. I had my small travel umbrella in one hand, my camera in the other. The Place Saint-Sulpice was shiny, and people were hurrying in the rain. I stood there for a few minutes, ready to press the shutter if anything interesting crossed my path. It was getting dark, so I increased my shutter speed to freeze some motion as much as possible, letting the ISO go as high as needed. I'm never worried about noise. It's not an issue, especially with my beloved X100T. It looks like grain and adds to the mood and timeless quality of the photograph. My camera was set in film simulation bracketing. This means that, for every frame, I would have two monochrome JPEGs (one with yellow filter, the other with red filter) as well as one Classic Chrome color. I rarely choose that mode because I like to make the decision of color or B&W before I take the shot, but in situations when both could work, it's a very convenient and fun setting to use. When this man on a bicycle rode by the fountain, I would have been tempted to make it a B&W shot, but when I saw the beautiful muted tones of the Classic Chrome film simulation on the back of the camera, I immediately decided that this would remain a color photograph. It exactly conveyed the mood of the moment, complete with the man's reflection on the wet pavement.

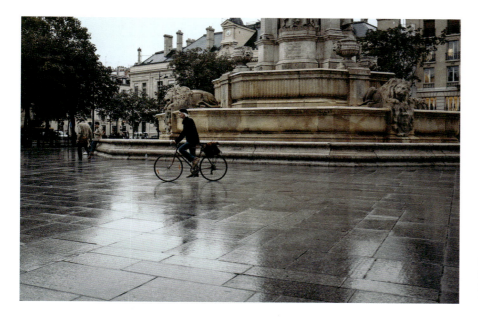

Bicyclist at Saint-Sulpice. Fujifilm X100T 23mm ISO 500 F/2.5 1/250 Sec

In Prayer

Every time I enter a church, I look for something I haven't seen before, such as an interesting subject or beautiful light. It was a bright, sunny day in Paris, and the light filtering through the stained-glass windows of Eglise Saint-Gervais was particularly soft and beautiful. The church was empty except for one nun in prayer in the front of the church. This area, although open to the public, clearly felt off-limits. I am very respectful of that, but the unknown also attracts my photographer's curiosity. I decided to find a way to capture this serene moment that would convey privacy and respect. I was working with 23mm wide angle lens, which made my reach quite challenging. I saw the architectural divider as a perfect frame for the shot. By including it in the foreground as a frame, it immediately conveyed the sense of privacy and respect I was aiming for. Because the light was low, my aperture was wide open. Classic Chrome and its softness perfectly complemented the subject and the setting. I grabbed a couple of frames and left the nun undisturbed in her sanctuary.

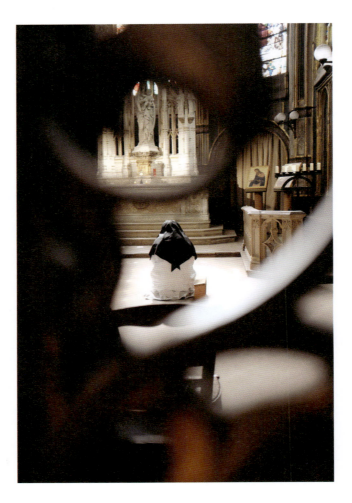

In Prayer. Fujifilm
X100T 23mm ISO 6400
F/2 1/80 Sec.

Blue Nun and Blue Door

What is it about nuns that always catches the street photographer's attention? Maybe it's the timelessness of their appearance, their usually friendly demeanor or possibly the mystery of their lifestyle choice. On that day, I was walking from Le Marais back 'home' on the left bank. I was on a casual walk with my childhood friend, who has grown accustomed to my sudden urges to grab a shot at any moment. As we were approaching an intersection, I spotted a nun in a blue habit out of the corner of my eye. She was walking at a brisk pace toward a blue door. This was my chance. I left my friend midsentence to position myself directly across the narrow street in front of the blue door. I waited one or two seconds until the nun reached the optimal spot and pressed the shutter. Unable to stand any closer without risking getting hit by a car, I decided to crop the photograph into a square. The ugly brown door behind her is rather inconspicuous and not too bothersome. There were more distractions next to it that needed to be removed, which was accomplished by cropping the frame tighter. The bonus element that I didn't see at the time I took the picture was the blue street number sign '14', which creates a triangle of blue and finishes the composition beautifully.

By the time I took the shot, my friend had caught up with me and was smiling, knowing that I had immortalized something special. We continued our conversation and resumed our walk toward the river.

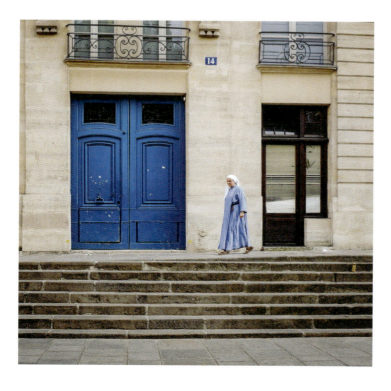

Blue Nun and Blue Door. Fujifilm X100T 23mm ISO 400 F/5.6 1/125 Sec.

Looking Out

Cold temperatures bring new opportunities for the creative photographer. Restaurants and cafés fill up with people wanting a reprieve from the cold, and condensation quickly forms on the windows. This natural filter can be used from the inside looking out or the outside looking in. I was having lunch with a group of students. There was only one window table, and I offered it to two of my students so that they could practice some newly learned skills. I was at a different table with a few others, enjoying a bowl of hot soup and lively conversation. I turned around and saw people walking on the sidewalk through the wet window. I joined my students and stood by their table, camera in hand. Cars are not allowed to park on that street, which made for an even greater opportunity and a stronger composition. The key now was to press the shutter for the right subject without any cars passing on the street at the same time. Within a few minutes and between green lights, I was able to capture two good shots. This one is my favorite. The woman seems elegantly dressed, and she is walking tall. The background is neutral, and her features stand out well. Many people have commented that this frame reminded them of a Saul Leiter photograph. What an awesome compliment—it made my day!

Looking Out. Fujifilm X100F 23mm ISO 2000 F/5.6 1/250 Sec.

The Old Man and the Book

I was very much drawn to windows during my January trip to Paris. And also to color. When it's cold outside, there is always something very reassuring about seeing people inside warm places, drinking coffee or reading a book. It's always challenging to deal with reflections in glass. They can be a welcome addition to the composition when they help create layers. This particular scene was too special to clutter it with unnecessary reflections. There was construction being done on the sidewalk, and some cables were wrapped in bright plastic tubing. It was important to keep that as inconspicuous as possible for the success of the shot. It was also important to get the shot quickly and not to disrupt the scene. I chose to compose from an angle, ensuring that my own reflection would not appear in the shot. The old man has such a beautiful face, and the blue cup and cigarette on the windowsill add interest to the photograph. The viewer's eye wanders for a short moment and then comes back to the man's interesting features. He seems to have a slight smile; I think he knows he is being photographed.

The Old Man and the Book. Fujifilm X100F 23mm ISO 200 F/4.0 1/160 Sec.

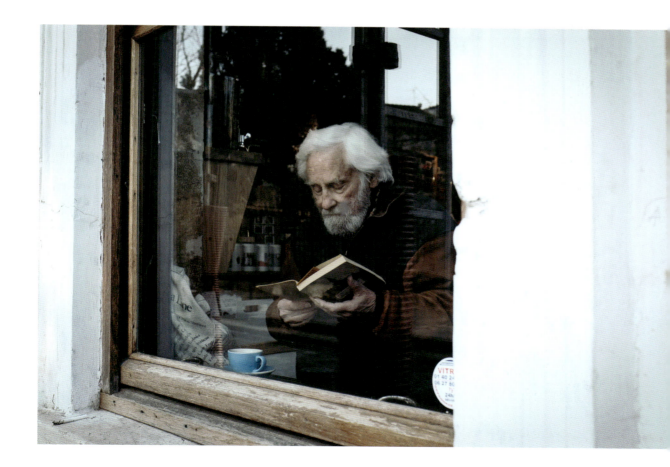

NORMANDY

The Young Nun and the Chapel

Mont Saint-Michel is one of the most visited sites in France. It is also very close to my family home, and I've had the opportunity to visit it hundreds of times. I have also spent the night on the island on several occasions. My favorite time to visit is in the evening after the thousands of tourists have left on the many tour buses. In my opinion, it's the only time to truly enjoy the island. I rarely photograph Mont Saint-Michel. It's hard to come up with something new in such a small area time after time. I carried my camera all evening. It was a family trip. We had just finished dinner on the island and decided to walk around the giant rock at low tide as the sun set. We were heading toward the stone chapel when I saw this young nun sitting on a rock. She seemed deep in thought. It had been a very emotional week in Normandy and around the world: A terror attack had occurred in the region, and a priest in a small Norman town was brutally murdered. I can't help but imagine that this young nun was reflecting on the recent events in this beautiful setting and praying for a more peaceful world.

The choice of color was evident: The nun's robe matched the color of the sky, and she stands out in the gray tones of the rocks. She would have been lost in black and white.

The Young Nun and the Chapel. Fujifilm X100T 23mm ISO 1250 F/4 1/125 Sec.

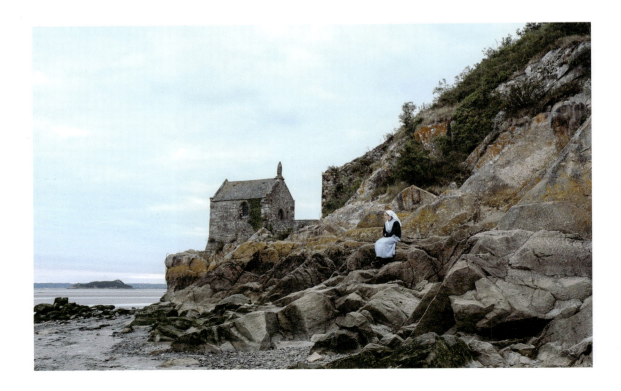

Stripes Among Stripes

There is a lot of humor on the beach. People are on vacation, and they let their guards down. Cabourg on the Normandy coast is a very elegant seaside town, with beautiful hotels and a waterfront casino. It also has a lovely beach with umbrellas and chairs for rent. My favorites are the blue-and-white striped tents. They are very retro and classic. They also make for wonderful subjects with the golden sand and blue sky. Walking around them is a little tricky because they are close together, and many of the people who use them know one another. It's important to be discreet and respectful while exercising some creativity. I was walking along the back row of tents when I spotted an older woman sunbathing in a blue-and-white striped swimsuit! I quickly framed her between the tents and clicked the shutter. Stripes among stripes, I had my shot! Of course, color was a must. This picture makes me smile. Did she realize that she matched her surrounding so perfectly? Did she see the humor in it? Did others see it? I will never know, but she sure made a street photographer very happy with her swimsuit choice that day!

Stripes Among Stripes. Fujifilm X100T 23mm ISO 320 F/5.6 1/1900 Sec.

Feet

Beach photography is challenging because you need to be cautious to avoid being seen as a 'creepy photographer'. It is also very rewarding because situations often lead to humor, one of the most difficult emotions to convey with respect in a still photograph.

I love the consistent spacing and repetition of the blue-striped umbrellas. They also make it very difficult to photograph people in the privacy of their temporary 'enclosures' without drawing attention to yourself. Those challenges make street photography even more fun. It's all about making the most of any given situation to create the strongest possible composition.

Here, my goal was to take full advantage of the stripes and to use them in the frame. I saw two feet and nothing else. I purposely left a lot of the striped canvas around the feet to overpower them for a more humorous effect in the composition. Color was a must, and I chose the timeless Classic Chrome film simulation in camera for this shot. This is an example of incorporating subtle humor into your street photography. The goal is simply to bring a smile to the viewer's face; the story is left to the imagination. Who is the man attached to those feet? Is he reading or sleeping?

Feet. Fujifilm X100T 23mm ISO 200 F/5.6 1/2000 Sec.

The Nap

I love May in Normandy, maybe because it's home, but it's also my birthday month. The city of Deauville is well known for its famous boardwalk and annual American Film Festival. The beach is also iconic, with its colorful umbrellas and canvas chairs available for rent. This spring, the beachgoers were enjoying the first truly warm days before the beginning of the busy tourist season. The chairs and umbrellas rarely get rented on weekdays in the spring, and most stay closed or stacked and used as needed. From the boardwalk, I immediately spotted this woman. She looked very French, with her straw hat and long scarf. She was using the stacked canvas chairs as a backrest for an afternoon nap in the sun. Her neat appearance contrasted with the chaos of the fallen chairs behind her. She was oblivious to her comical posture. She sat with the intention of reading a magazine and soon dozed off in the warm sun. I was shooting with an 18.5mm lens and purposely included the leaning umbrella to add to the sense of chaos created by the fallen chairs. The umbrellas in the background are leaning from the western wind. Being so close, I was careful not to cast a shadow over my subject or anywhere in my frame. I walked around the woman, taking a few approaching shots from the hip. Because my camera was silent and the sand absorbed the sound of my steps, I managed to get quite close. She didn't notice me, but a few people sitting nearby looked amused at what I was doing.

Beach photography usually works best in color, as it often adds to the humor. The situation is funny without ridiculing the subject. It's about finding humor in the ordinary.

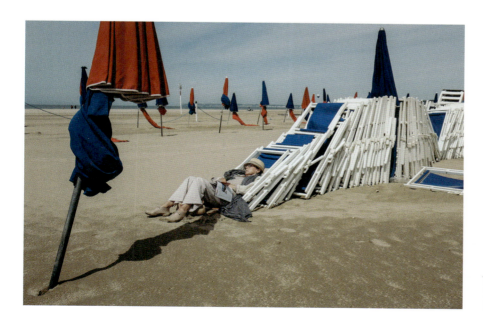

The Nap. Fujifilm X70
18.5mm ISO 200 F/8
1/250 Sec.

Normandy Sunburst

I spend part of my summer vacation at my family home on the Normandy coast in France. I enjoy long walks on the beach every evening. That night was particularly hot, as we were experiencing a rare heat wave in the northwest part of France. The sun was setting, and the beach was still full of families enjoying the cool water and a reprieve from the burning sun.

While taking a break and watching people walk by, I noticed the beautiful golden light on the wooden guardrail along the path that borders the beach for several miles. It made for a perfect leading line, a compositional element that is as important in street photography as it is in any other genre.

A gentleman with a hat entered my frame from the right and paused for a few minutes. A subject with a hat always makes for an interesting silhouette. I placed the camera on one of the wooden rail posts and waited for other people to walk toward me. A couple soon walked by and gave me a balanced composition. The wooden railing leads to them, while the man with the hat is waiting for them. I set my camera to a small aperture to create a sunburst and used exposure compensation to darken the scene. Et voilà!

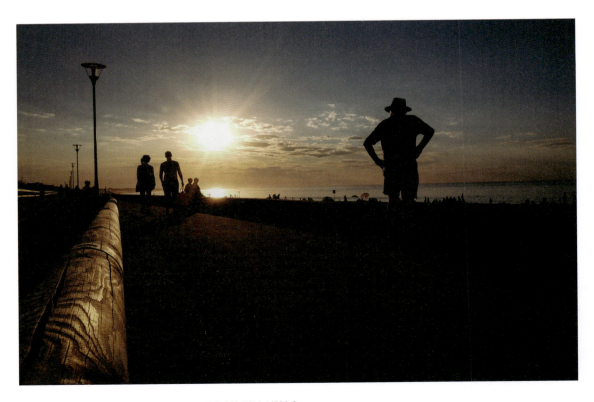

Normandy Sunburst. Fujifilm X70 18.5mm ISO 320 F/16 1/500 Sec.

The Girl and the Bicycle

Working with a creative focus lens such as the Lensbaby Velvet 56 is not easy. It's a fun challenge in creativity, and it beats trying to achieve similar effects in postprocessing. This lens requires manual focusing, and just as important, the choice of an adequate subject for a dreamy look. I never carry two cameras or extra lenses. I make a choice, and I live with it. It was a quiet July afternoon at the beach. I was walking toward the wooden pier when I spotted this young woman and the yellow bicycle from a distance. I immediately visualized it with the dreamy Lensbaby effect. I shot a few frames, trying different focal lengths. The lens was still new to me, so I wanted to make sure I'd get the shot. The trick with the Lensbaby Velvet is that if the aperture is too large, then the effect is too strong. If the aperture is too small, then it doesn't really give the desired effect. I found a happy medium and took a few shots using the camera's Classic Chrome film simulation, which I found very fitting for this particular subject and for beach scenes in general. The girl turned her head for one of the shots, which made it the strongest image in the series.

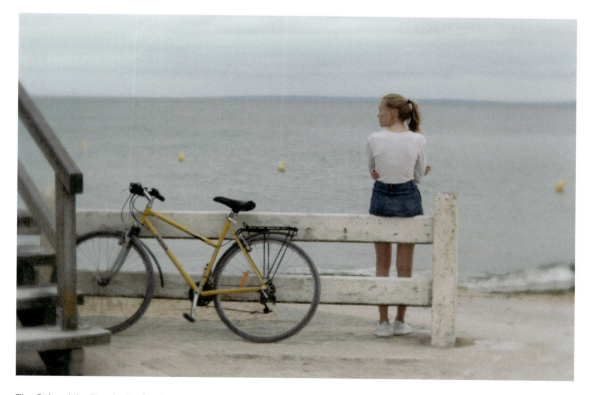

The Girl and the Bicycle. Fujifilm X-Pro2 Lensbaby Velvet 56mm.

The Hat and the Sea

This was near my family home in Normandy. I approached this subject like I would a street portrait. I saw two women sitting along the beach and was drawn to the unusual crocheted hat of the older one. I immediately envisioned the photograph of the hat in the foreground and the sea in the distance. I walked to the women and greeted them. I told them that I was seeing an interesting composition and asked if I could stand close behind the woman with the hat to photograph her with the sea in the background. They smiled and accepted. I took a couple of frames with a different aperture. I also had to include some of the white plastic chair, as the woman was very small, and I didn't want to alter the scene by asking her to move. Authenticity is very important to me, and I intended to immortalize the scene without altering what I saw originally. I didn't want to bother the two friends any longer, so I showed them the resulting image on the back of the camera and thanked them for their time.

The Hat and the Sea.
Fujifilm X100T 23mm
ISO 200 F/8 1/420 Sec.

Smoking on the Pier

There is a long wooden pier in a coastal town nearby my family home in Normandy. The symmetry and lines of the structure can make for interesting shots. There are also fishermen at the end of the pier, and I always make a point to walk to the end with my camera. That day, there were a few fishermen and a retired couple. I walked to them and asked if they were catching anything. They smiled and said they never really caught anything, but they enjoyed the fresh air, as it was better than sitting in front of their TV screen all day like most retired couples do. The woman told me that being so high over the sea at the end of the wooden pier made her feel like she was on a ship in the middle of the ocean. We talked for a while, and they told me they live near Marseille in the south of France but much prefer the Normandy climate and visit relatives often. I asked if I could make a few portraits, and they were pleased to oblige. This photograph was shot after the portrait, when the woman was in a more natural pose, unguarded and smoking a cigarette. The sailor-striped shirt adds a nice touch and a sense of place, as most people who live on the coast own such a shirt. Here again, Classic Chrome was my choice of color for consistency in the beach series.

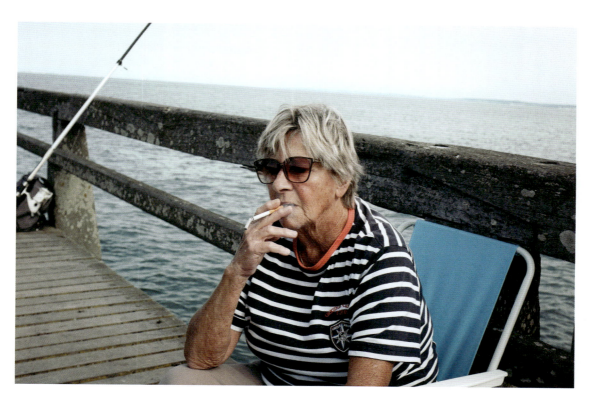

Smoking on the Pier. Fujifilm X100T 23mm ISO 200 F/5.6 1/420 Sec.

The Mysterious Shadow Figure

I was visiting the Abbey of Saint-Etienne in Caen, Normandy, where William the Conqueror's remains are buried. The famous grave attracts tourists from all over the world, so there is a constant stream of people walking through. I wanted to capture something different and decided to use the lit candles as a frame and focal point and to wait for a person to walk along the far wall. The figure had to be caught between the candles and in the correct step. I also wanted to photograph someone who didn't look like a tourist. Although the figure is small and out of focus, a backpack or bright shorts would still be unwanted distractions. Within a few minutes, a person dressed in inconspicuous black clothing walked by. I shot six frames and only this one made the cut. The person is in step and at the correct position, appearing almost as a ghostlike figure. Mission accomplished. I wanted a different shot in a place I had visited often, and I made it happen with some vision and a little bit of patience.

The Mysterious Shadow Figure. Fujifilm X100T 23mm ISO 1600 F/2.0 1/125 Sec.

Grand Hotel

The Grand Hotel in Cabourg is an elegant hotel with classic charm. Its restaurant is equally stylish and grand. I visited the hotel one midafternoon in July. It was between the lunch and dinner service, and the restaurant was empty. One waiter was busy arranging wine bottles on a table. The sheer curtains draping the large windows created a beautiful filter on the scene. The man stood in one place for quite a while, which didn't make for a very dynamic photograph. I knew that he would eventually walk away, and I waited for the shot I was envisioning. Soon after, the silhouette walked through the grand dining room, and I captured this photograph. The man seems to be floating in this timeless scene, as if from a different era. I like the mood of the black-and-white look, as it adds to the classic feel of the scene.

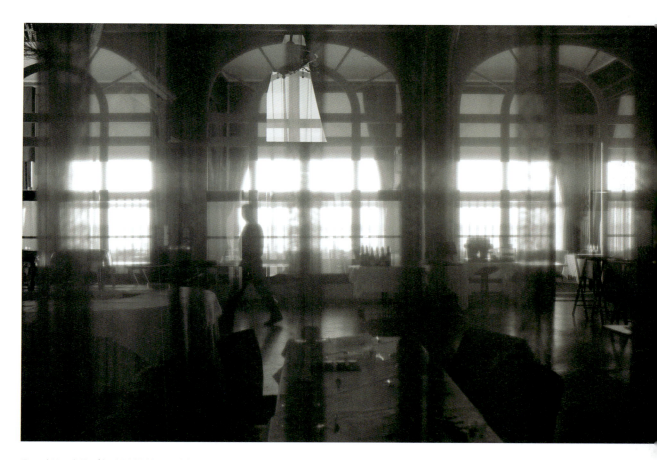

Grand Hotel. Fujifilm X100T 23mm ISO 500 F/2.4 1/125 Sec.

BRUSSELS AND BRUGES

Sister Selfies

I had arrived in Brussels minutes before I took this picture. The apartment I had rented was just a couple of blocks from the famous Grand Place. The beautiful city square is an architectural delight but not the type of place where I usually hunt for subjects, as it is mostly filled with tourist groups. It was late afternoon, the weather was beautiful and Grand Place was packed with tourists. Just as I entered the large square, I saw a group of nuns taking in the sights. I found it amusing that they all had smartphones and were taking selfies and panoramic shots. They almost looked like a group of teenage girls on a field trip, all wearing the same uniforms and sandals. They were so absorbed in the scene that I was able to get quite close and started photographing them both individually and in small groups. I saw the humorous potential in each frame while remaining respectful. This is one of my favorite frames. The composition is well balanced. The women's expressions are priceless; they are clearly having a great time. One of them, in the back, is listening to her friend, who is quite possibly giving her a short course on Flemish architecture. The first subject, on the left, seems to be posing for a selfie. And, as a bonus, they are standing in front of a Godiva chocolate store, which adds another level of humor to the scene.

Capturing humor is one of the most difficult self-assignments for the street photographer. When photographing groups, the level of complexity is much higher than dealing with a single subject, hence making the success of the image even more gratifying.

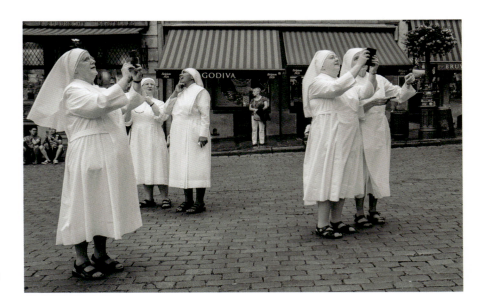

Sister Selfies. Fujifilm X100T 23mm ISO 250 F/5.6 1/125 Sec.

Eye Contact in Brussels

Many street photographers will come really close to their subjects in order to provoke eye contact, snap the picture and walk away. This is not the way I do street photography, not because it intimidates me but simply because I do not enjoy making people uncomfortable on purpose. Also, I would not enjoy being the subject of such a practice.

Yet there are times when this eye contact happens organically. You get so close that the subject senses your presence and looks up. I call this 'candid' eye contact. No harm done, the person simply takes notice of you and your camera. There is no real emotion, yet it's the first acknowledgment of your presence. Most times, there is no subsequent reaction. The picture is taken, and I walk away. If, on a rare occasion, the subject asks if you took his or her picture, then it is very important to stay calm. Remember that you are not doing anything wrong. Let him or her know that you saw a special moment (here I was working on my 'readers' series), show the subject the resulting image, smile and wish him or her a good day. If the subject becomes confrontational, then it is *very* important to stay calm. The worst thing a street photographer can do is to become confrontational. Although you may be within your rights, no picture is worth making someone upset.

This young man noticed me but quickly returned to what he was doing. I walked away without any interaction.

The Eye Contact in Brussels. Fujifilm X100T 23mm ISO 200 F/2.5 1/140 Sec.

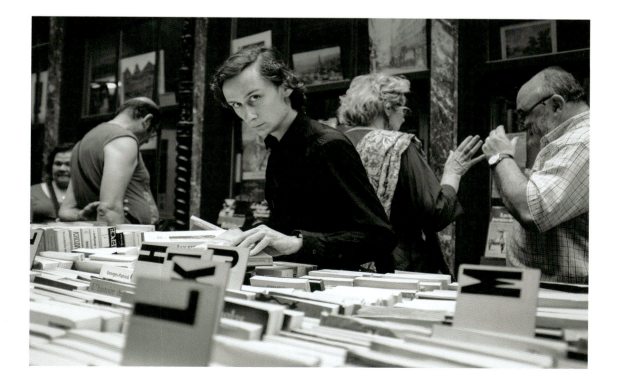

The Contortionist Photographer. Fujifilm X100T 23mm ISO 250 F/5.6 1/125 Sec.

The Contortionist Photographer

Grand Place in Brussels was good to me. It gave me two successful shots in just a few minutes, both humorous in their content.

I usually ignore people taking selfies. They are so common that they almost become a nuisance on the streets. People with point-and-shoot cameras are rare these days. This gentleman struck me immediately by his awkward posture. It immediately reminded me of a pretzel. Moving one step backward would seem like the most logical thing to do, and yet I know that photographers take the strangest postures to get the right frame. This gentleman was asked to photograph a young woman, most likely a tourist, and the subject was standing quite far from the photographer. This made me smile because, unless the camera was zoomed in on her, she would appear quite small in the frame. Framing the photographer and his subject would have been difficult without also including many other distracting elements in the frame. Having only a second or two to react to the scene, I made the decision to include only the photographer, isolating him and leaving the subject of his picture a mystery.

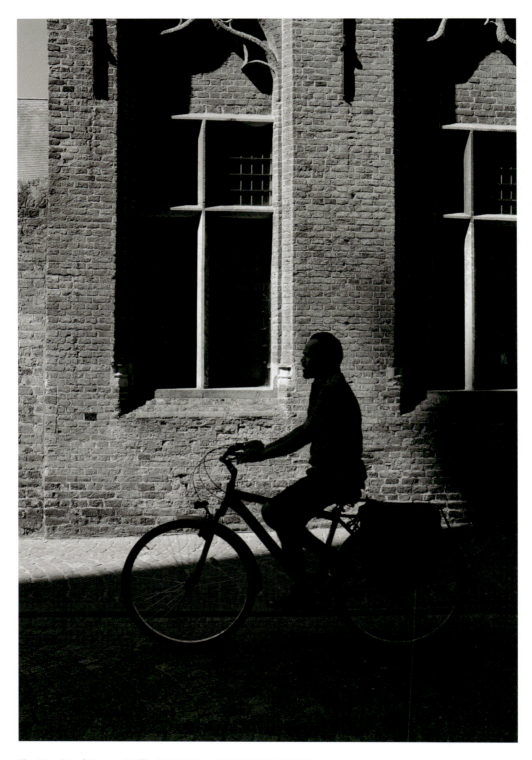

The Bicyclist of Bruges. Fujifilm X100T 23mm ISO 320 F/5.6 1/500 Sec.

The Bicyclist of Bruges

Bruges is a beautiful city. Unfortunately, visiting on a Sunday in July is not the ideal time for the minimalist street photographer. Hordes of tourists take over the lovely cobblestone streets and make for difficult compositions of authentic scenes of everyday life. I wasn't planning on even getting one satisfactory picture that day. Instead, I had decided to enjoy the beauty of the place with my eyes while keeping the camera by my side. It was a family vacation, and during those times, photography takes a back seat. We were walking down that street in the late morning when I noticed the harsh light on the brick building. I decided to wait for a couple of minutes for a lone subject to enter my frame. I told my family that I would catch up and quickly adjusted the settings on my camera. I stopped the exposure compensation down to give the scene the high contrast it called for and increased my shutter speed to freeze motion.

Luckily, this bicyclist entered the frame, and I clicked the shutter at the right moment, framing him between the windows for the best silhouette outline possible. I really like how he sits tall and straight and doesn't wear any distracting elements such as a helmet or backpack. I was satisfied with one shot that turned out to be a keeper and quickly caught up with the rest of my family a couple of blocks away. This is an example of vision and preparation meeting serendipity. Also, the photographer's satisfaction is greater when the shot is captured in a single shutter click.

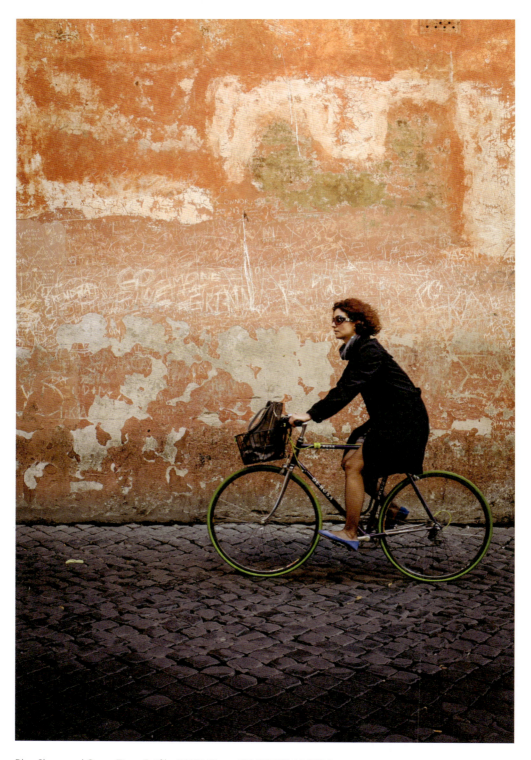

Blue Shoes and Green Tires. Fujifilm X100S 23mm ISO 800 F/5.6 1/250 Sec.

ROME

Blue Shoes and Green Tires

I was in Rome in my favorite neighborhood of Trastevere. If you've ever been to Rome, then you know that it is very difficult not to embrace the colors, even for a black-and-white photographer like me. The rich colors and textures are so often a part of the story in Italy that it would be a crime to remove them. That was the case at this specific location. I was working with a couple of students when we stumbled upon this amazing wall. It was the perfect backdrop! Now we just had to be patient and wait for the right subject to enter the frame. I remember that my students walked away after a few minutes. I was surprised because I had not yet seen any subject worth a shutter click. When I asked them what they had captured, they showed me the backs of their cameras, but all they had was a tourist walking in front of the beautiful wall. I asked them if they thought the subject matched the location and reminded them of the importance of being discerning and to never settle. We had discussed the importance of capturing authenticity and that coming home with memory cards filled with pictures of tourists would not be very satisfying.

In my opinion, a backdrop such as this one is well worth a thirty-minute wait—or one much longer!

Within ten minutes, this woman on an Italian bicycle with green tires pedaled through our frame. Elegantly dressed, wearing blue suede shoes, she was the perfect subject. Never settle for the first person who walks by; a better subject will soon appear. Lesson learned for my students.

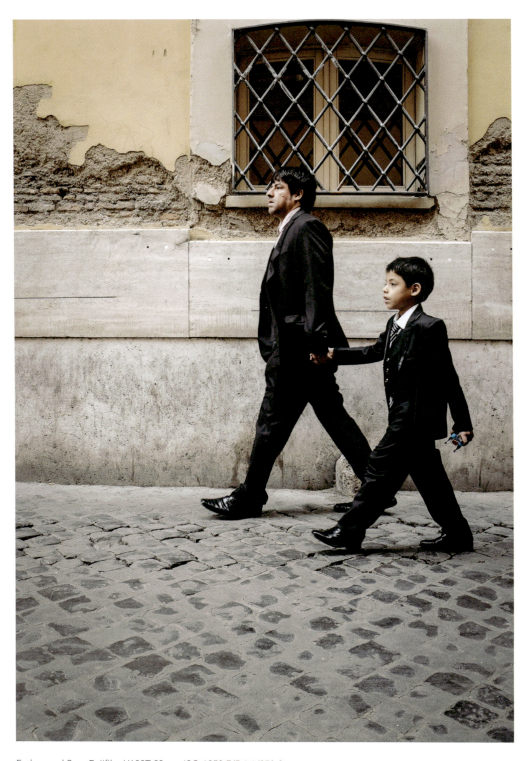

Father and Son. Fujifilm X100T 23mm ISO 1250 F/5.6 1/250 Sec.

Father and Son

On a different day in Trastevere, I was having lunch with a good friend outside a wonderful pizzeria. We had specifically picked a table on a lovely narrow street because we are photographers and lunchtime is no reason to put the camera down. Having my camera ready at all times is so important to me that I can only compare it to the security blanket that a toddler carries around 24/7. Thankfully, my family understands that need. My friends are mostly photographers, so they feel the same way. My friend and I were enjoying a conversation while scanning the street for interesting subjects. Fortunately, I was facing the side of the street from which this father and son suddenly appeared. I was shooting with a 23mm focal length but had my camera turned vertically, since the street was so narrow, and I didn't want to risk cutting my subjects' feet or cutting too close. It is important to leave enough space to 'ground' your subject whenever possible and to plan for the possibility of someone walking much closer to you than you'd expect. This father and son pair, dressed identically, was too good to miss. I can capture the right stepping for a single person, but I have no control over the synchronicity of the movement when two people are walking side by side. Luck was on my side because father and son were in sync and walking at a fast pace. I pressed the shutter, grinned and ate another slice of pizza. My friend smiled. He was facing the other direction and knew I had nailed the shot. It was the first day of a photographically rewarding week in Roma!

Tie Your Shoes

One of the appeals of street photography is that we never know what is going to happen when we turn the corner. The constant search for something different keeps us going mile after mile, day after day.

I was exploring the streets of Rome with a photographer friend when this sharply dressed Italian man stopped near us and casually raised his foot on the backrest of a park bench to tie his shoelaces. I had never seen anyone tie his or her shoe this way before, hence the immediate interest. Why the backrest and not the seat? Was it out of respect for the next person who was going to sit there or simply because the bench was turned this way? Did the man want to draw attention? At that same moment, a pigeon walked into the frame and added a nice touch to the overall scene. This was a color photograph, as the tones of the textured wall added a definite sense of place to an ordinary moment.

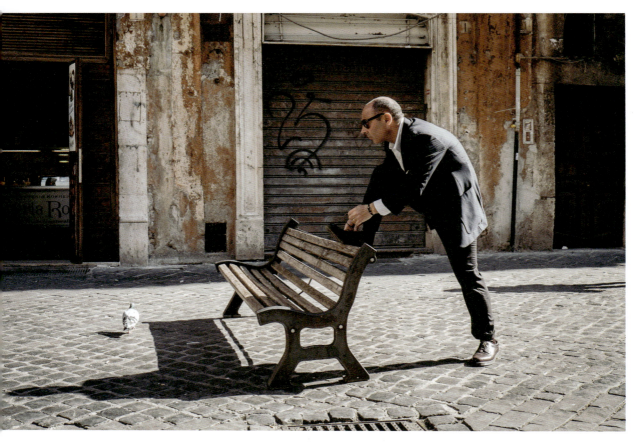

Tie Your Shoes. Fujifilm XT-1 27mm ISO 200 F/5.0 1/200 Sec.

A Roman Sun Shaft

It was April, near the Spanish Steps in Rome. Not wanting to fight the crowd near the main attraction, I wandered the side streets in search of more authentic Italian scenes and people. It was early afternoon, and the sun was casting shafts of harsh light on the sidewalk. I was looking for a plain backdrop with a shaft of light and came upon this doorway with no distraction from signage or graphics. It was the perfect stage to wait for a local to walk by. Shafts of light do not last very long, so I kept my fingers crossed that someone interesting would enter my frame relatively soon. Within a couple of minutes, an older woman with light-gray hair walked by. I was counting steps to catch her at the right moment just as she looked sideways and glanced in my direction. I pressed the shutter, capturing the right stepping motion and the eye contact. Although I never provoke eye contact with my subjects, it's a plus when it happens spontaneously. This was my shot of the day!

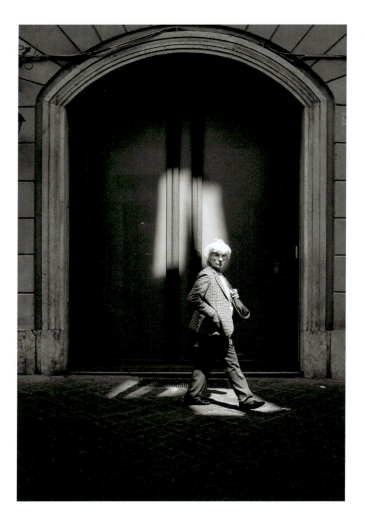

A Roman Sun Shaft.
Fujifilm X100T 23mm
1/250 F/5.6 ISO 800.

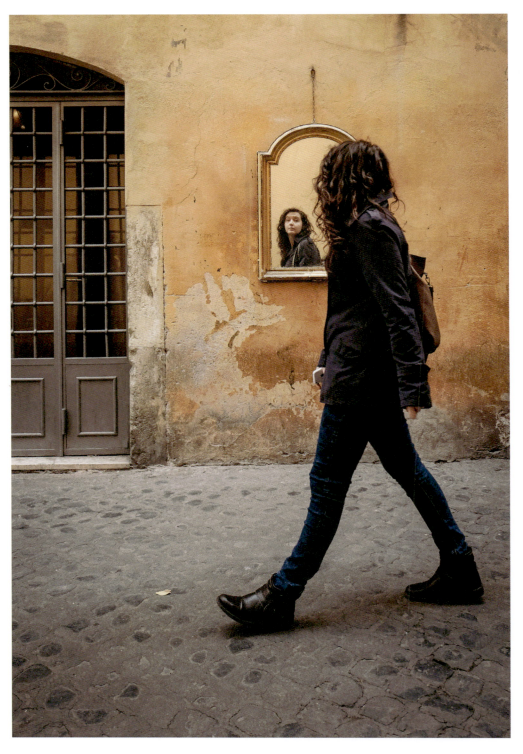

Mirror, Mirror on the Wall. Fujifilm X70 18.5mm ISO 1600 F/5.6 1/500 Sec.

Mirror, Mirror on the Wall

Roma, Italia! One of my favorite streets, near Campo de' Fiori, has an interesting mirror on a wall. I have always wondered who put it there and whether they take it down at night. I've taken a few fun selfies in that mirror. But I knew it was going to offer me something special eventually. When I teach a workshop, I have very little time for my own photography. I try to spend at least an hour before and after the scheduled photo walk to wander on my own. I was staying only a few blocks from the mirror on the wall and made a point to visit it regularly in the hope that it would eventually reveal its secrets. My week in Rome was drawing to an end, and I made one last visit to the mirror. I had a few minutes with a wide-angle 18.5mm lens and stood across from it. This is a very narrow street, barely wide enough for a small Fiat. My lens was not wide enough for a horizontal shot without risking cutting off the feet of my subject. The solution in that case is always to switch to a vertical shot. It gives you more leeway if the right person walks closer to you than you expect. I often have to remind my students of this technique. For whatever reason, most photographers rarely turn their cameras to the side.

I watched the pedestrians, ready to shoot. The street is located near the daily market at Campo de' Fiori, one of Rome's many tourist attractions. My intention was not to photograph a tourist but a local or someone who didn't look like a typical tourist. Within a few minutes, this young woman walked by with no one else in the frame. As a bonus, she made eye contact in the mirror at the right moment and in step. Was I a happy photographer at that moment? I'll let you guess . . .

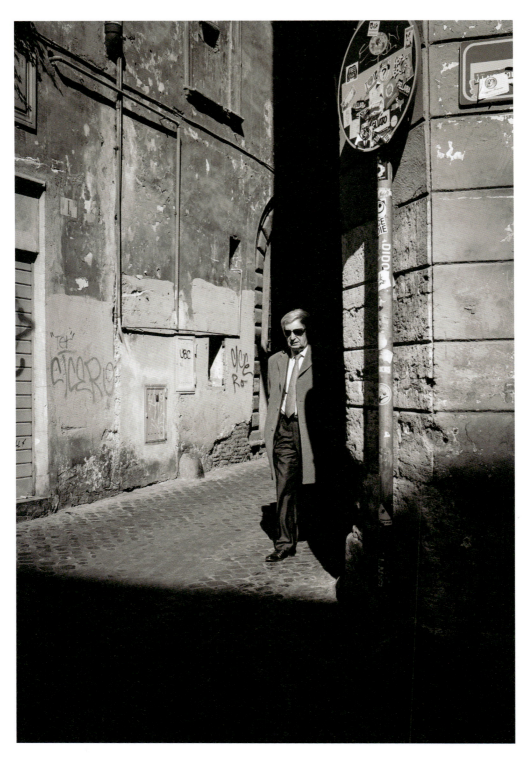

Into the Light. Fujifilm X100S 23mm ISO 400 F/5.6 1/900 Sec.

Into the Light

Rome is a feast for the eyes, and every street is more interesting than the next. It is also possible to escape the tourists and to find some authentic Roman street life by exploring less-traveled neighborhoods. I avoid tourist attractions as much as possible when I travel, especially during the high season. I'm not interested in fighting entire busloads of tourists to get a quick glimpse of an art piece. If I can't enjoy the sight peacefully, then I don't go. I much prefer to casually stroll the quiet streets that are off the beaten path, talk with the locals and catch slices of everyday life in a more authentic Rome.

I had just left my students after a morning photo walk when I spotted this narrow street where people were emerging from the shade, and for a brief moment, into the light. I had found the stage, but that was the easy part. Next came the task of waiting for the right subject and not settling for just anyone. There were very few people coming down that street, and from the angle where I needed to stand to get the right shot, I could not see down the street. I stepped into the shadow street to take a quick look and saw a potential subject in the distance. It looked like a gentleman in a trench coat, definitely not a tourist. I quickly gauged the distance, timed the pace by counting, ran to the ideal point of view and waited a few seconds, ready to fire. My camera was set on burst mode to give me an additional edge in case the subject was indeed interesting. I fired as soon as the subject stepped into the light. This is the third shot in the series and the strongest one. I was still shooting RAW that year, and while Rome is a colorful city, I converted this photograph to black and white because the blue-and-red street signs above the subject grab your attention and compete with the human element. Removing the color brings your attention back to the subject.

I was quite pleased with this photograph. The mysterious man with sunglasses is very Italian, and I had to wait only a few minutes for him!

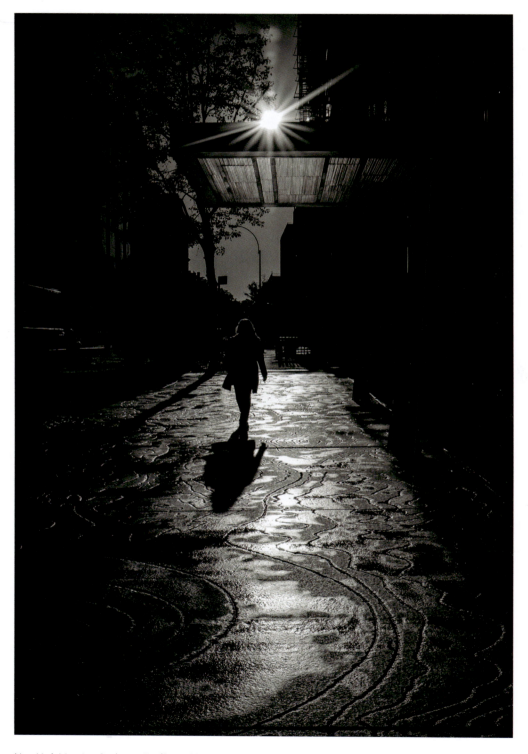

New York Morning Sunburst. Fujifilm X100T 23mm ISO 400 F/16 1/1600 Sec.

NEW YORK CITY

New York Morning Sunburst

I was walking from the Lower East Side to the Javits Center to give a presentation at the PhotoPlus Expo on a beautiful October morning when I noticed the sidewalk's unusual texture. The water on the freshly washed pavement enhanced the patterns. I could not believe my luck. It felt like I was given a gift, and I could not pass up the opportunity. I quickly scanned the scene to see the best way to take advantage of the shiny patterns. The awning above the doorway made a perfect barrier for the bright sun and allowed for a sunburst effect. All I needed was a good subject to walk on the backlit sidewalk. Standing in the middle of the sidewalk was not an option. Anyone seeing a photographer there would either duck to get out of the shot or walk on the edge of the curb. I positioned myself in a way that would not prompt passersby to leave my frame and waited for a good silhouette subject. Several small groups of people walked through, but such a narrow location called for a single subject and enough separation to make the body shape stand out. Within minutes, and before the sun dried the pavement, a woman walked toward me. The sun created a nice light around her hairline, which offered some separation from the dark background. I caught her in an elegant stepping motion, with her arm nicely separated from her body. The sunlight on the pavement gave her a pathway, and the sunburst made the image stronger. All the elements came together in a fraction of a second.

I was distracted so many times by amazing photo opportunities during my walk that day that I never made it on foot all the way to the Javits Center. I hailed an iconic yellow cab and made it to my presentation just in time!

Competition on 5th Avenue

This photograph is an example of interconnection in street photography. 5th Avenue in New York City offers a myriad of photo opportunities but also the challenge to tell a story without having a hundred people contaminate the frame. Isolating your subjects on a busy street can be very difficult. I saw the store mannequin 'looking' at people on the sidewalk at eye level. I really liked the sunglasses and thought of different possibilities that could work, such as a subject with similar glasses or another elegantly dressed woman. I had my stage. Now I had to be patient, discerning and ready. I spotted this good-looking man with similar glasses coming rapidly from the right, accompanied by a woman. I caught just the right moment when both the mannequin and the woman appear to be checking him out, possibly competing for his attention. Ironically, he seems to be ignoring them both. It's very New York!

Competition on 5th Avenue. Fujifilm X100T 23mm ISO 1250 F/5.0 1/250 Sec.

The Window

The Lower East Side, now a trendy part of Manhattan, remains gritty and mysterious at night. I was walking back to my hotel after dinner with friends when a mysterious silhouette appeared at one of the lit windows. It's a man, perfectly framed within the sheer curtains. He appears to be leaning with one arm against the window frame, possibly observing the windows across the streets. He seems to be holding something in his left hand. A cigarette? A glass of wine? Binoculars? Is he watching me?

The focal length with which I was shooting prevented me from getting closer and isolating the dark buildings from the brightly lit store below. I cropped and straightened this photograph to give it more impact. This is the framing I envisioned. A dark, Hitchcock-like story in a once very different neighborhood.

Being a street photographer is a bit voyeuristic. As a child, I was very curious when I saw people inside their brightly lit houses at night. Maybe it was because of the added mystery of the dark. It always seemed to me that secrets were being kept, and I wanted to uncover them. Today, I can't help doing the same thing in the hope of seeing a mysterious shadow looking back at me.

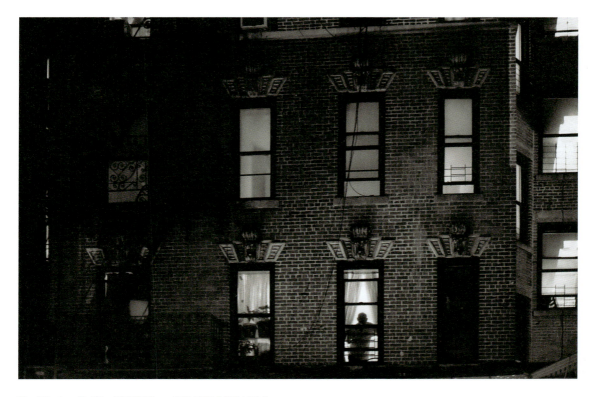

The Window. Fujifilm X100T 23mm ISO 6400 F/2.0 1/40 Sec.

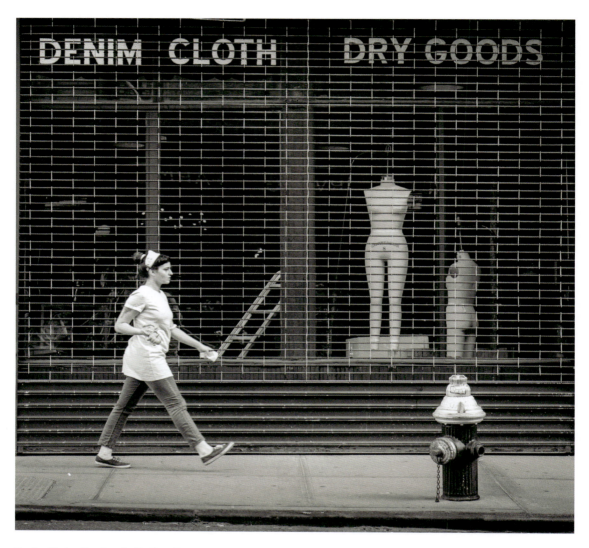

Denim Cloth—Dry Goods. Fujifilm XT-1 40mm ISO 1000 F/4.5 1/240 Sec.

Denim Cloth—Dry Goods

I was teaching a workshop in New York City. It was a Sunday morning in mid-October on the Lower East Side of Manhattan. The streets of New York were just waking up. We decided to start the day with a good cup of coffee from one of the independent coffee shops that flourish at each street corner of this now-trendy neighborhood. The line was long, and while I waited for everyone to get their orders, I stood on the sidewalk with my camera.

I had noticed the storefront across the street. No photographer would miss its retro look, with the ladder and naked mannequins in the window. It was such a quiet morning that I wondered if anyone interesting would walk by in the next few minutes while I waited for my students. A few minutes earlier, I had seen a young woman walking hurriedly on that same sidewalk. She was wearing a uniform you'd expect to see in a deli back in the 1950s. The timeless look appealed to me and fit well with the storefront. I thought that, with any luck, she would be back.

Within a few minutes, she came around the corner carrying mini pumpkins, probably to use as Halloween decorations. She was walking at a fast and determined pace. I had enough time to frame and grab the shot in stride, just before her heal touched the ground. Luckily, her arm makes a line with the ladder in the window. The ladder itself makes a triangle with the mannequins and down to the fire hydrant. The triangle of her legs is repeating the elements within the frame. Triangles make strong compositional elements. The combination of the strong subject, the interesting elements in the frame and the triangles all make this photograph particularly interesting. The subject is in slight motion blur, which is not a bad thing either. It emphasizes the speed at which she was walking. She was probably on a short break from work and was now returning. This shot definitely made my day. I knew I had something special.

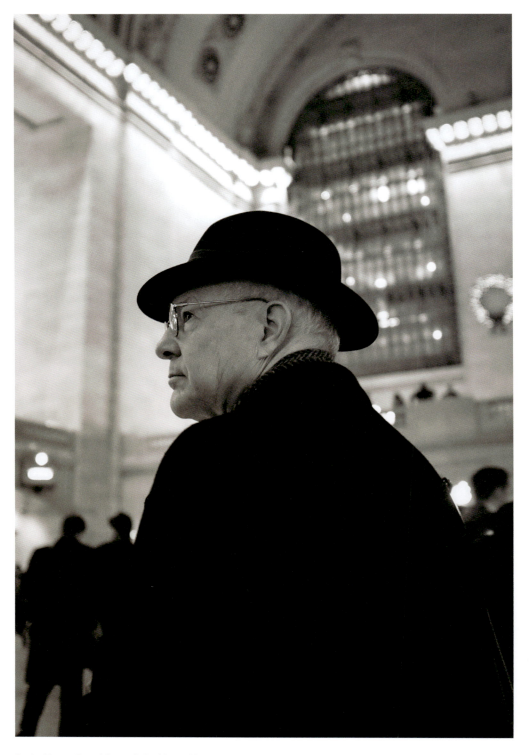

Derby Hat at Grand Central. Fujifilm X100T 23mm ISO 6400 F/2.2 1/60 Sec.

Derby Hat at Grand Central

New York, like Paris, has the ability to draw my eyes to timeless subjects. It almost feels like they are there just for my camera. For hours and hours, I can focus my attention exclusively on such elegant and classic subjects, as if no one else existed around them. I've noticed this phenomenon only in Paris and New York. It's almost as if these two amazing cities are trying to compete with each other for my attention by carefully planting the subjects that would draw my photographer's eye. Is it a conspiracy between the cities or simply my creative vision listening to my heart?

I was meeting a friend at Grand Central Terminal. It was December, and New Yorkers often wear beautiful timeless winter coats and hats. I saw this gentleman immediately. No photographer would miss a potential subject with such a hat. He was looking at the schedule on the wall, and I took advantage of the crowd to get closer without drawing attention to myself. I wanted to include both the architecture and the other passengers around him in my frame, but it was also important to keep him isolated. I chose a low angle for that very purpose. By doing so, the architecture of the iconic landmark was very much visible. A large aperture gave me the shallow depth of field needed to make him stand out while still allowing the background to be recognizable. The other passengers, also dressed in black, are very much a part of the scene, even while being out of focus. He turned his head, and I pressed the shutter. This photograph could have been taken fifty years ago. It has that classic New York timelessness that I am very drawn to.

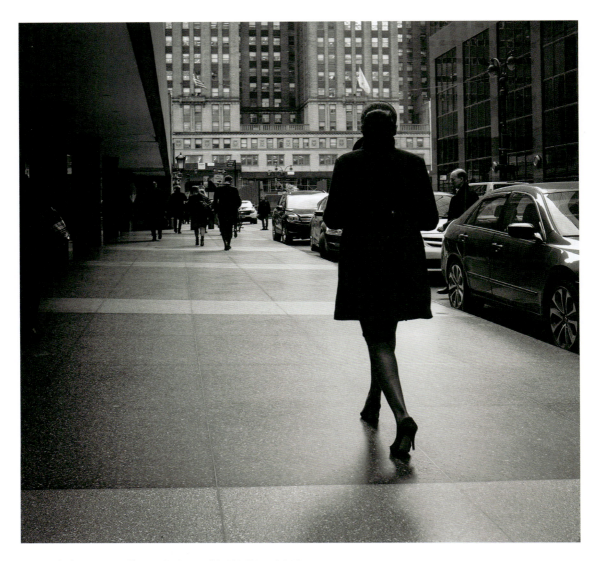

New York Elegance. Fujifilm X100T 23mm ISO 800 F/5.6 1/125 Sec.

New York Elegance

That same afternoon, as I was leaving Grand Central with my friend, another classic New York scene presented itself. My friend, a former workshop participant, and I had just reunited and were chatting away as we made our way from Grand Central to Bryant Park. We had just stepped out of Grand Central when this elegant woman passed us to the right on the sidewalk. I had already changed the settings on my camera and was ready to fire. I quickly followed the woman on the sidewalk and captured this photograph. Photographing people from the back can be very effective when the subject is particularly interesting. This elegant woman was the perfect subject. Fortunately, the large sidewalk was not crowded, and the only other people in the frame are quite far away. She is in harmony with the architectural backdrop. Only the cars reveal the time period, but they are not a distraction in a black-and-white setting. I cropped this frame into a square in Lightroom to lose some of the cars, and I darkened the left side to remove some other distractions. These classic subjects clearly represent what has drawn me to black-and-white street photography for years.

The Mystery Woman at Grand Central

Grand Central Terminal is just like a busy street corner. It's the perfect place to let people come to you. Because such an amazing variety of interesting people pass through the main hall, there is no need to keep walking endlessly. Just find a good spot or shaft of light and observe. I was doing just that when this woman walked by me. Her large hat obstructed her eyes. Her clothes, makeup and nail polish reflect her elegance, yet surprisingly, she doesn't wear any jewelry. She is walking out of the frame, which adds to the rushed feeling. Her hand at her neck conveys a feeling of uneasiness. Is she late for her train or escaping something or someone? The mystery remains intact, and that is the beauty of street photography. The viewer is invited to enter another world, one that is both secretive and exciting.

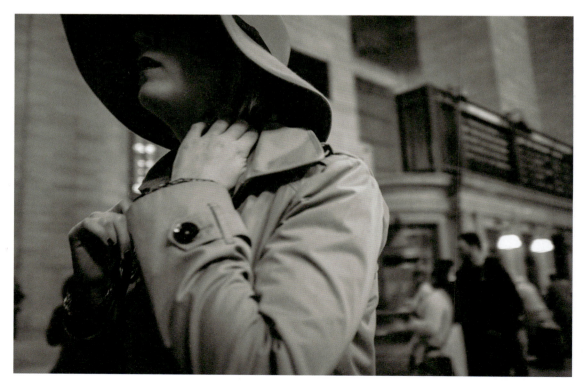

The Mystery Woman at Grand Central. Fujifilm X100T 23mm ISO 2000 F/2.0 1/125 Sec.

Ready For Departure

This was on the same Friday afternoon as the mystery woman with the hat. It was my lucky day, as another mysterious woman crossed my lens a few minutes later. I was walking along the tracks just minutes before a train was scheduled to leave the station. After passing dozens of train cars filled with passengers looking at their smartphones, I finally encountered a subject of interest. This elegant blond woman, clearly hiding her age behind large sunglasses, made eye contact as I photographed her looking out the window. She was traveling alone, possibly going to her country home in the Hamptons for the weekend. In the seat directly behind her is another beautiful woman, younger, with dark hair, which makes a nice juxtaposition in the composition.

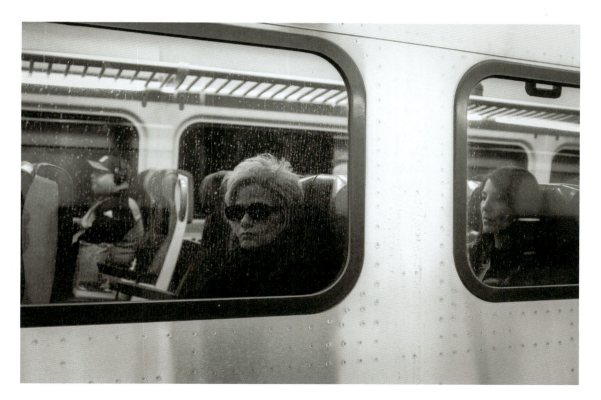

Ready For Departure. Fujifilm X100T 23mm ISO 3200 F/2.0 1/125 Sec.

High Heels in the Light

On sunny days, the main hall at Grand Central offers spots of light that catch the attention of light seekers like myself. At a certain angle, those spots are quite small and require some creative thinking. That day, I decided to get down to the ground and to look for interesting legs instead of faces. It's amazing how people ignore you when they are in a hurry or too busy looking at their smartphones. I was on the floor and had positioned my camera to catch the next interesting person who passed by when a woman in a dress and heels walked through my frame. There is movement in the dress, the iconic clock in the frame gives a sense of place and the anonymity of the subject and the deep shadows add mystery.

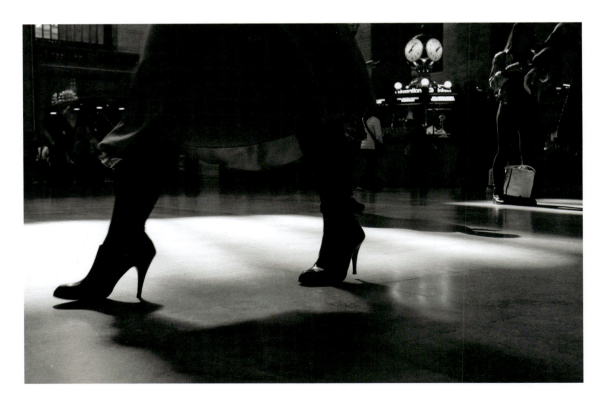

High Heels in the Light. Fujifilm X100T 23mm ISO 2500 F/4.0 1/125 Sec.

Face Mask and Trapper Hat

Riding the New York subway is something a street photographer could do all day and never get bored. Just like the Paris metro, the subway sees people of all walks of life and socioeconomic backgrounds.

When using public transportation, I make a point to look for interesting faces, juxtapositions, humor, interconnections or anything else unusual. The quest is challenging, as most passengers are busy texting or keeping up with their many social media streams. The search becomes a treasure hunt.

That day was particularly busy. I had already set my camera to black and white and a large aperture in hopes of finding a 'nugget' in the crowd. Just before the doors closed, I saw this young man, carrying a large suitcase, step into the crowned train. He was a sharp dresser, with a shirt and tie and a vest and suit coat. The combination of the trapper hat and face mask made me smile. He was obviously a tourist who was prepared to brave the New York winter while keeping the germs at bay during flu season. The funny part was that the hat was meant to be worn with an equally warm winter coat. His suit jacket didn't seem quite warm enough to match the hat. The woman with the scarf helps make this photograph work. She is looking at him as well, and the viewer is drawn from the main subject to her eyes and then back to him before jumping to the man in the lower right corner of the frame. The triangle makes the compositional elements flow well together.

Face Mask and Trapper Hat. Fujifilm X100T 23mm ISO 2000 F/2.0 1/125 Sec.

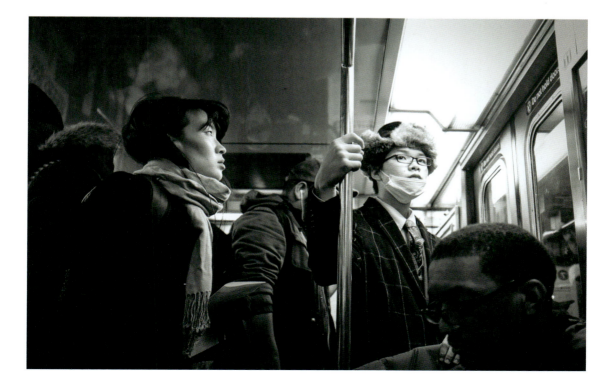

Stranger in the Night

I was walking with a small group of students, demonstrating how to use available light on the streets, when I spotted this nice young man leaning against a brightly lit store window. I approached him and asked if he would be our model to demonstrate the use of window lights in night street photography. He was a bit surprised by the request but quickly agreed to let several students experiment with the technique. The most common response from people on the streets when you ask to photograph them is an expression of surprise. Once you tell them why you find them interesting, they are always flattered. My students got to practice a newly learned technique, and we made someone's day in the process. It was a perfect street portrait experience for all. I took this photograph by positioning myself in a way that lit only one side of his face, while the other remains in shadow. After looking at the main subject, the viewer's eye then wanders through the frame and down the street to the human figures in the distance and the unfocused city lights.

Stranger in the Night. Fujifilm X100T 23mm ISO 6400 F/2.8 1/80 Sec.

Pause in Symmetry

It was my first time at the Lincoln Center in New York. I had just left the Smith restaurant across the street and decided to wander in search of a frame or two. Nighttime photography offers many wonderful opportunities in a city. The bright lights from stores and businesses are like giant studio lights. It's the perfect time to look for the right backdrop for a good silhouette shot. The Lincoln Center offers some great opportunities, all very symmetrical. I saw this old man with a cane enter my frame. Luckily, he was not walking very fast. I had the time to run ahead and to compose my shot in a way that would be uncluttered and allow him to walk through my frame. This photograph works for two reasons: The location is beautifully symmetrical, and the subject is unusual. The cane is the element that adds interest to the scene, and the subject almost looks like he paused to catch his breath.

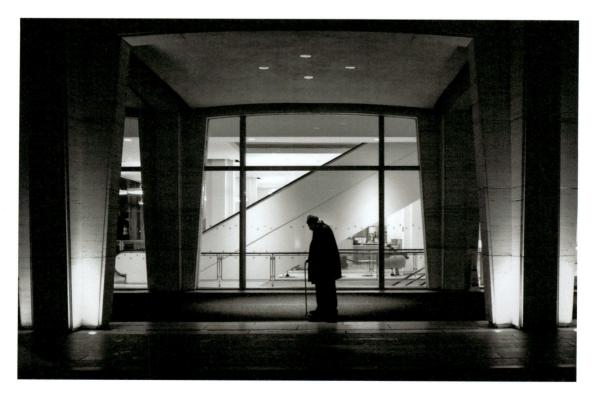

Pause in Symmetry. Fujifilm X100T 23mm ISO 3200 F/2.0 1/125 Sec.

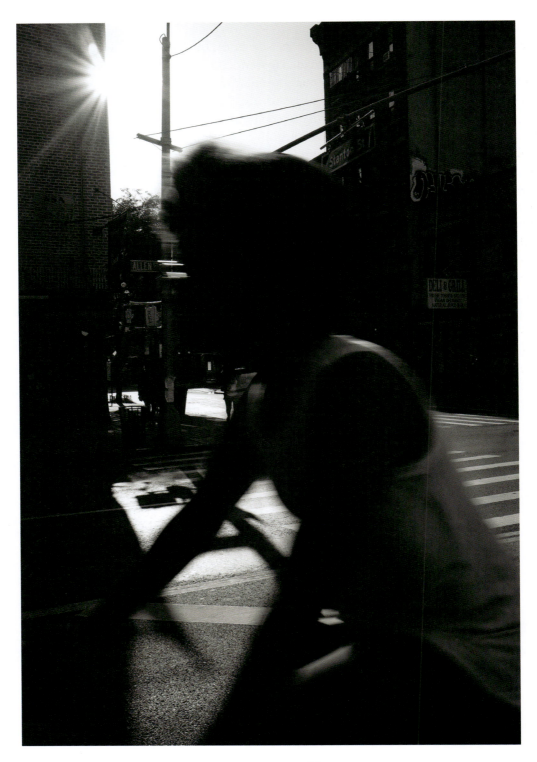

New York City in Motion. Fujifilm X100T 23mm ISO 200 F/13 1/170 Sec.

New York City Motion

The sun was still low in the sky that morning in October as I walked toward the classroom space I had rented to kick off my New York City photography workshop. I had my coffee in one hand and my camera in the other. I kept looking behind me at the brightly lit street, wishing I had the luxury of a few minutes to photograph before going inside to begin my presentation. Wherever I need to go, I always try to allow myself a few extra minutes on the streets to avoid feeling frustrated about missing interesting shots. I am always on time, usually early. I don't like to wait, and I don't want to make people wait for me. I finished my coffee and scanned around me. A busy bike path lined the parkway where I was standing. Cyclists where going by very quickly. I decided to try to capture some action with a sunburst in the background. I was standing between two rows of buildings, which allowed me to obstruct the sun just enough to achieve the desired effect. A cyclist, wearing a white sleeveless tank top, zoomed right in front of me. I quickly pressed the shutter the moment before she reached the dark side of my frame. She is a blur, which creates the feel of speed. The sunburst adds a nice touch above her head. The sun illuminates the top of her thigh. Her face is barely defined in the blur and mixed light, but there is an emotion, a timelessness, that particularly appeals to me in this image. It is complex in its simplicity. Had this photograph been sharp, it probably would have lost all interest. This is a good example of emotion winning over technical perfection, which is always the case in this type of photography.

Invisible Chef

The Chelsea Market is bustling with people in December. It's an urban food court and shopping mall that takes up an entire block in the meatpacking district of Manhattan. It attracts foodies from all over the world and is one of New York City's top attractions. Not being much of a 'crowd photographer', I wasn't expecting to shoot anything exceptional during my short visit, but it's always good to keep an open mind and a camera ready to fire. I walked by the entrance of an Asian restaurant and saw the cooks behind a clear glass. What caught my eye immediately was the steam coming from the pots and the condensation forming on the glass. If I could manage a shot without reflections in the glass, then the photograph could potentially be very interesting and unusual. I stood in front of the glass for a few seconds and waited to isolate just one cook and capture an interesting gesture. I grabbed a few shots, and this is the one that worked best. The chef is alone and well defined, the face is hidden in the steam and condensation is dripping on the glass just in front of the hidden face, giving it an eerie look. The hand gesture conveys some action.

Because the inside of the kitchen was brighter than where I was standing, there is no reflection in the glass, which helped make this photograph work. The viewer doesn't see the glass and is perplexed for a moment by the presence of condensation in front of the subject's face. This element made the photograph work particularly well.

The invisible chef remains one of my favorite pictures of my December visit to New York City, and it was shot in one of the most unlikely locations for me.

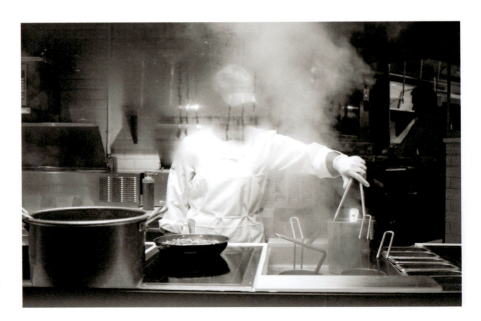

Invisible Chef. Fujifilm X100T 23mm ISO 800 F/2.0 1/125 Sec.

Sisters on the Boardwalk

Visiting Coney Island may seem like a crazy idea in December, but I had such a great first visit. It was not very cold for a December day; there was no snow in New York yet. But it was cold enough to keep most of the tourists away, which was a bonus.

I knew that Brighton Beach was heavily populated by Russian immigrants. Most came to New York City in the 1940s and 1950s. What I didn't expect was to hear the Russian language almost exclusively. In fact, I tried to have a conversation with several of the elderly people who were out for a stroll on the boardwalk, and several knew no English at all. This enhanced the timeless feel of the experience for me.

I quickly decided to shoot in B&W because there was very little color, and I found monochrome fitting for the dreary winter day. Also, because the boardwalk patterns were so interesting, I chose to shoot several of the frames from a very low angle.

As soon as I arrived on the boardwalk, two similarly dressed elderly women walked by. They were talking and listening to a small radio or tape player. The scene was so surreal. It felt like I was time traveling. I was not only photographing in black and white but also seeing the world around me in monochrome. The two women, maybe sisters, are in step and undisturbed by the world around them. Are they telling each other childhood stories from the 'old country' in their native language? Or simply sharing anecdotes about the grandchildren born and raised on the new continent?

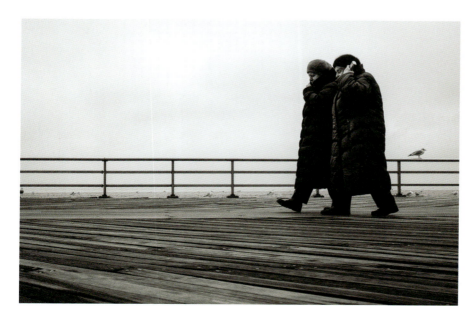

Sisters on the Boardwalk. Fujifilm X100T 23mm ISO 200 F/5.6 1/280 Sec.

The Man and the Bird

The amusement park at Coney Island was shut down for the season, but crooners' Christmas music was streaming from the speakers on the deserted boardwalk. It was an eerie atmosphere.

There is a large pier located directly across from the amusement park. There were a few fishermen and a couple of lost tourists on the pier on that cold December day. I had nearly reached the end of the pier when I noticed a nicely dressed man sitting on one of the benches directly below a lamppost with a seagull on top. I found the scene amusing because we all know how much damage a seagull could do to a nice winter coat! The man was resting, maybe waiting for someone. He seemed comfortable and most likely oblivious to the peril looming overhead. Without drawing attention to myself, I walked closer to get the best possible composition. I snapped an approaching shot from a side view. The man was looking to the horizon. To include the seagull in the frame, I could get only a vertical shot. As I moved behind the bench, the man spread his arms over the backrest and leaned his head back. I shot another frame. The seagull remained undisturbed in both.

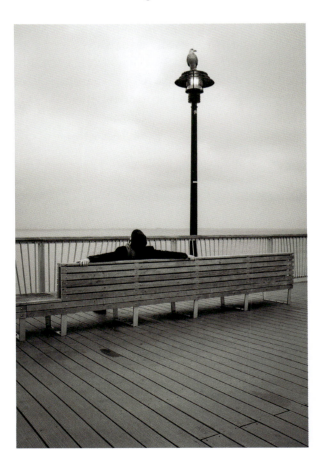

The Man and the Bird.
Fujifilm X100T 23mm
ISO 200 F/5.6 1/320
Sec.

Seagull and Dog Walker

Seagulls are such interesting birds. Having grown up on the coast in France, seagulls always remind me of home. I find their call strangely comforting. They also make interesting photographic subjects because they are predictable and tame. Whenever possible, I try to include them in a shot as an added element of interest. I saw this dog walker from a distance but didn't find the subject particularly interesting until I decided to include the fence in the foreground and a seagull as an added bonus. The layers make the composition more interesting. The seagull seems to be posing and appears huge in comparison with the main subject. The seagulls in the sky add interest as well.

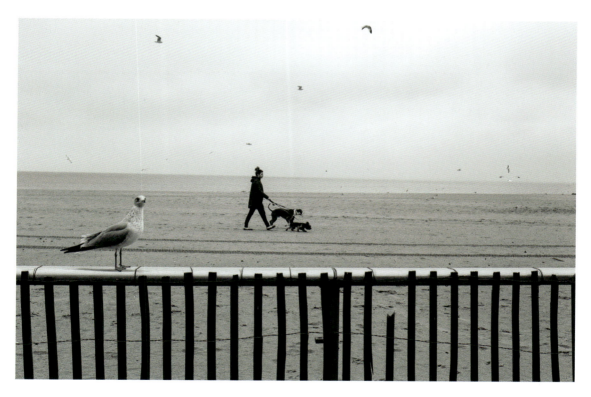

Seagull and Dog Walker. Fujifilm X100T 23mm ISO 200 F/5.6 1/210 Sec.

A A A, Chinatown

There is a great building in Chinatown, in an area known as 'Barbershop Alley'. Its bright-red color and texture is the perfect backdrop for a photograph. It had just started to rain slightly, and very few people bothered opening umbrellas. I didn't have one with me and simply covered my camera with my hand, which is another clear advantage of using a small camera. It is always worth waiting a few minutes for a good subject at that red wall. There are many tourists on that street, so it's an exercise in discernment once again. I had spotted the green A-frames and was hoping for a local pedestrian to walk by and make a third "A" with a stepping motion. Fortunately, this gentleman, dressed in black and carrying an open umbrella, walked by. I framed him between the two green A-frames and pressed the shutter. A better subject was not going to come by anytime soon. I had my shot. It was time to move on.

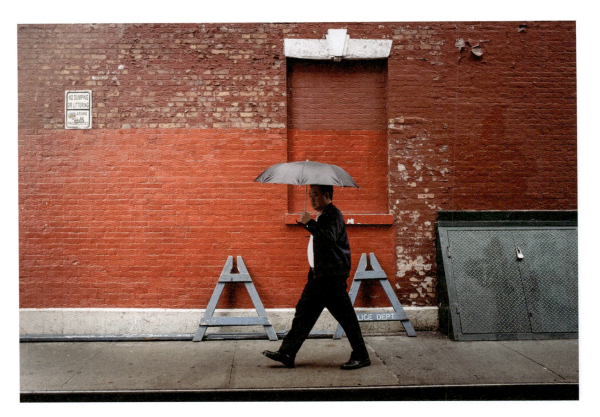

A A A, Chinatown. Fujifilm X100T 23mm ISO 2000 F/5.6 1/250 Sec.

Love is . . . Helping the Other Change a Camera Battery

Union Square always draws an interesting mix of people, from nannies taking children to the playground to locals taking their dogs to the tiny dog park. The alleys are lined with park benches, where many sit and engage in people watching. It's not easy to remain invisible as a photographer when you walk down a path where people are sitting and watching life go by. I don't want to be intrusive or disrespectful of their moment of peace so I walk very slowly, the observer being observed. This elderly couple caught my attention immediately. They are obviously in their nineties. Are they husband and wife? Brother and sister? He has a wedding band, but she doesn't. They look so much alike with their beautiful white hair and matching jackets. Her colorful socks provide a hint of her spunky personality. She is putting fresh batteries in a point-and-shoot camera. Is she helping him? Maybe his hands are too shaky for the task. Notice that she opened a tissue on her lap to set the camera on it. It shows that she takes good care of her things. This story is about patience and love. Keeping the color was a must here. The blue of their jackets, as well as her socks and walker, are all complementary and make the white heads of the couple stand out.

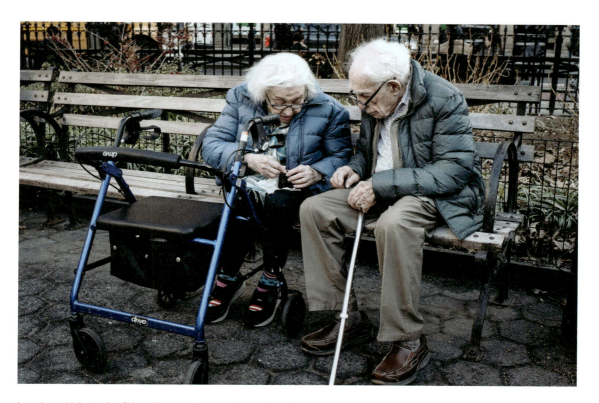

Love Is . . . Helping the Other Change a Camera Battery. Fujifilm X100F 23mm ISO 1000 F/5.6 1/125 Sec.

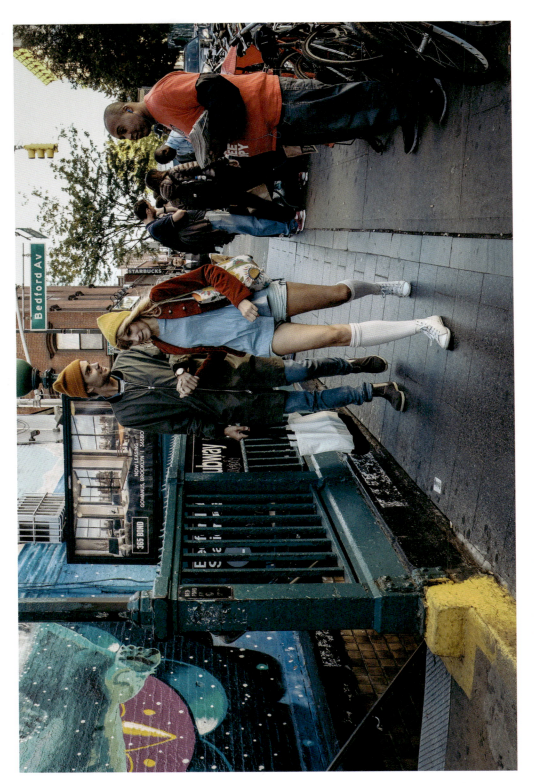

Brooklyn. Fujifilm X100T 23mm ISO 1250 F/5.6 1/250 Sec.

Brooklyn

This was my first time in Brooklyn. I was excited to finally discover a borough that I had read so much about over the years. I met with friends, and we made our way to Williamsburg by subway from Manhattan. Within a few minutes, we arrived at a busy station and emerged in a very different world. We walked to Bedford Avenue. Bedford is a mix of hip coffee shops, boutiques, gritty buildings and alleys. My friends and I split up to walk the streets separately for a while. Street photographers are lone hunters. The distraction of a conversation is not conducive to capturing a decisive moment. I decided to wait at a subway station and to let things happen organically instead of walking in every direction looking for a story. My wishes were granted within a few minutes when this young couple walked toward me, hand in hand, in the most retro and colorful attire I could have wished for. It was as if they appeared just for my camera, which was set to Classic Chrome. I caught them in step; the young man, wearing a vintage-looking coat and an orange knit hat, is making eye contact with the newspaper guy at the edge of the sidewalk. The young woman, with a matching yellow hat over her long blond hair, is sporting the seventies look with a baby-blue shirt, mini shorts and knee-high white socks. She is heading for the subway in a very determined step. They are *so* New York! They both look as if they had just walked out of a movie set.

Blue Hair on Broadway. Fujifilm X100T 23mm ISO 500 F/5.6 1/280 Sec.

Blue Hair on Broadway

Prince and Broadway is one of those intersections where photographers can spend all day and wait for the subjects to come to them. That is generally the case in bustling Manhattan during the day. Sometimes the photographer makes the mistake of continuing to walk and misses many opportunities in doing so.

Every time the traffic light changes, a new opportunity for a potential photograph emerges. You have to feel comfortable standing in the way of the crowd coming at you. Set your camera at a high enough shutter speed to freeze action, and stay alert. It's New York, so it's only a matter of minutes before you come face-to-face with someone extraordinary.

This photograph works for several reasons. The subject is obviously beautiful and stands out. She is in step, and there is even a slight separation between her heel and the ground. She is going against the leading line of the street and the flow of the other pedestrians. Instead, she is following the lines of the crosswalk. The woman entering the frame on the left, also in step, is dressed in black. She is very plain in contrast. There is no major distraction in the background. The choice of color was an obvious one.

Windy Seattle. Fujifilm X70 18.5mm ISO 400 F/5.6 1/250 Sec.

SEATTLE

Windy Seattle

It was my first visit to Seattle. I had been looking forward to the trip and was curious to experience what everyone was talking about. What was it about Seattle and the Pacific Northwest that everyone was so drawn to? It was March, and I was hoping to experience the many weather patterns the Emerald City is known for. I was not disappointed! The weather was changing rapidly. I had just reunited with one of my workshop participants, who had attended my Paris photo trip the year before. One of the best parts of teaching international photo workshops is that I make friends all over the world.

After the mandatory coffee break in one of the many amazing local coffee shops that Seattle is known for, we headed down one of the steep hills to the water against an incredibly strong wind. From a distance, I saw a gentleman with a trench coat and a matching rain hat, a sight that was unusual to me but fitting for the location. He was holding his hat to keep it from flying away. I looked at my friend, who immediately understood my plan, and I dashed across the street to catch up to him. I was shooting with an 18.5mm lens, so I had to get quite close to my subject. I took a few approaching shots until I was able to stand right behind him at a red light. I captured this close-up of him. To me, this photograph reflects the Seattle weather. It is important to capture moments like these that convey a sense of place, an image that brings you instantly back to the location you visited. There is movement, and you can almost feel the strong wind blowing.

The light turned green, and he disappeared down the steep hill. My friend and I continued our photo walk. I had my shot of the day, and there was a smile on my face.

VANCOUVER

Goodbye, Vancouver

When I think of Vancouver, the mountains and the sea naturally come to mind. I'm a people photographer, not a landscape photographer. I was walking along Canada Place on a warm and sunny Sunday morning in August. Naturally, I wanted to capture the essence of the city in a photograph where the main subject would be a person. Just like capturing an iconic landmark, making the mountains and the sea a part of my story without overpowering my subject was a challenging task. I decided to find a silhouette on the waterfront and balance the exposure so that the mountains would not be too prominent while still being ever present to give a real sense of place.

This woman wearing a large hat was contemplating the view. I quietly walked close to her and stood slightly to her left to include her in the beautiful scenery, giving a feeling of watching the landscape through her eyes.

When you travel, giving a sense of place is an important aspect of street photography. It should be done in a way that the background doesn't distract from your subject. Giving the viewer the feeling that he or she is watching the scene through the subject's eyes is one way to approach it.

Goodbye, Vancouver. Fujifilm X100T 23mm ISO 200 F/5.6 1/550 Sec.

Walkin', Readin', Smokin' in Chinatown, Vancouver

I cannot resist photographing people reading real books. It's merely an attempt at recording the last remnants of a time almost gone. But just like photographing people who stare at their handheld screens, photographing people who read books should be done with discernment. Carefully selecting the subject, composition and gesture is key to a successful photograph.

I was walking through Chinatown in Vancouver when I saw this woman walking in the opposite direction while reading a book. I quickly moved to a good spot to photograph her, hoping to include some interesting shadow patterns on the sidewalk. I had the time to position myself and frame her just before she stepped into the shadows. Fortunately, she was wearing a dress and a large hat, making her a particularly strong subject. She was also holding a cigarette in the other hand and took the right step at the right moment. Vision, preparation and luck made this photograph particularly strong.

The choice of B&W was made in camera prior to taking the picture. In my opinion, the background colors and the trees were a distraction from the subject. Although she was wearing dark colors in a dark background, the rim light around her makes her stand out particularly well.

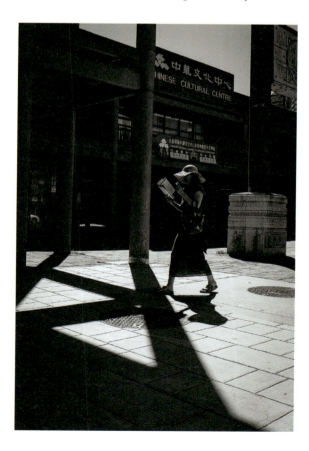

Walkin', Readin', Smokin' in Chinatown, Vancouver. Fujifilm X100T 23mm ISO 320 F/4.0 1/1900 Sec

Chicago Photo Crawl. Fujifilm X100T 23mm ISO 6400 F/2.8 1/120 Sec.

CHICAGO

Chicago Photo Crawl

I had never done a 'photo crawl' before . . . until the 2016 Out of Chicago Photography Conference, that is! Maybe such a thing had never been invented yet. On the opening night of the conference, the presenters were given one location for the evening. The goal was for the attendees to follow a map and to meet up with their favorite photographers to get to know them and to gain a few tips in the process. As a street photographer, I was given the corner of State and Lake for two hours. It's located right under the L platform and across the street from the famous Chicago Theater. Luckily, it was a beautiful Friday night in the Windy City, and theatergoers were all waiting for the green light at my corner. It was a great opportunity to do some casual street portraits as people waited for the light to change. Street portraiture is something I used to do a lot of. It's not a big challenge for an extrovert like me. I talk with strangers all the time, and telling someone that they look interesting and that I wish to make a portrait of them is not difficult. But I realize that for some photographers, the thought of approaching a stranger is nerve-racking. My workshop participants are always surprised by the positive responses they get. People are very flattered to be photographed. The most common response is "Why me?" People simply don't see anything special about their appearance. Needless to say, people are very flattered when you tell them that they caught your attention because you found them interesting.

While I was visiting with conference attendees at the corner of Lake and State on a beautiful Friday evening in June, I photographed happy theatergoers, all dressed up for an evening in town. It was getting dark, so I asked the few people who would pose for me to face the light from the theater marquee and other bright street signs. Since I was shooting B&W in camera, I didn't have to worry about white balance, which can be tricky when a variety of light sources come into play. This young woman caught my attention because of her beautiful hair. She was rather shy but paused for a brief moment for a candid portrait. I tilted the camera for a more dynamic look. She walked away happy, which is usually the case when someone receives a compliment.

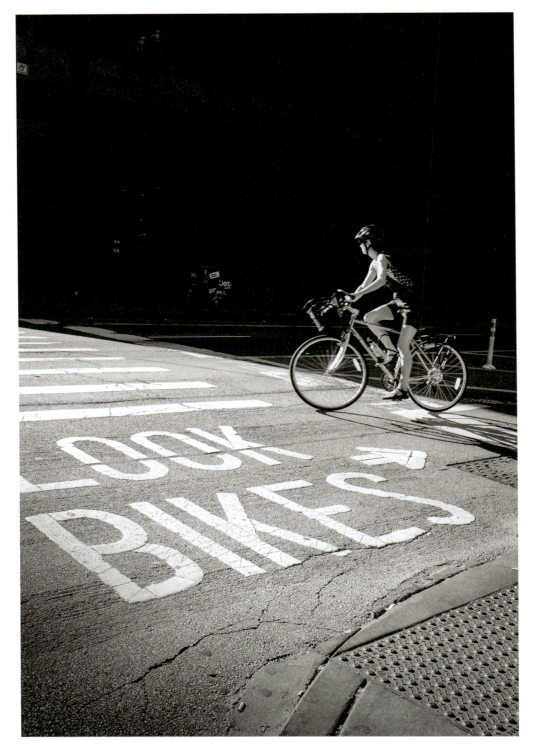

Look! Bikes! Fujifilm X100T 23mm ISO 200 F/5.6 1/200 Sec.

Look! Bikes!

Summertime in Chicago! It was a very hot and sticky day in June. I was walking several blocks toward the conference center where I was to give a presentation, trying to stay as cool as possible on the shady side of the street. As always, when I am walking to an appointment, I need to plan a lot of extra time because I know that I will not be able to resist taking a few shots along the way. This is especially true when I'm in a large city such as Chicago!

I am always drawn to interesting light, harsh shadows and the like. Sunny days on streets lined with skyscrapers are a street photographer's delight. There were not very many bicyclists out. It was a quiet Sunday morning, and the heat and humidity was not inviting for any type of exercise. I soon spotted the large 'Look Bikes' signage in the roadways at each intersection with bike paths. I looked for one that was situated on the sunny side, immediately next to a dark, shadowy area. When I'm on a schedule, I usually allow myself so many minutes to get the shot before I need to move on. After all, this wasn't a photo walk. I had a room full of attendees expecting me to deliver a presentation later that morning. It's easy to lose track of time when you are 'hunting'. Occasionally, I'll set the timer on my phone to ring after five or ten minutes as a reminder.

It took nearly all the time I had allowed myself before a bicyclist entered my frame exactly at the desired spot. Et voilà . . . mission accomplished!

SAN FRANCISCO

San Francisco Streetcar Abstract

It was nighttime in San Francisco. Some friends and I decided to take the streetcar for a few blocks to photograph passengers. Unfortunately, streetcar passengers were few and far between. I'm not one to give up easily, and I was really attracted to the softness of the streetlights. To add some interest, I chose to do a creative focus on the grid inside the open window. I took several shots during the ride, especially when the streetcar was slowing down or stopping at lights. It takes a lot of trial and error to get the right balance. I wanted to include a human element, preferably a lone silhouette, on the sidewalk. This shot was my favorite in the few that I captured during this short ride. It's moody, the lights are soft and there is a distinct silhouette passing by the storefront on the right. Also, the focus is spot-on the inside grid, and the lines are straight. It was the best possible way to turn the situation around, since there were no interesting subjects on the streetcar itself. It's all about thinking outside the box, seeing possibilities, harnessing the quantity and quality of light offered to you and using some creative focusing.

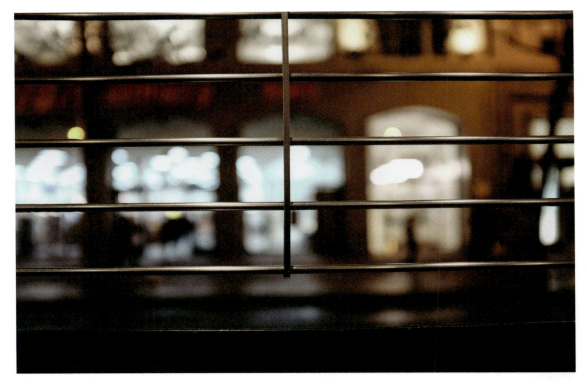

San Francisco Streetcar Abstract. Fujifilm X100T 23mm ISO 2000 F/2.0 1/125 Sec.

Peaceful Protest

I arrived in San Francisco on the day the world woke up to the news that Donald Trump had been elected president of the United States. Needless to say, the shock was particularly obvious in the blue state of California. There was a certain sense of mourning on the streets: There were few smiles, and people seemed to be in a daze. Two days later, I was walking down Powell to Market Street with a couple of friends after dinner when we heard police sirens. We were drawn in that direction. There was an incredible amount of police in cars and on motorcycles preceding what seemed to be a spontaneous anti-Trump protest. The marchers were encouraging people to join in. My guess is that the amount of police presence reflected the size the protest could potentially reach. It was very peaceful. I moved into the street, camera in hand, facing the marching crowd. It was nighttime, so I set my camera to a large aperture and fast burst mode. I was expecting a lot of motion blur, but I really wanted to capture some of the writings on the protesters' signs. It was critical that the viewer could read the signs, or the photographs would lose their impact or sense of place and time. By setting the camera on burst mode, I increased my chances of getting a few decent shots in a rather difficult situation. Here is one photograph that worked particularly well. The cardboard sign is clearly visible, giving a historical value to the photograph. The subjects in the frame are undeniably somber in light of the recent political developments. Photojournalism is a close parent to street photography. Although we often avoid including signage in street photography because it distracts from the subject, the photojournalist knows that the writing on the signs is key in the social documentation of an event such as a political protest.

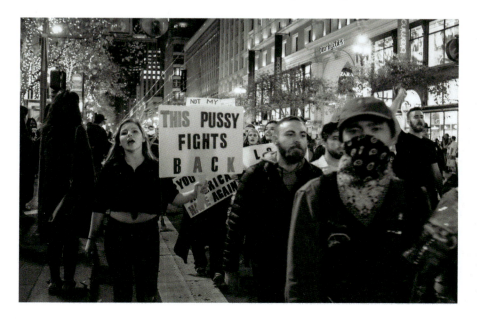

A Peaceful Protest in San Francisco. Fujifilm X100T 23mm ISO 6400 F/2.8 1/60 Sec.

The Date. Fujifilm X100T 23mm ISO 6400 F/2.0 1/60 Sec.

AUSTIN

The Date

I was visiting Austin, Texas, to give a lecture for Fujifilm in December 2015. Whenever possible, I meet up with online street photographer friends or fans wherever I go. That evening, a few local street photographers offered to hit the streets of Austin with me. What a fun time! "Keep Austin Weird" is their motto, and I can see why! The place has such a unique vibe. We explored several neighborhoods that Saturday night. There were so many people out and about enjoying the outdoor nightlife, which seemed strange to me in December, coming from frigid Minneapolis.

Street photographers are curious people. We love looking through restaurant, café, bus or train windows. As I walked by this nice restaurant, a gentleman sitting at the window table caught my attention. Or, rather, his body language caught my eye. I had never seen anyone look so uncomfortable before. He looked like he wasn't even breathing. Not wanting to draw attention to myself, I took a shot and kept walking. After reviewing the shot on the LCD display, I had some doubts on the focus. I quickly made the decision to run back and get another shot, hoping he had not taken a breath yet. Fortunately, he was still in the most uncomfortable position, and I took my time to get the focus right. I really like the layers in this image. The viewer's eye travels from the main subject to the secondary story of the other diners placing their orders next to him as well as farther inside the restaurant.

It wasn't until I reviewed the image in Lightroom that night that I realized there was a Zales jewelry store gift bag in front of him on the table. Was he about to propose? Is that why he was uncomfortable and nervous? That's my story! The beauty of street photography is that it always leaves room for the imagination.

MINNEAPOLIS AND SURROUNDINGS

Symmetry

I walk by this building regularly in Minneapolis. Its architecture lends itself to minimalist shots as well as reflections. I had never seen anyone walk between the building and the water before. I was mentioning that to my friend when he pointed to a security guard doing just that! I had just enough time to get my camera in position, time the stepping and press the shutter release. There was only one way to capture this shot. The subject had to be photographed in front of one of the white pillars for the strongest possible image. This also had to happen in the correct stepping motion, which increased the difficulty. My camera was not in burst mode, which reduced the chances of success but made for much more gratifying results. I got three shots. This one was the best. The subject happens to be in the right stepping motion in front of a column, and her reflection is not only in the water but also in the glass surface.

I had envisioned this shot for a long time. It was exciting to finally get it. The only drawback is that this shot will be hard to beat. Anything else would have to be something completely different. What are the odds of someone riding a bicycle between the building and the water? I can only hope!

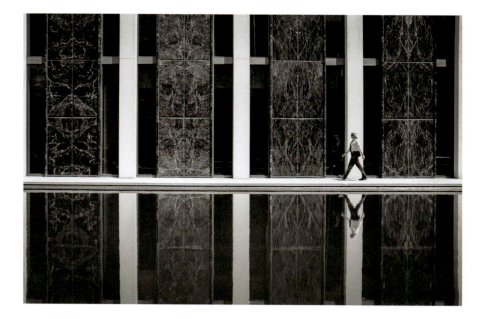

Symmetry. Fujifilm
X100T 23mm ISO 200
F/5.6 1/350 Sec.

Dreamy Lens

I had just received the new Lensbaby Velvet 56mm lens. It's a manual soft focus lens that helps you create a dreamy look in camera. It's very challenging to use. It works only with the right subject, and it is best with close-ups and wide-open apertures. You have to embrace the limitations as well as the soft, dreamy, out-of-focus look. There is no sharpness allowed here. It's all about creative fun!

There was an antique car show at the nearby river town of Stillwater in Minnesota that evening. I put the new lens on the only interchangeable camera body I own, the Fujifilm X-Pro2, and headed out the door.

I soon discovered the challenges of the lens. First, I'm a wide-angle photographer, and 56mm is really tight for me, so that was one extra challenge to consider. The subject matter was bountiful, as old cars lend themselves to some creative soft focus. As a street photographer, I always try to include the human element in the frame. I soon spotted a beautiful hood ornament. I had found my focal point of interest. Now I just had to wait for the right human element to enter the frame. This gentleman with a large hat was ideal. Knowing how much he would be out of focus, having easily recognizable features became a key element to the image's success. The focus, however soft, is on the elegant hood ornament. The human element gives added interest and life to the resulting photograph, and the hat makes the subject much more interesting. I quite like it. The timeless feel and artsy look is exactly what such a lens was made for. It's all about in-camera creative fun, no postprocessing needed!

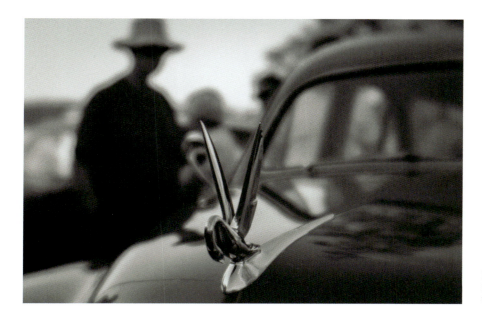

Dreamy Lens. Fujifilm X-Pro2 Lensbaby Velvet 56mm.

State Fair—Having Fun Yet? Fujifilm X100T 23mm ISO 6400 F/2 1/105 Sec.

Having Fun Yet?

The state fair is the most anticipated summer event in Minnesota. It lasts ten days and attracts tens of thousands of visitors daily. As a photographer, such an event can quickly become overwhelming with photo opportunities. For that reason, I advise that you choose a theme for the day. That will help you stay focused and allow you to leave with a series of images that work together. Last year, I gave myself the ultimate challenge to photograph humor at the fair.

Humor on the streets should be subtle. Look at it as the 'feature photograph' at the end of a newspaper. Its purpose is to bring a smile to your face after reading the drab daily news. When photographing humor on the streets, I also make a point to never capture people in embarrassing situations or to ridicule them.

We all know how much money people spend to win those giant stuffed animals at the carnival. You can only imagine the time and money invested in collecting the toys that surround this man on the bench. I immediately smiled when I saw him. If you have kids, then you've also been stuck having to carry the cumbersome prizes for hours in the summer heat. Evidently, this fairgoer was done for the day. He wasn't going to take another step until the rest of the family joined him to finally head home after a full day of fun at the fair. Surprisingly, there were not many people on this stretch of the fairground. This was both a positive and a negative. I was able to compose the shot without much distraction around him, but it was also more difficult to get close without him noticing me. As I walked closer, he looked in my direction. I grabbed a couple of approaching shots until I got close enough. He ignored my presence as I framed him just right for this final image. He was lost in thought, probably wishing for his bed after the bus ride back to the parking lot and the drive home.

County Fair Cowboy

Going to a county fair in rural America is a bit like stepping back in time. For example, when you're in a northern state like Minnesota, seeing someone with a cowboy hat on the streets is rare. But when you go to a county fair, cowboys are everywhere: at the horse barns, at the food trucks, or waiting to try their skills at the carnival shooting games.

The sun was already quite low in the sky as I wandered through the large horse barn. I was drawn to the exit at the far end because of the amazing light coming through. I was hoping to catch the silhouette of a horse and rider, so I waited there for a few minutes. As I walked out to quickly look if anything interesting was happening outside, this cowboy walked out of one of the horse stalls toward the exit. I quickly framed him with the barn door opening and pressed the shutter. My settings were already good, as I was hoping to photograph the silhouette of a horse; the quick reaction and the use of the tilt screen of the Fujifilm X70 made this low angle possible, removing as many distractions as possible from the frame. Only the lone streetlight remains. Most photographers would remove it in postprocessing, and this could be done easily in a second or two. However, removing elements goes against my ethics as a street photographer. I've done it only once or twice in the past and have always regretted it. Now, when I look at the photograph, the streetlight seems to fit right in. It anchors the cowboy in a way. I also like the mood of the black-and-white look here. It enhances the light and the unmistakable shape of the hat.

This was a very satisfying shot. Preparation and quick thinking made it possible in a single frame with no postprocessing necessary. It felt a bit like shooting in the film days again!

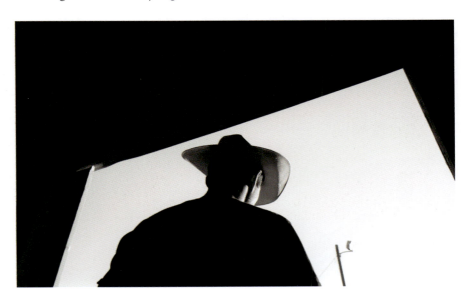

County Fair Cowboy.
Fujifilm X70 18.5mm
ISO 400 F/5.6 1/200
Sec.

County Fair Couple

Photographing the backs of people can make for very boring images. This is often something you see new street photographers do until they get the courage to move closer and face their subjects. Yet such photographs can also be beautiful, given the right subject, the right gesture and the right light.

I was leaving a local county fair on a late summer day. The sun was low in the sky as I made my way toward the parking lot. I was walking behind an elderly couple wearing hats. They looked very cute, holding hands, and the low angle of the sun was casting a nice light from the left. I moved closer and walked directly behind them at their pace. I photographed them from a low angle using a wide 18mm lens. The low angle made them more imposing while effectively removing distractions on each side of them. I was moving while photographing, and with a fast shutter speed, I was able to freeze the motion. There is something timeless and reassuring about this couple. Even from the back, you can feel how much they care for each other.

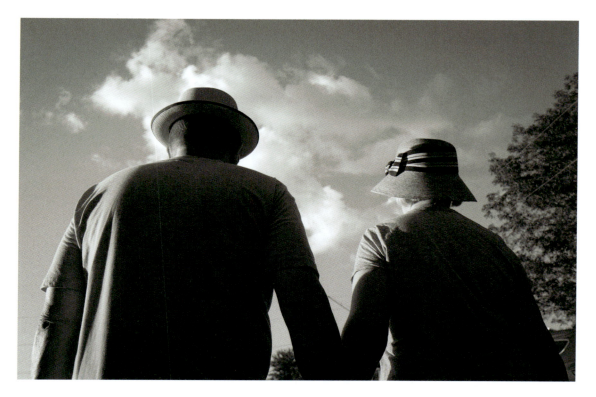

County Fair Couple. Fujifilm X70 18.5mm ISO 200 F/4.0 1/500 Sec.

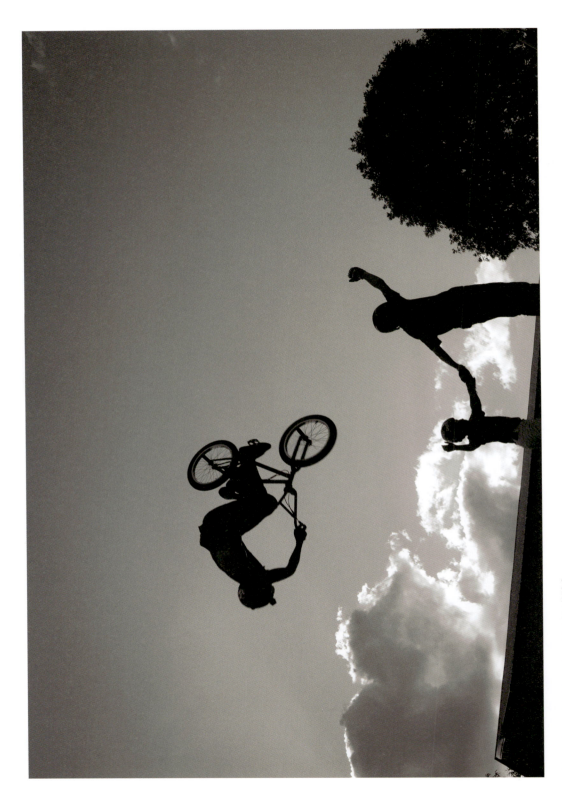

BMX. Fujifilm X70 18.5mm ISO 200 F/8 1/350 Sec.

BMX

Photographing events such as BMX competitions can be quite repetitive. Unless you know the competitors or compete yourself, if you've seen one, then you've seen them all. I've had the opportunity to watch a few, and I find the imagery of such events rather common. Usually, the bicyclist is photographed in midair with a very busy background, which can be distracting. These were exactly the kinds of shots the 'official' photographers were capturing that evening. The sun was at their backs, and trees were in the background because they were not shooting from a creative angle. It made me smile because they were all carrying heavy professional gear and looking through the viewfinder at eye level. I was using the tilt screen of my tiny Fujifilm X70 and shooting in such a way that only the sky was behind the trick performers. I was also shooting from the opposite side of the ramp, facing the sun in order to capture silhouettes for a more dramatic result. The competitors were not only quite good but also performed a trick I had never seen or photographed before. Two of the younger competitors stood on top of the ramp and held hands while the cyclist flew right over them. This created a more interesting shot by using odd numbers in my favor. Three subjects make for a strong photograph, as they allow the viewer's eyes to naturally flow from one to the next.

I was amused after the performance when one of the competitors was looking at the official photographers' pictures on the backs of their cameras. I interjected, "Hey, is that you on this shot?" I showed him this image on the back of my little camera. His eyes opened really wide!

When photographing something that has been done time and time again, try something a little different. Shoot from a different perspective, and break some rules. See something you haven't seen before!

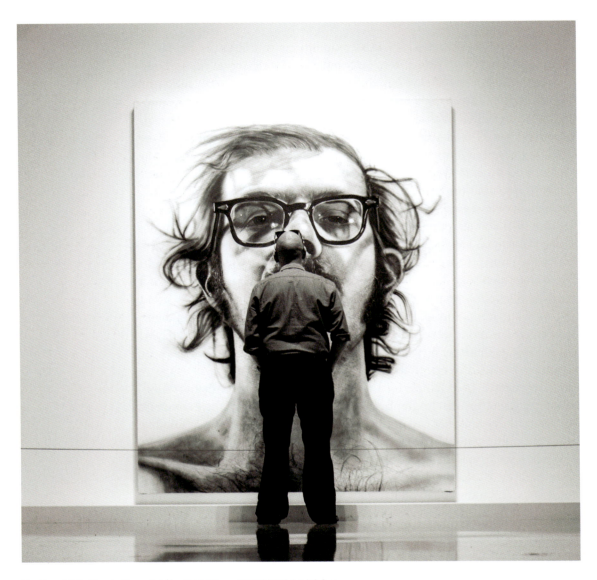

Up Close With Chuck Close. Fujifilm X-T1 27mm ISO 500 F/2.8 1/40 Sec.

Up Close with Chuck Close

Most museums in Minneapolis allow photography, with the exception of some special traveling exhibits. It becomes a favorite playground for street photographers during the bitterly cold and long winter months. I have spent a lot of time photographing inside art museums. Consequently, I started an ongoing series titled 'Museum-goers' in which I shoot only B&W and square format. There is no particular reason for this choice, it's just a way to set some limitations and to maintain consistency in the project. I always find it interesting to see the way people look at art. It can be quite comical at times.

One of my favorite museums in Minneapolis is the Walker Art Center. Modern art can offer interesting responses from visitors, with some connecting with the art, while others struggle to grasp the artist's vision. Many times, this leads to humorous situations for the photographer to immortalize.

The giant self-portrait by Chuck Close is one of my favorite pieces at the Walker. Many think that it is a photograph, as the details are so extraordinarily realistic.

There is a rope in front of it to prevent people from getting too close or from touching the art piece. It is still within arm's reach but most know that such a large piece is best appreciated from a fair distance. I entered the gallery where the famous piece is on display and immediately noticed a museum-goer standing in the center. The shot was too good to pass up. I quickly positioned myself to be centered with the subject and snapped the picture. Better yet, he was leaning so close toward the art piece and pushing onto the rope that a guard immediately asked him to step back. Fortunately, this all happened seconds after I had pressed the shutter. It remains one of my favorite photographs of the series.

Snowy Day at the Museum. Fujifilm X100s 23mm ISO 800 F/4.0 1/90 Sec.

Snowy Day at the Museum

Minneapolis is the home of several great museums, one of which is the Minneapolis Institute of Art.

It was a snowy day and a relatively slow Saturday at the MIA. People were more inclined to stay home than to venture out on the icy roads. I enjoy the place more when fewer people are present. Isolating one person in a frame is much easier, although it may be more challenging to find an interesting subject. The wait and anticipation are part of the game, and the challenge is what makes street photography so appealing.

I was standing inside one of the photography galleries. The bright hallway at the end and the snow falling outside made for a perfect distraction-free background. It's important to remember that avoiding distractions is just as crucial in the background as it is in the foreground. I was working on my museumgoers project, and I wanted to give a clear sense of place by including part of the exhibit in my frame. I waited a few minutes as one of the docents slowly walked near the window, pausing briefly to contemplate the falling snow. He was the right subject for many reasons, including that he was wearing a dark suit, which made him stand out clearly from the white background. Capturing the stepping motion also created the much-desired separation that defines the human body. This photograph immediately brings me back to the moment, the good feeling of being inside when the snow is falling outside. I believe the docent was probably thinking the same thing, unless he was contemplating the long drive home on the icy roads after his shift.

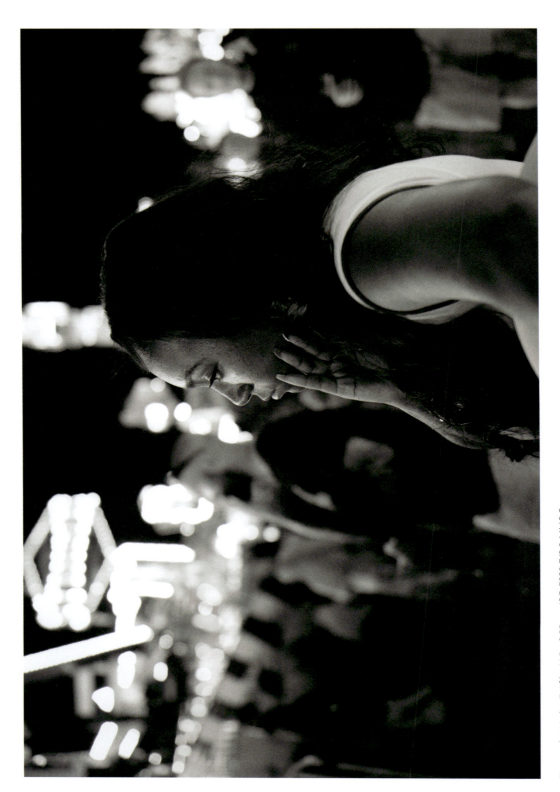

Face in the Night. Fujifilm X-Pro2 35mm ISO 5000 F/2.0 1/160 Sec.

Face in the Night

Photographing at night by using available light is like a treasure hunt. Not only is the night a challenge but also the right subject has to be at the right place at the right time and in the right light. It was Labor Day weekend, the end of summer vacation and the end of the Minnesota State Fair.

I went to the fair with the goal of capturing the expressions on visitors' faces. I used a fast prime lens, 35mm f/1.4. The key to good night street photography is to make use of all available light and to let the shadows be dark and not bring out details in postprocessing for no reason.

I noticed this woman in the crowd. She was looking toward one of the fair rides with a concerned look on her face. Maybe she was exhausted after a long day and was waiting for her children to use up their last ride tickets. She had a large stuffed toy under one arm. I moved closer in order to frame her face as tightly as possible. The glow from the many light sources lit up her face nicely. She placed her hand with long fingernails near her face. I locked my focus and pressed the shutter.

I think it's her delicate hand gesture that makes the photograph extra special. Her eye and her hand are the focal points of the image. She is well isolated from the crowd with the use of a shallow depth of field while keeping the sense of place that is necessary to tell the story.

The Complexity of Light

It was a brisk November morning in Minneapolis. After a warm fall, the cold wind was an omen of things to come. I had just met a student for a private instructional photo walk. I decided on a route that would give the most learning opportunities while also allowing us to go inside once in a while to warm up. It was a bright and sunny day, and we set out to chase the light between the tall downtown buildings. We had just stopped to get some coffee on Washington Avenue when I looked up and saw the bright sunlight through the skyway. But that was only a small part of it. Not only was there some condensation inside the glass that created an interesting filter but also the reflections on the glass added to the complexity of the scene. It's almost like being in another dimension. Several people walked through the light in the skyway, but this woman with a hat was the strongest subject. The complexity of the composition draws the viewer in. Even I, the photographer, keep going back to this photograph to analyze it. This moment was one of the highlights of the photo walk. My student will surely become more aware of light the next time she hits the streets with her camera.

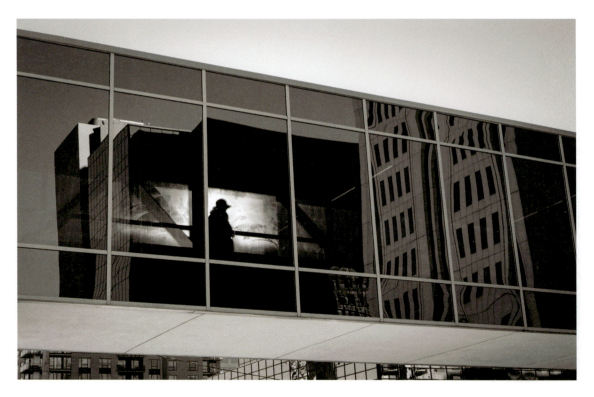

The Complexity of Light. Fujifilm X-PRO2 35mm ISO 200 F/5.6 1/340 Sec.

Film Noir

Saint Paul, Minnesota, is not Paris or New York. In the winter, people dress warmly without worrying about style. It's all about surviving the extreme cold temperatures. Their coats look more like sleeping bags with arms. They usually do not make for very elegant subjects on the streets unless you are documenting the struggles of residents shoveling a foot of snow off their sidewalks. If I'm not photographing expressions, then I usually aim for a certain look, often one that matches the architectural background. You can imagine my surprise when I saw this elegantly dressed man in a crowd of families in parkas during the holiday tree-lighting ceremony at the Union Depot in Saint Paul. Union Depot being such a beautiful building, I positioned myself so that it was clearly visible in the background. The hat is the strongest element. The rim light on the side of his face and shoulder defines the man's features against the columns in the background. Is he looking for someone or simply admiring the beautifully lit building? This example illustrates the point that sometimes photographing the backs of people can make for stronger photographs than if the faces were visible. It adds a sense of mystery. This could be a frame taken from a 1950s film noir.

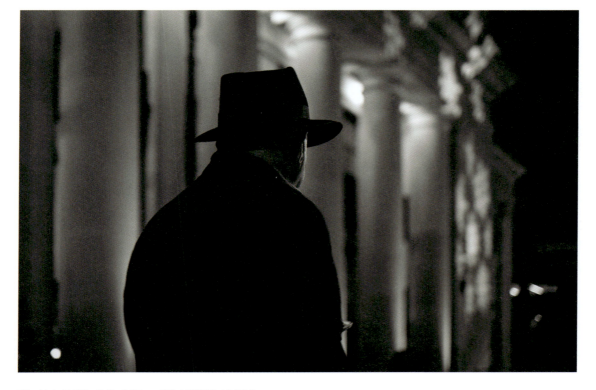

Film Noir. Fujifilm X-Pro2 35mm ISO 1600 F/1.4 1/80 Sec.

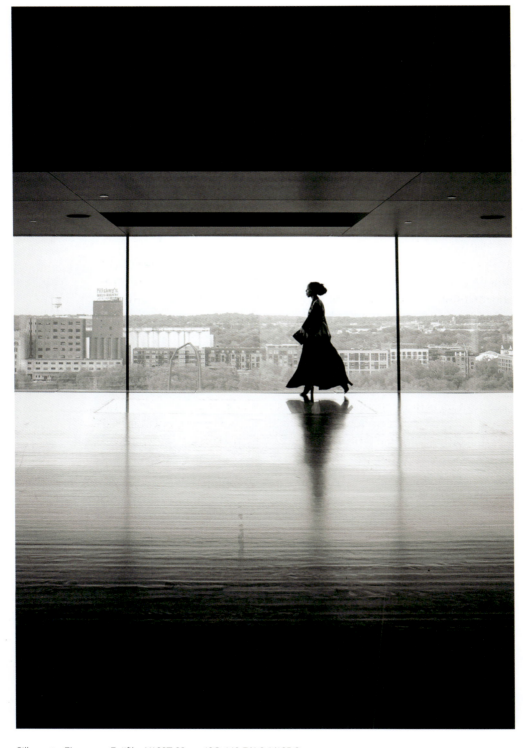

Silhouette Elegance. Fujifilm X100T 23mm ISO 640 F/4.0 1/125 Sec.

Silhouette Elegance

One of my favorite locations for silhouettes in Minneapolis is at the Guthrie Theater on Level Nine. The large windows and reflective wood floors make for some great shots if the right subject walks in front of your lens.

I was not on a photo walk that day. It was a fun family outing, but I happened to have a camera with me . . . Surprise! We were looking at the construction site of the new football stadium through one of the yellow windows of the theater's ninth floor when three women in traditional African dresses stepped out of the elevator. By the time they entered the space, we were getting ready to leave. But the moment was too good to pass up. I always look for something I haven't seen or photographed before. These women in such beautiful outfits offered a new photographic opportunity. I quickly glanced at my family with a look on my face that they have come to know. The "Please, I see a shot. I need a couple of minutes" look.

The frame I envisioned would require the three women to separate for a moment. The space is not huge, and silhouette photographs only work if there is separation among the subjects. Adequate separation is not so simple when there are three people in the frame. Within a few seconds, one of the women walked across the room alone. This was my chance! I turned my camera to capture a vertical shot. By doing so, I removed distractions on each side of the space, which allowed enough room to include the shadow reflection on the floor while still providing a negative space in my composition. The woman is in stepping motion, and there is movement in her dress and even separation between her foot and the floor. All these elements contributed to a successful silhouette photograph, which made the cover of two art publications within a few weeks.

What can we draw from the experience? Always have a camera with you, and always follow your creative instinct.

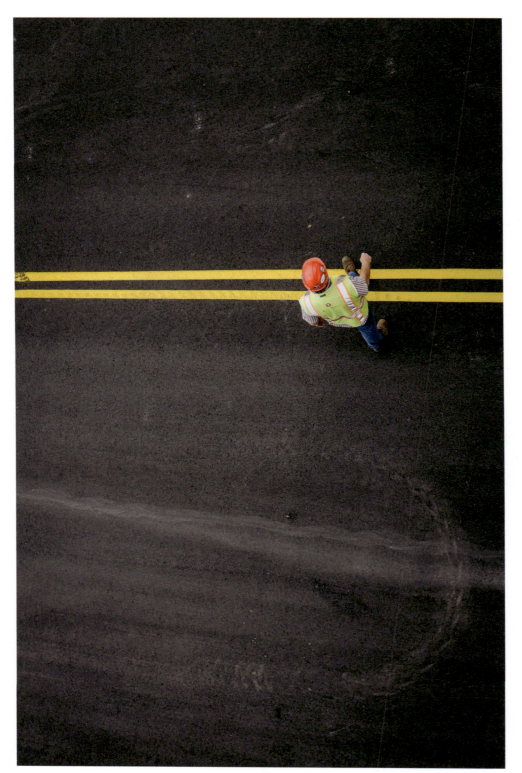

Crossing the Yellow Lines. Fujifilm X100T 23mm ISO 320 F/5.6 1/500 Sec.

Crossing the Yellow Lines

Minneapolis has a new football stadium. It's a very impressive structure, and it's been quite controversial too due to its size, location and cost. It had just opened when I took my son to check it out up close and personal. After months of watching it being built from a distance, we were both excited to see the finished product at last. After walking the perimeters (and trying to sneak a peek inside through an unlocked door, only to be asked to leave by the security guards), we made our way across the new walking bridge connecting it to the light-rail station. As we walked across, I noticed the freshly painted yellow lines below on the new blacktop. I had a shot in mind, but very few people were crossing at that spot, as it was not a designated crosswalk. There were a few construction guys on the site, putting the finishing touches on a new sculpture near the front gates. They were all wearing white helmets, except for one who walked by us on the bridge with a red one. I immediately envisioned a shot of him walking across the yellow lines from above. But what were the odds that he'd decide to cross at that exact spot?

My camera was set on B&W, as I was planning to capture some minimalist street shots of people walking in front of the modern architectural backdrop. I quickly set my camera to color, and serendipity played the next part. I was leaning over the railing when I saw this red dot enter my frame. I got the exact shot I had envisioned minutes earlier. The satisfaction was immediate, and I looked at my LCD with a large grin on my face. My son was happy not to have to wait patiently any longer, especially since he was reminding me that our parking meter was about to expire. On that day, vision, preparation and serendipity gave me a present.

Abstract

Rainy days bring wonderfully creative opportunities for the street photographer: the mood, the reflections, the umbrellas. I was visiting Stillwater, a small river town known as the birthplace of Minnesota. It was a family outing, and a storm had forced us to run back to the car for temporary shelter. Luckily, our car was parked next to a brightly lit storefront. Always looking for photo opportunities, I quickly turned this situation to my advantage. The raindrops on the car window and the condensation building up on the inside created a filter between my lens and a potential subject walking in front of the window. I manually focused my camera on the car window and waited for people to walk by. Fortunately, three women dressed in colorful fashion soon entered my frame. I grabbed the shot. You can easy distinguish the human forms through the impromptu filter, but the scene remains mysterious due to its abstract nature.

It is important to take control of your camera in situations like this. On autofocus, most cameras would focus outside the window, and the filter created by the raindrops would be lost. By going into manual focus, I made the creative decision to focus on the window instead. Remember, the camera is very good, but it is completely devoid of creativity or vision.

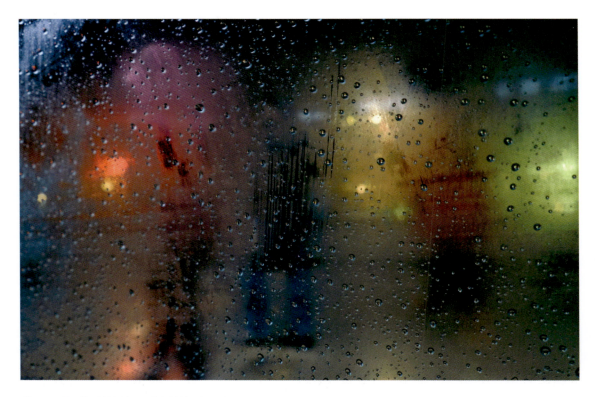

Abstract. Fujifilm XT-1 30mm ISO 5000 F/5.6 1/60 Sec.

When Light and Subject Meet

The sun sets at 4:30 p.m. at the end of November in Minnesota. It was a beautiful Saturday afternoon, perfect for a long walk along Summit Avenue in Saint Paul. I parked the car at Saint Paul Cathedral, walked down along Summit, passed the famous James J. Hill House, glimpsed Garrison Keillor's home and stopped at F. Scott Fitzgerald's early residence. On the way back, the sun was getting low. By the time I returned to the cathedral, the side entrances were basking in the golden sun. I was determined to catch a churchgoer coming out of the side entrance and composed the shot. I was beta-testing a soon-to-be-announced camera that features a joystick in the back. I set the focus point to the doorway and patiently waited for a single subject for maximum effect. The color of the clothes was also important. I had set high expectations and would not settle. Several people went in and out, but they were either not particularly interesting or in small groups. Luckily, within a few minutes and before I lost the quality of light, a woman dressed in black with curly blond hair walked out. I couldn't believe it. Her hair caught the golden light. She was the perfect subject! She walked out, followed by her friend, made eye contact with me and smiled. I had a large smile on my face. I had the best shot I could wish for with such beautiful light and so little time to work with. My job was done, as I knew I would not beat that shot. I returned to my car feeling very satisfied.

When Light and Subject Meet. Fujifilm X100F 23mm ISO 200 F/5.6 1/550 Sec.

Stories in Series

LA PÉTANQUE

La pétanque, or Boules, is a favored old game played in most city parks throughout France, especially in the south. Many take it very seriously and play in leagues several times a week. Others play it only during summer gatherings with friends and family. It's always fun to watch and to listen to the interactions between players. The goal is to throw the steel balls as close as possible to the small wooden 'cochonnet'. I always visit the courts located inside the Jardin du Luxembourg in Paris. There are two different groups of people on those courts, and you can't miss them: the expert players who live and breathe the sport and the casual players who don't take it quite as seriously. I always encourage my students to take their time and to make it a storytelling assignment in a series of images. The detail shots are really interesting, and I always capture something different at each visit. I enjoy my conversations with the players, and they never miss an opportunity to show off their skills and to talk about the game.

The wide shots are always a bit tricky, as the location is busy, and the protagonists get lost in the noise. Getting close is important in order to isolate certain subjects. Close-up shots of some of the details are my favorites, and they should largely outnumber the wide and medium shots in a series. The hands, the steel balls, the dusting rags—they are all details that are indispensable to tie the story together. It's also very important to keep a few things in mind. For example, avoid photographing people with large lettering on their shirts. The eye is drawn to words, and unless they are meaningful to the story, it's best to avoid them. They can be an even bigger distraction than a bright color. Lots of interesting people are watching the game and are just as passionate about it as the players themselves. Make sure to scan the courts and to capture some images of the spectators. Pétanque can be considered a national pastime in France. It is played by people of all ages. Some of the supporters around the courts can be quite passionate and animated about the game and the scores. Capturing some of the stories behind the scenes is a great addition to any series. The key is to spend enough time to really take in the scene without always having the camera to your eyes. Walk slowly, and let the moment do its magic.

(facing page)
Fujifilm X100T 23mm
ISO 200 F/4.0 1/125
Sec.

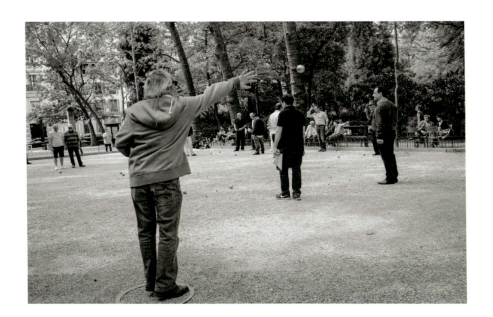

La Pétanque. Paris,
France. Fujifilm X100T.

BEAUTIFUL SMILES OF STRANGERS

There is something very heartwarming about seeing a beautiful smile. For several months, I worked on a street portrait series titled 'Beautiful Smiles of Strangers' and photographed people from Paris to New York, Minneapolis to Melbourne, with the goal to share at least a beautiful smile every week on social media. I could have shared one every day. The project became so addictive that I would stop several strangers on any photo walk whose smiles I noticed. People responded very well when I said, "Wow, you have a beautiful smile. I would really like to do a portrait!" I even made some long-lasting friendships during the project. It was so gratifying because I was not only making other people's days but also my day too! Making people happy made me happy, and I think that's the reason why the project became so addictive. The response on my blog posts was also very positive. I still photograph strangers' smiles and continue adding to the collection.

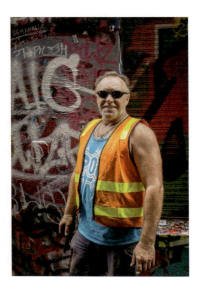

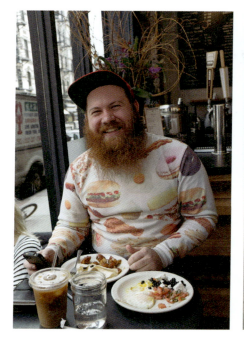

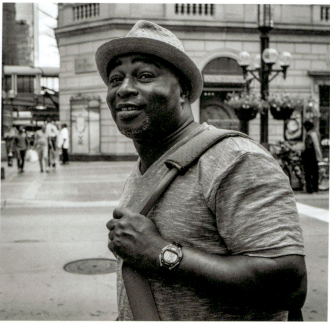

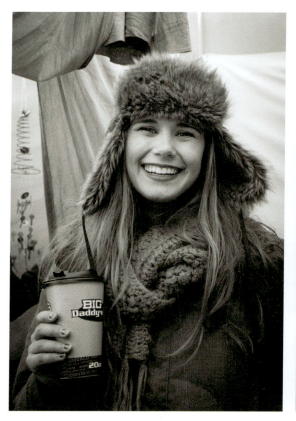

A DREAMY 19TH CENTURY CHRISTMAS

Using a special effects lens is a great exercise in creativity. I love the extra challenge. Seeing the resulting photographs on the computer screen after a photo shoot is always a bit like opening a present. The Lensbaby Velvet 56 offers a new way of seeing and forces the photographer to let go of the notion of sharpness. The fun is in experimentation with different levels of soft focus, depending on the chosen aperture.

It was a snowy day in Minnesota, a couple of weeks before Christmas. My family and I visited The Landing, a village composed of authentic buildings designed to recreate nineteenth-century life in the prairie. The buildings were all moved from various locations throughout the state. Reenactors welcome visitors into their 'homes' and talk about the hardship of life on the prairie during the winter months. For a few hours, you travel from 1850 to the turn of the century, immersed in a different time period. Fortunately, the snowstorm had kept the crowds away that Sunday afternoon, and I was able to collect quite a few images without 'modern' people in the background.

I had never used this lens in low-light situations, and it was difficult to know how the pictures would turn out just by looking at the LCD on the back of the camera. I had to trust my instincts and hope for a few keepers. I

was using the Fujifilm X-Pro2 in Acros and Classic Chrome film simulation bracketing. After a few shots, I knew that I would use the Classic Chrome. It was a perfect choice with the lens and subject matter.

I had so much fun exploring each building in search of interesting details of life from the past as well as adequate window light. The actors were so authentic and passionate about the time period they were reliving. I grabbed a few shots while they were talking with the visitors.

A Dreamy Nineteenth-Century Christmas. Fujifilm X-Pro2 and Lensbaby Velvet 56mm.

The challenge of manual focusing added another level of difficulty to the low-light situation inside the buildings. I was very impressed with the performance of the lens, though I don't think one can ever master it completely. There will always be an element of surprise in the photographs it produces, which may just be the biggest appeal of such a lens. The anticipation is somewhat reminiscent of shooting film.

Overall, I am quite pleased with the results. The lens was the perfect companion for my time-travel adventure. I can't wait to use it again in a different era.

These were just a few of the thousands of stories I've been privileged to witness while roaming the streets of the world with my camera. I hope you enjoyed the photo walk and feel inspired to look for extraordinary stories of ordinary people.

My journey is just beginning. Now it's time to grab my camera and hit the streets!